ARRAYS OF LIGHT

BENJAMIN SAMUEL

DISTANZ

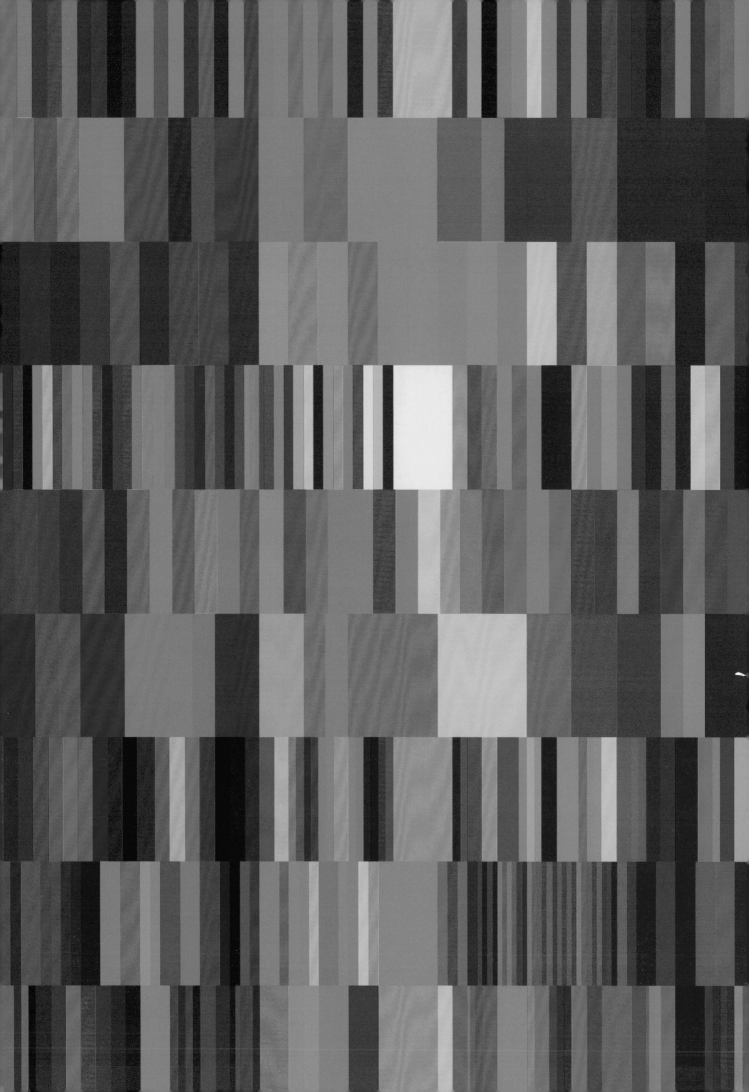

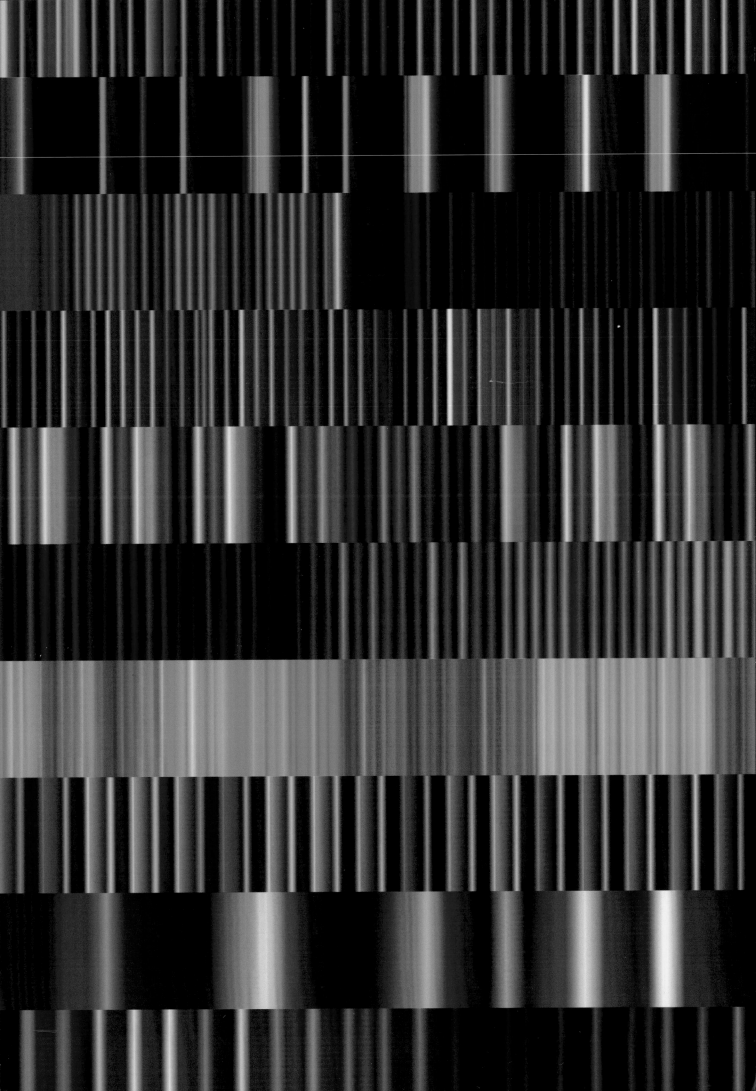

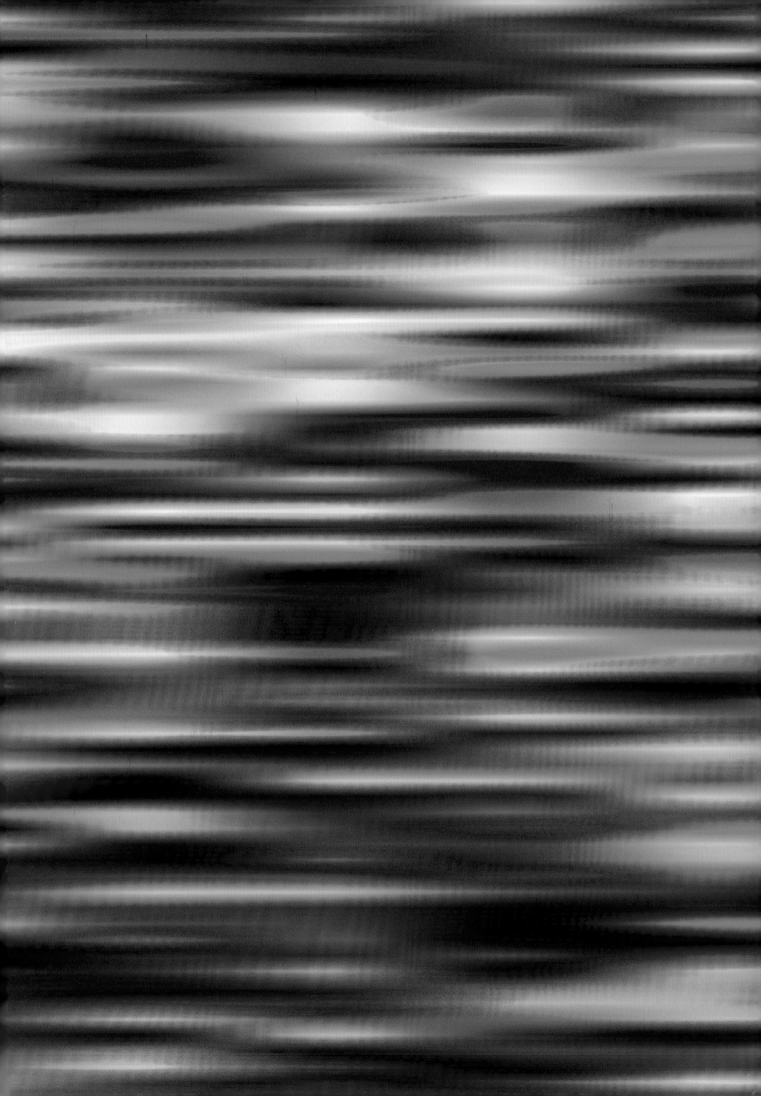

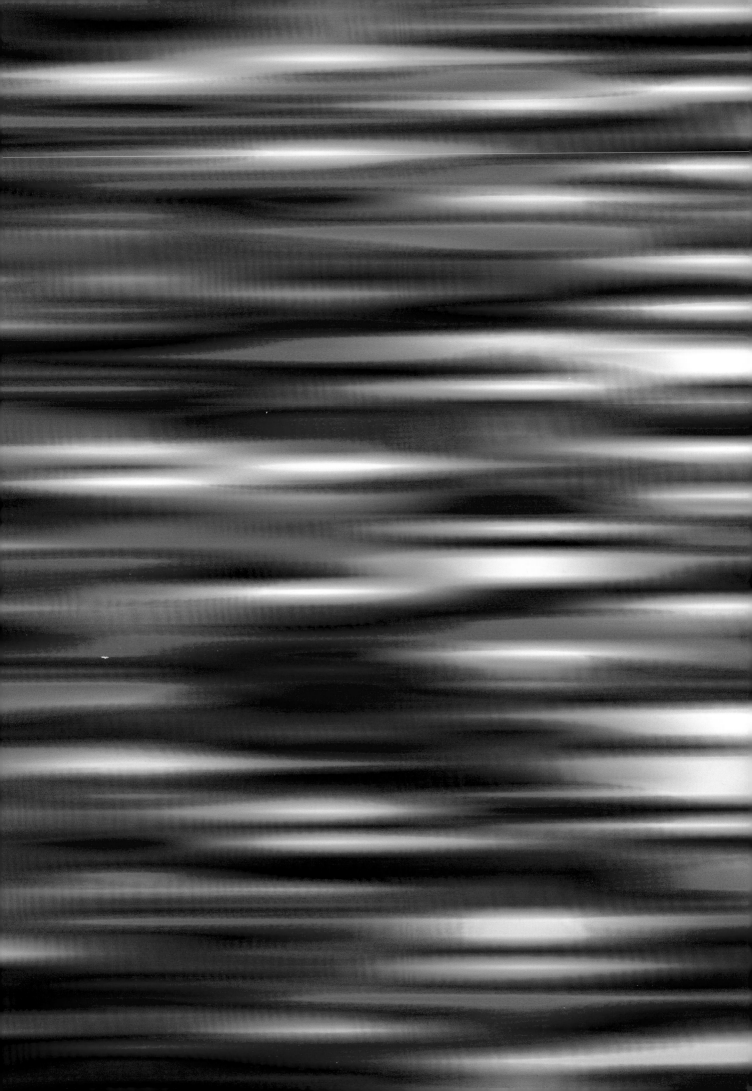

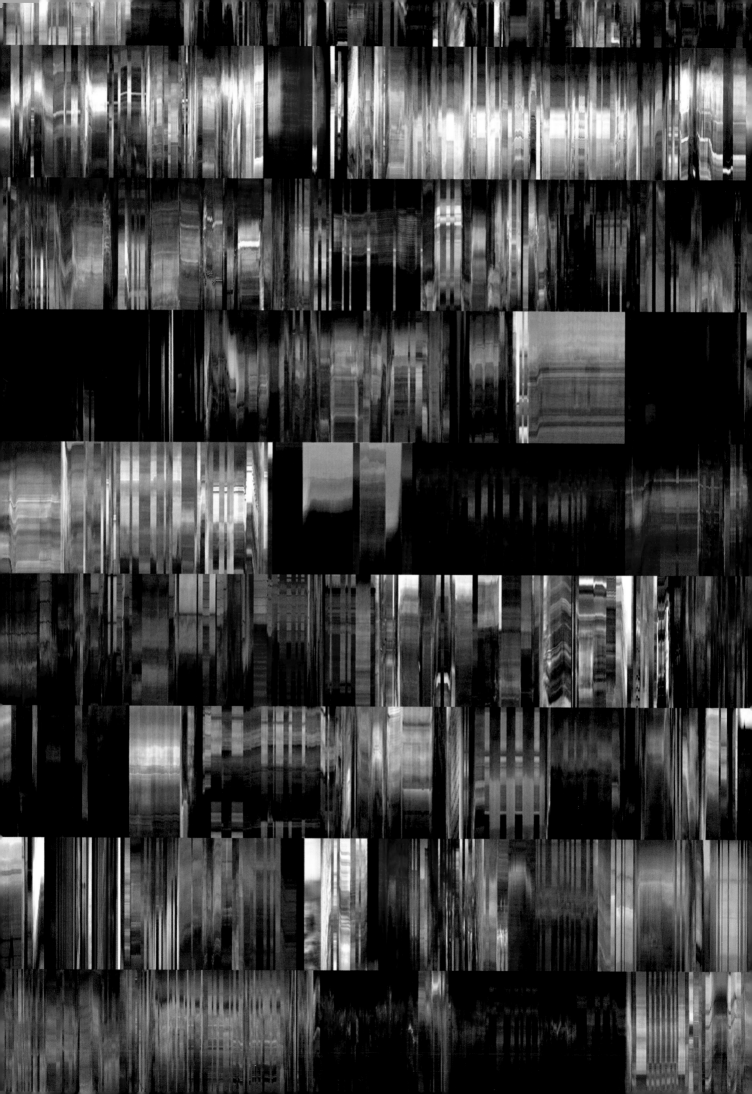

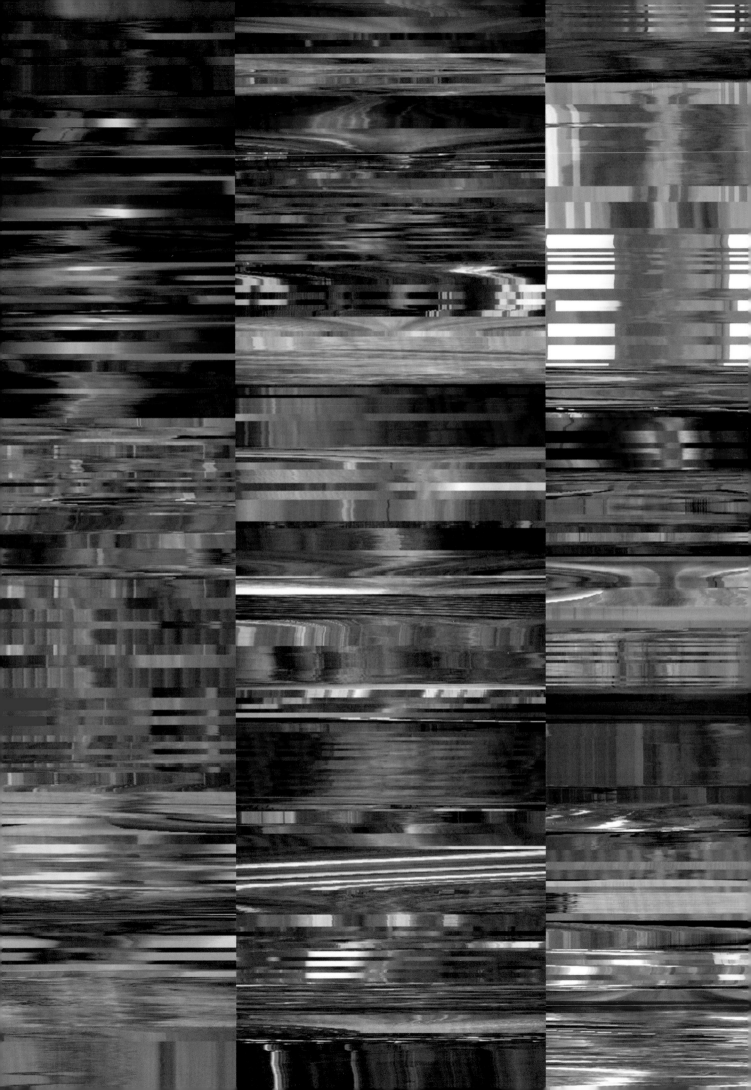

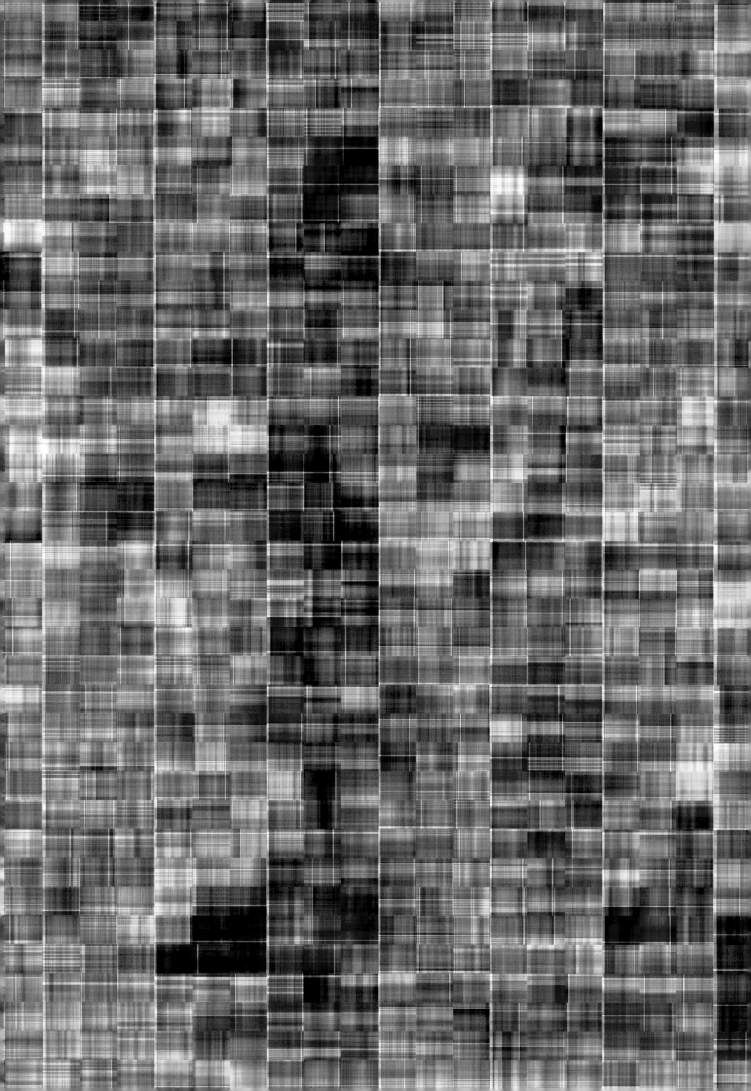

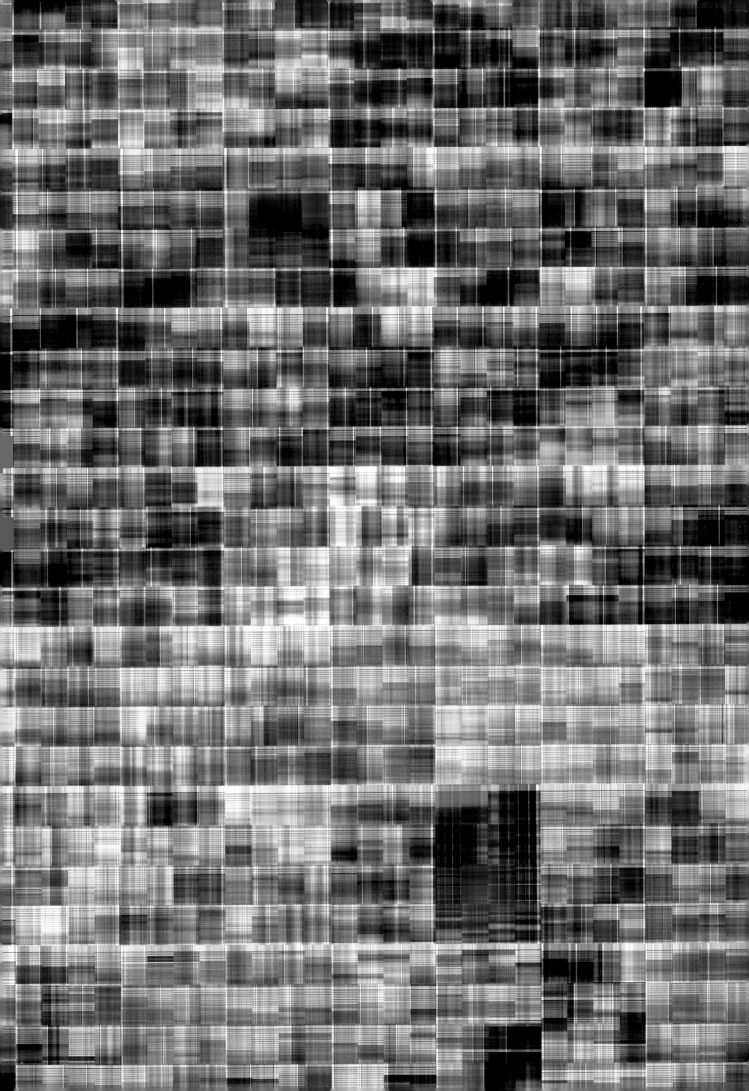

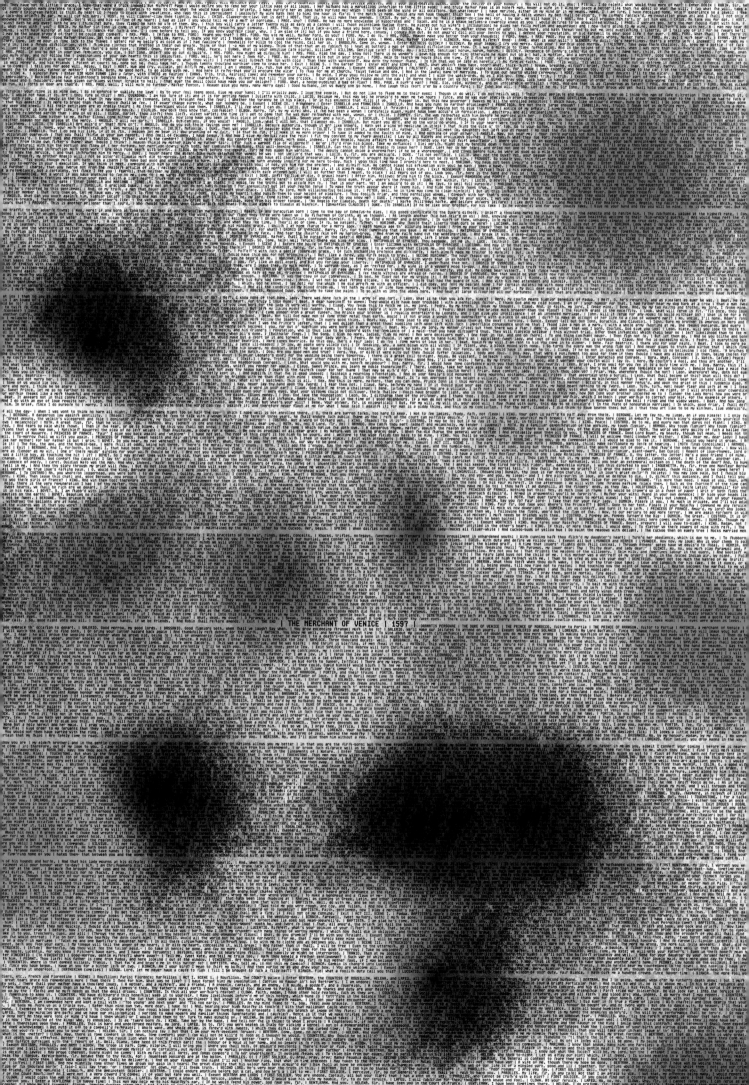

THE MERCHANT OF VENICE | 1597

Contents
Inhalt

Summa Summarum
On the works of Benjamin Samuel

During the Scholastic period of the Middle Ages, writings meant to represent the complete extent of a particular field of knowledge, were called *summa* (the Latin word for totality). These texts were at first purely encyclopaedic summaries, compiled in a rather disorganised fashion. Their form developed over time, with the fields of knowledge compiled as complete as possible and in an organised way. Famous examples of these summaries include *Summa Theologica* by Thomas Aquinas (written around 1265–1273) and the *Summa Logicae* by William of Ockham (written around 1323). The authors' intention in organising these texts was to reveal the omnipresent divine order. The sum, to a certain extent, is a mirror through which not only a subject area can be captured comprehensively, but also structured meaningfully like the order of the cosmos.

Even after the Middle Ages, such *summaries* seemed to keep coming back in fashion each time a new large body of knowledge appears on the scene, ready to be organised and managed. Maybe because we live in an age in which the quantity of available knowledge, information, and images rose sharply and continues to increase steadily, new technologies and genres have developed, enabling us to sum up a large number of phenomena and artefacts. These technologies and genres reduce inherent complexity, as we see in the simplistic illustrations of *Shortology*, a method which depicts such different subject matters as "The Last Supper, Lady Gaga, the moon landings, the Mona Lisa, the invention of electricity, Ikea, the Berlin Wall, celebrity chefs and everything in-between" in five-second diagrams. The advertising line for the book *Live in Five Seconds* written by Matteo Civaschi and Gianmarco Milesi in collaboration with their Milan agency H-57, published in 2012 reads: "200 world events, inventions, great lives, places, animals and cultural icons that you really need to know about, and then, hey presto!, cuts away all the useless details". The following year, the publication *Film in Five Seconds* followed, showing that perhaps especially some movies' plot lines can be condensed into such short diagrams (the whole point and the punchline is that the abbreviated subject matter can of course only truly be understood and savoured by someone who is actually familiar with it). [Fig. 1]

19

Fig.1
Film in Five Seconds, Matteo
Civaschi and Gianmarco Milesi,
Quercus Publishing 2013
www.h-57.com / www.shortology.it

Supercuts pursues another path, selecting from, rather than reducing, the original source material. Specific scenes from a director's works, a series or a genre are assembled in such a way that distinct idiosyncrasies, such as genre-specific clichés or even aesthetic peculiarities, are highlighted. This process lends itself particularly well to directors such as Stanley Kubrick or Wes Anderson, where the compilation emphasises the character-istic preference for forced central perspec-tive (Kubrick) or symmetrically arranged (Anderson) scenes (see for example the Supercuts by the Seoul film-maker kogonada www.kogonada.com).

The effect is that of *Shortology*: The confusion caused by the wealth of images and information is avoided by drawing our attention to the sum of specific aspects, by providing us with the possibility of an overview and orientations. Certain *Supercuts* especially reveal specific properties, rules, proclivities or phenomena, so that an addi-tional aspect of such sums emerges. They can, at times, exert an aesthetic appeal in themselves, beyond that of the source material. It is not the material itself that is appealing, but rather the manner in which the sum is selected, edited, arranged, and combined.

This appeal is also clear in the work of Benjamin Samuel. The works also free themselves from the source materials' original appearance and primary mode of presentation: music, stock exchange reports, film-stills, comics and literature. Through abstracting methods of com-pression, his works also develop a completely unique aesthetic.

At the same time, this does not reduce their significance, as Benjamin Samuel's works distinguish themselves from images that may at first glance seem related. "Photo-mosaics" have been around since the 1950s, and gained the popularity they still enjoy today in 1993, when they became computer-generated. The single image is subor-dinate to an overall composition that emerges from the assembly of a multitude of small images. In contrast, in Benjamin Samuel's works each individual element maintains its own individual statement alongside its significance in the work's overall appearance.

Fig. 2
FRICKbits, Laurie Frick
www.lauriefrick.com

Some programmes and apps go in a similar direction as the photo-mosaics, arranging data stored on a smartphone into aesthetic patterns, as did the American artist Laurie Frick, who developed the app *Frickbits* in 2012. This specially-developed algorithm represents data in coloured shapes, which are then organised into abstract, seemingly hand-painted patterns. [Fig. 2] The discrepancy between the invisible and disembodied abstract data on the one hand, and their conversion into colourful, seemingly hand-crafted forms on the other, makes the relationship between these two levels seem arbitrary and at times quite difficult to comprehend. This is very unlike Benjamin Samuel's works, which enable the viewer to understand the relation between the original (a screenshot, for example) and its context in the overall structure of the image.

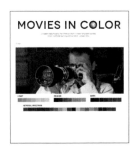

Fig. 3
Movies in Color
by Roxy Radulescu
www.moviesincolor.com

Los Angeles-based graphic designer Roxy Radulescu's project is yet another step towards abstraction. Her website (www.moviesincolor.com) presents results that she obtained from measuring colour palettes used in certain films. [Fig. 3] Radulescu's goal is not only to reduce the respective movies to their colour basis, but also to show a clear relationship between the colours, the light used, and the overall effect achieved in the films. Filmmakers can study and refer to it: "One of the goals", she writes on her website, "is to give artists colour palettes they can use in paintings, films, videos, graphic design, and other pursuits."

A contrast to *Frickbits* is the 2009 / 2010 work *All the Blinks*, by the Ecuadorian artist Oscar Santillan. Unlike Frick, Radulescu or Benjamin Samuel, he renounces abstraction of his source material, stringing together screenshots of all the moments of all James Dean's films in which the actor blinks. [Fig. 4] The result is indeed interesting to look at, but remains, in contrast to Benjamin Samuel's work, very much attached to the purely illustrative level. At first glance, a comparison between Santillan's *All the Blinks* and the seemingly similar appearance of Samuel's images, demonstrates the quality of the latter. His images also set out to compile a complete survey with clearly defined parameters — for example, all thirty films, in chro-

Fig. 4
All the Blinks,
2009/2010
by Oscar Santillan

nological order, that Alfred Hitchcock made from 1940 onwards (when he moved to Hollywood), in *Hitchcock* [30], and all thirteen of Stanley Kubrick's films in *Kubrick* [13+9+10]. But Benjamin Samuel does not stop, for example, by arranging a total of 285,000 screenshots of movies side by side in *Hitchcock* [30]; rather, he continues by condensing 30 films from 36 years of the director's life on a single board, in a single space so to speak, freezing it in time. Benjamin Samuel applies this concentration and condensing work even further, as he compresses the individual screenshots in a prescribed manner, using an algorithm he developed and programmed himself. All the screenshots in *Hitchcock* [30] were squeezed together from side to side. This process itself dictated the horizontal ordering of these results, with Benjamin Samuel referring in the overall picture to the format of a movie screen. In *Kubrick* [13+9+10] on the other hand, the individual images were compressed from above and below, and the results are, accordingly, arranged vertically from top to bottom. This order firstly refers to Kubrick's extremely conscious approach to the film format, and also to the vertical, rectangular produced shape of the work alluding to the outline of the monolith in Kubrick's 1968 film *2001—A Space Odyssey*.

The parallels and differences in Benjamin Samuel's above-mentioned works demonstrate that they can stand alone. There is additional potential in their relationship as a pair (for example, two pieces of music, one by Johann Sebastian Bach and one by Ludwig van Beethoven; two representations of stock market performances, one from the DAX, the other from the Dow Jones; two comic book series, Astérix by Goscinny and Uderzo on the one hand and Tintin by Hergé on the other; literary works, the plays of William Shakespeare and the tales of Edgar Allan Poe): looking at *Hitchcock* [30], we observe the historical transition from black and white to colour film and Hitchcock's first experiments with colour in the 1940's. Within the individual films, we see such formal elements as the change between dark and light sequences. Since Kubrick also lived through the transition from black and white to colour film, it is particularly exciting to visualise his confrontation with colour, especially when compared to Hitchcock. Time plays a role in Benjamin Samuel's work, both in the historical sense (What happened when? What followed

22

what? What was done at the same time?), as well as in the original performance of the phenomena Benjamin Samuel presents, because all of them (music, film, the stock market year, comics and literature as sequential works of art) require time to unfold and develop. Benjamin Samuel has released them from this captivity of time, abstracted and reprogrammed them, within his own matrix, and put them into a new temporal context. Even the viewer of Benjamin Samuel's work needs time to study and understand them in different layers, first as singular, autonomous images, then as couples relative to each other, which are finally regarded all-in-all, *Summa Summarum* so to speak, seen and understood together as a whole.

PROF. DR. HENRY KEAZOR
Professor of Early Modern and Contemporary Art History
Institute of European Art History
University of Heidelberg

Summma Summarum
Zu den Werken Benjamin Samuels

„Summa" wurden während der Scholastik des Mittelalters Schriften genannt, die – der Bedeutung des lateinischen Begriffs für „Gesamtheit" gemäß – als vollständige Darstellung des soweit bekannten Stoffes eines bestimmten Wissensgebietes konzipiert waren. Waren diese Überblickstexte zunächst als das verfügbare Wissen eher ungeordnet und rein enzyklopädisch darbietende Zusammenfassungen angelegt, so entwickelte sich die Gattung der „Summe" im Laufe der Zeit zu Formen, in denen die gewählten Wissensbereiche nicht nur möglichst vollständig, sondern zudem nun auch auf strukturierte Weise dargeboten wurden. Berühmte mittelalterliche Beispiele für diese Art der „Summen" stellen Schriften wie die „Summa theologica" des Thomas von Aquin (entstanden um 1265 – 1273) oder die „Summa logicae" von William von Ockham (verfasst um 1323) dar, bei denen zudem die Perspektive deutlich wird, aus der heraus die erwähnte Systematisierung auch angestrebt wird: Mit ihrer Hilfe soll eine die ganze göttliche Schöpfung durchwaltende Ordnung sichtbar gemacht werden, d. h. die „Summe" ist ein Stück weit auch als ein Spiegel angelegt, in dem nicht nur möglichst umfassend ein Themengebiet eingefangen wird, sondern dessen Darstellung zugleich auch erkennen lässt, dass der so wiedergegebene Teilbereich menschlichen Wissens ebenso von einem sinnvollen Aufbau geprägt ist wie das ganze kosmische Gefüge.

Derartige „Summen" haben auch nach dem Mittelalter offenbar immer dann naheliegenderweise Konjunktur, wenn der Eindruck vorherrscht, dass auf eine große Masse an Wissenszuwachs zurückgeblickt werden kann, die geordnet und verwaltet werden will. Vielleicht, weil wir selbst in einem Zeitalter leben, in dem der Umfang an verfügbarem Wissen sowie an Informationen und Bildern sprunghaft angestiegen ist und stetig weiter steigt, lassen sich seit einiger Zeit Technologien und z.T. daraus entwickelte neue Genres beobachten, bei denen ebenfalls „Summen" aus einer großen Anzahl von Phänomenen und Artefakten gezogen werden. Hierbei wird meistens mit einer Reduktion der dort angetroffenen Komplexität gearbeitet, etwa in den vereinfachenden Veranschaulichungen der so genannten *Shortology*, einem Verfahren, sämtliche und so unterschiedliche Sachverhalte wie „The Last Supper, Lady Gaga, the moon landings, the Mona Lisa, the inven-

tion of electricity, Ikea, the Berlin Wall, celebrity chefs and everything in-between" in Fünf-Sekunden-Diagrammen darzustellen: „200 world events, inventions, great lives, places, animals and cultural icons that you really need to know about, and then, hey presto!, cuts away all the useless details", wird das 2012 von dem Autorenteam Matteo Civaschi und Gianmarco Milesi im Zusammenarbeit mit ihrer Mailänder Agentur H-57 publizierte Buch *Live in Five Seconds* beworben, dem im Folge-jahr der Band *Film in Five Seconds* folgte, der zeigt, dass sich vielleicht insbesondere der Plot mancher Filme dazu eignet, auf solche knappen Diagramme reduziert zu werden (die freilich – dies der Witz des Ganzen – nur von jemandem wirklich verstanden und goutiert werden können, der das damit Abgekürzte tatsächlich bereits kennt).[Abb. 1]

Abb. 1
Film in Five Seconds, Matteo
Civaschi und Gianmarco Milesi,
Quercus Publishing 2013
www.h-57.com / www.shortology.it

Einen anderen, weniger mit Reduktion denn mit Auswahl aus Originalmaterial arbeitenden Weg schlagen die so genannten *Supercuts* ein: Bei ihnen werden bestimmte Szenen aus dem Werk eines Regisseurs, einer Serie oder eines Genres so hintereinander weg montiert, dass bestimmte Eigenarten, z.B. gattungs-typische Klischees oder aber auch ästhetische Eigenheiten deutlich werden – ein Verfahren, das sich besonders bei Regisseuren wie z.B. Stanley Kubrick oder Wes Anderson bewährt hat, wo ein solcher Zusammenschnitt u.a. ihre charakteristischen Vorlieben für forciert zentralperspektivische (Kubrick) bzw. symmetrisch arrangierte (Anderson) Szenenbilder filmübergrei-fend veranschaulicht (vgl. die entsprechenden Supercuts des aus Seoul stammenden Filmemachers kogonada unter www.kogonada.com).

Der Effekt ist der gleiche wie im Fall der *Shortology*: Die mit dem Informations- und Bilderreichtum einhergehende Unübersichtlichkeit wird durch das Ziehen der gezielt bestimmte Aspekte in den Blick nehmenden „Summe" dahingehend konterkariert, dass wieder Orien-tierung und Überblick möglich sind.

Vor allem bei den bestimmte Eigenschaften, Regeln, Vorlieben oder Phänomene erkennbar machenden *Supercuts* tritt jedoch noch ein zusätzlicher, möglicher Aspekt solcher „Summen" zutage: Die so kom-ponierten Gebilde können zuweilen selbst ästhetische Reize ausüben, die jenseits des von ihnen verwendeten Materials liegen, d.h. es ist weniger dieses selbst, das diesen Reiz ausmacht, als vielmehr die Art

und Weise, in der es für die „Summe" ausgewählt, bearbeitet, arrangiert, und darin kombiniert und montiert wird.

Dies wird auch bei den Arbeiten von Benjamin Samuel besonders deutlich und anschaulich, denn gerade dadurch, dass sie sich vom ursprünglichen Erscheinungsbild und der originären Wirkweise des zugrunde gelegten Materials – Musik, Börsenberichte, Filmscreenshots, Comics, Literatur – durch abstrahierende „Kompression" emanzipieren, vermögen sie es, eine ganz eigene Ästhetik zu entwickeln.

Zugleich geht hierüber jedoch nicht ihre Aussagekraft verloren, was Samuels Werke von auf den ersten Blick vielleicht verwandt erscheinenden Bildern unterscheidet: Seit den 50er Jahren sind sogenannte „Foto-Mosaike" als Verfahren bekannt, die jedoch erst ab 1993, als sie computergeneriert werden konnten, jene Popularität erfuhren, die sie noch heute genießen. Hierbei wird freilich das einzelne Bild einem Gesamtmotiv untergeordnet, das aus der Vielzahl der zueinander montierten kleinen Bildern entsteht. Bei den Werken von Benjamin Samuel erhält sich demgegenüber jedes einzelne Element eine eigene und zugleich mit der Gesamterscheinung des Bildes untrennbar verbundene Aussage.

Abb. 2
FRICKbits, Laurie Frick
www.lauriefrick.com

In die ähnliche Richtung wie die „Foto-Mosaike" gehen Programme und Apps, welche z.B. sämtliche auf einem Smartphone gespeicherten Daten zu ästhetischen Mustern ordnen wie im Fall der von der amerikanischen Künstlerin Laurie Frick 2012 entwickelten App *Frickbits*, wo ein speziell hierfür entwickelter Algorithmus dafür sorgt, dass die Daten in Form farbiger Formen repräsentiert werden, die sodann zu abstrakten, wie handgemalt wirkenden Mustern geordnet werden. [Abb. 2] Entsprechend der damit gegebenen Diskrepanz zwischen den an und für sich abstrakten, da unsichtbaren und körperlosen Daten auf der einen und deren Umsetzung als farbige und zudem wie händisch ausgeführt anmutenden Formen auf der anderen Seite, erscheint das Verhältnis zwischen diesen beiden Ebenen gelegentlich eher schwer nachvollziehbar und damit auch willkürlich – sehr im Unterschied wieder zu den Werken Samuels, wo der Bezug zwischen der ursprünglichen Vorlage (z. B. einem Screenshot) und dessen Kontextualisierung im Gefüge des Gesamtbildes stets visuell nachvollziehbar bleibt.

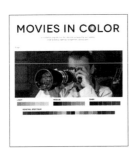

Abb. 3
Movies in Color
von Roxy Radulescu
www.moviesincolor.com

Noch einen weiteren Schritt hin zur Abstraktion vollzieht schließlich das Projekt der in Los Angeles tätigen Grafikdesignerin Roxy Radulescu, die auf ihrer Seite www.moviesincolor.com Ergebnisse vorlegt, die sie bei der Messung der in bestimmten Filmen verwendeten Farbskalen erhoben hat. [Abb. 3] Radulescu geht es hierbei nicht alleine um eine Reduktion der betreffenden Filme auf deren koloristische Grundstruktur, sondern auch und vor allem darum, aufzuzeigen, dass ein nachvollziehbares Verhältnis zwischen den in Ausstattung und Kostümen verwendeten Farben, dem eingesetzten Licht und der damit erzielten Gesamtwirkung des Films besteht, an dem sich andere Filmschaffende orientieren und schulen können: „One of the goals", so schreibt sie auf ihrer Seite, „is to give artists color palettes they can use in paintings, films, videos, graphic design, and other pursuits."

Abb. 4
All the Blinks,
2009/2010
von Oscar Santillan

Eher einen Gegenpol zu den *Frickbits* stellt demgegenüber die Arbeit *All the Blinks* des aus Ecuador stammenden Künstlers Oscar Santillan aus den Jahren 2009 / 2010 dar, denn anders als Frick, Radulescu oder Benjamin Samuel verzichtet er auf jegliche Abstrahierung seines Ausgangsmaterials, wenn er Screenshots von all den Momenten aus sämtlichen Filmen James Deans aneinanderreiht, in welchen der Schauspieler blinzelt. [Abb. 4] Das Ergebnis ist zwar interessant anzuschauen, bleibt aber im Unterschied zu den Bildern Samuels etwas zu sehr einer rein zusammenstellenden und damit illustrativen Ebene verhaftet. Gerade ein Vergleich zwischen Santillans *All the Blinks* und den auf einen ersten Blick hin ähnlich scheinenden Bildern Samuels lässt die Qualität letzterer noch deutlicher zu Tage treten, denn zwar gehen auch sie von einer Überblicks-Zusammenstellung mit klar definierten Parametern aus – z. B. alle 30 Filme in chronologischer Reihenfolge, die Alfred Hitchcock ab 1940, d.h. nach seinem Umzug nach Hollywood, gedreht hat, in *Hitchcock*[30] bzw. alle 13 Filme Stanley Kubricks in *Kubrick*[13+9+10]. Doch Samuel belässt es nicht einfach dabei, z.B. bei *Hitchcock*[30] die insgesamt 285.000 Screenshots der Filme nebeneinander zu stellen. Vielmehr führt er die so begonnene Verdichtungsarbeit konsequent weiter fort, die zunächst einmal darin besteht, dass bei *Hitchcock*[30] 30 Filme aus 36 Jahren Regisseurstätigkeit auf einer einzigen Tafel und damit sozusagen in

27

einem Moment, innerhalb eines Raumes zusammengefasst und so-
zusagen außerhalb der Zeit stillgestellt werden. Die so vorgenommene
Konzentration und Raffung setzt Samuel sodann fort, wenn er die
einzelnen Screenshots mit Hilfe eines eigens selbstentworfenen und
programmierten Algorithmus komprimiert – und dies nicht etwa
beliebig, sondern adäquat zum jeweiligen Ausgangsmaterial: So wurden
die Fotos für *Hitchcock* [30] von der Seite her zusammengepresst
und die Arbeit selbst ordnet die Ergebnisse dieses Prozesses dann
auch horizontal an, da Samuel schon mit dem Format des Gesamt-
bildes an eine Kinoleinwand erinnern möchte. Bei *Kubrick* [13 + 9 + 10]
hingegen wurden die einzelnen Bilder von oben und unten her kom-
primiert und das Resultat findet sich dementsprechend vertikal von
oben nach unten verlaufend angeordnet – nicht zuletzt, um so zum
einen auf Kubricks äußerst bewussten Umgang mit dem Filmformat
hinzuweisen, sowie zum anderen, um mit der so entstehenden, hoch-
rechteckigen Form des sich so ergebenden Gesamtbildes auf die
Form des Monolithen in Kubricks Film *2001 – A Space Odyssey* von
1968 anzuspielen.

Eben eine solche Parallelen wie Unterschiede aufzeigende Gegen-
überstellung der beiden Arbeiten macht zugleich deutlich, dass Samuels
Werke sowohl je für sich stehen, als auch zusätzliches Potenzial aus
ihrer Paarbeziehung heraus entwickeln (z. B. zwei Musikstücke von ein-
mal Johann Sebastian Bach, einmal von Beethoven; zwei Arten der
Darstellung von Börsenentwicklung mit einmal dem Dax und einmal
dem Dow Jones; zwei Comics, einmal *Asterix* von Goscinny und
Uderzo, dann *Tintin* von Hergé; zwei literarische Werke, einmal die
Dramen von William Shakespeare, dann die Geschichten von Edgar
Allan Poe): Betrachtet man *Hitchcock* [30], so kann man dort den histo-
rischen Übergang von der Schwarz-Weiß- zur Farbfilm-Technik sowie
Hitchcocks frühe Experimente mit derselben Ende der 40er-Jahre beob-
achten. Innerhalb der einzelnen Filme wiederum lassen sich formale
Mittel wie der Wechsel zwischen dunklen und hellen Sequenzen studie-
ren. Da nun auch Kubrick den Wandel von der Schwarzweiß- zur Farb-
filmtechnik durchlebt hat, ist es besonders spannend, sich wiederum
seine Auseinandersetzung mit der Farbe auch und gerade im Ver-
gleich zu Hitchcock zu vergegenwärtigen. Zeit spielt bei den Arbeiten
Samuels also sowohl im Sinn der Historie (Wann war was? Was folgte
auch was bzw. geschah zeitgleich?), als auch hinsichtlich der grundsätz-
lichen Funktionsweisen der von Samuel in den Blick genommenen
Phänomene eine wesentliche Rolle, denn sie alle (Musik, Film, das Bör-
senjahr und sein Verlauf, der Comic als sequentielle Kunst, Literatur)

bedürfen der Zeit, um sich in ihr entfalten und entwickeln zu können.

Eben dieser Zeit hat Samuel sie enthoben, abstrahiert, um sie sodann – seiner eigenen Matrix gemäß neu- und umprogrammiert – in einen neuen zeitlichen Kontext zu stellen: Denn auch der / die BetrachterIn der Werke Benjamin Samuels benötigt Zeit, um sie zu studieren und zu verstehen – erst als einzelne, autonome Bilder, dann als zueinander in Beziehung zu setzende Paare, die schließlich, gewissermaßen als Summa Summarum, auch wieder untereinander zu einem Ganzen zusammen zu sehen und zu denken sind.

PROF. DR. HENRY KEAZOR
Professor für Neuere und Neueste Kunstgeschichte
Institut für Europäische Kunstgeschichte
Universität Heidelberg

GOLDBERG VARIATIONEN

30+2

DIABELLI VARIATIONEN

33

GOLDBERG
VARIATIONEN
30 + 2

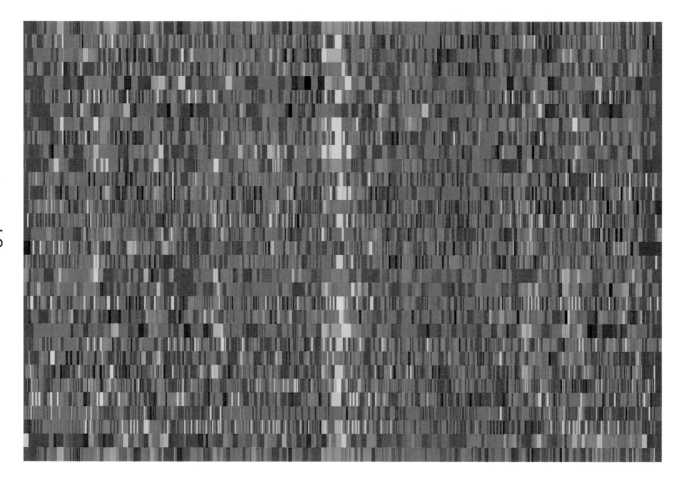

Goldberg Variationen 30 + 2
2010, duraclear transparency in lightbox, 105 × 157.5 cm

DIABELLI
VARIATIONEN
33

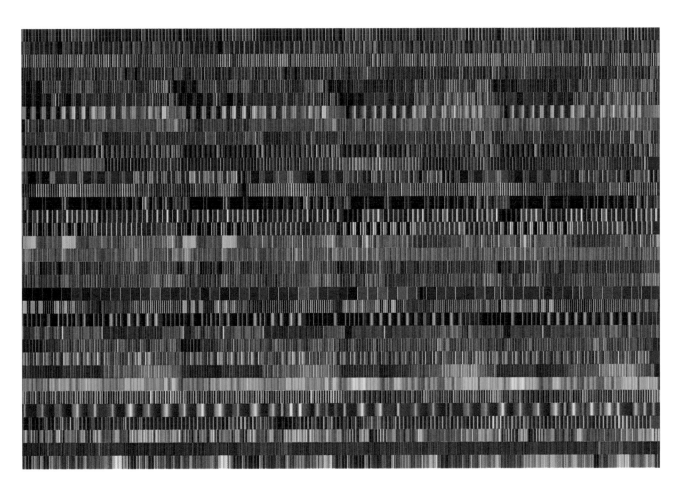

Diabelli Variationen 33
2010, duraclear transparency in lightbox, 105 × 157.5cm

Note-/ Colour Palette
Ton-/ Farbpalette

Note-/ Colour Palette of the First Goldberg Variation
Ton-/ Farbpalette der ersten Goldberg Variation

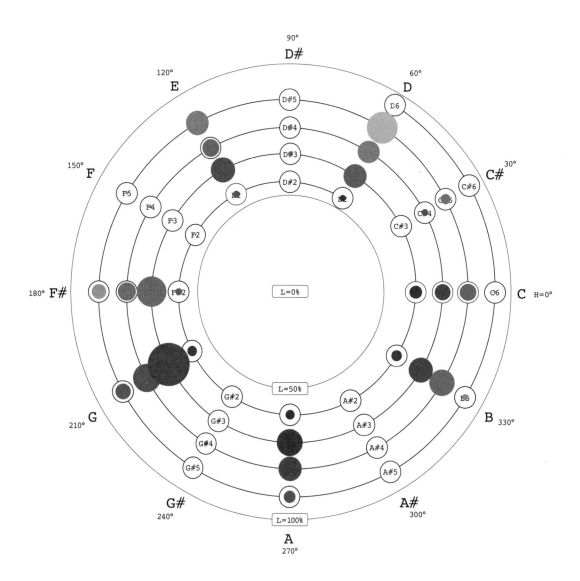

The dataset for this work is based on the two arias and 30 variations of Johann Sebastian Bach's *Goldberg Variations* (1741). The colour palette is based on the link between a chromatic tone spiral and an HSL colour space model.

Als Datengrundlage dienen die zwei Arien und 30 Variationen der *Goldberg Variationen* (1741) von Johann Sebastian Bach. Die Farbpalette verknüpft eine chromatische Tonspirale mit einem digitalen HSL-Farbraummodell.

Note-/Colour Palette of the First Diabelli Variation
Ton-/Farbpalette der ersten Diabelli Variation

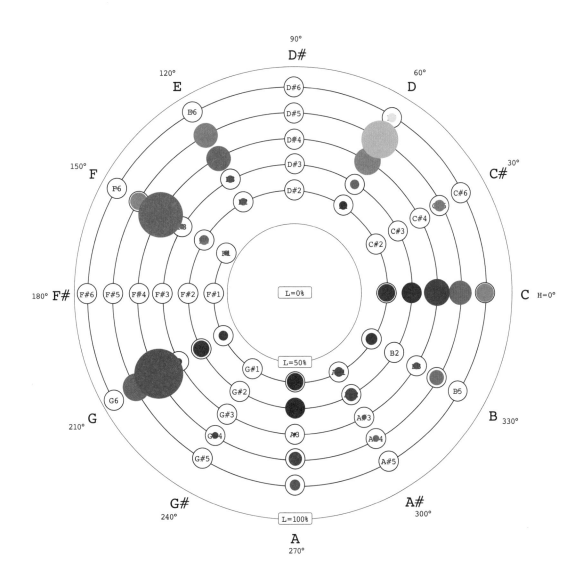

The dataset for this work is based on the theme and 33 variations of Ludwig van Beethoven's *Diabelli Variations* (1823). The colour palette is based on the link between a chromatic note spiral and an HSL colour space model.

Als Datengrundlage dienen das Thema und 33 Variationen der *Diabelli Variationen* (1823) von Ludwig van Beethoven. Die Farbpalette verknüpft eine chromatische Tonspirale mit einem digitalen HSL-Farbraummodell.

Transformation Process
Übersetzungsprozess

Note to Colour Translation and Colour Mixing
Noten in Farbenübersetzung und Farben-Mischung

Goldberg Variationen

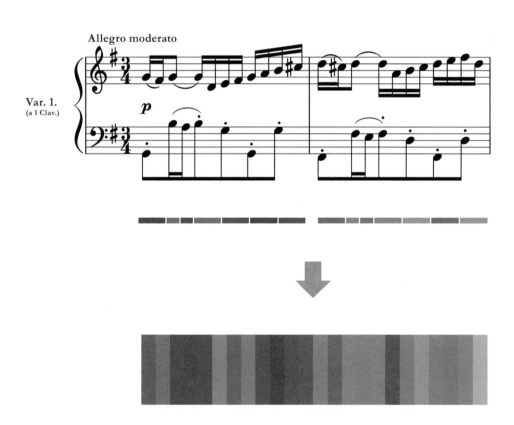

Each note is assigned a colour; notes of different voices sounded simultaneously are mixed together. The notes were initially represented in MIDI format and interpreted by a software programme. The *Goldberg Variationen 30+2* required the processing of 75,730 lines of MIDI code. The resulting colours were placed within a two-dimensional coordinate system. Each row within the coordinate system corresponds to a single variation. Each variation starts at the left edge of the canvas and ends at the right edge.

Jedem Ton wird eine Farbe zugewiesen, gleichzeitig erklingende Töne unterschiedlicher Stimmen werden gemischt dargestellt. Die Noten wurden ursprünglich im MIDI-Format gespeichert. Bei den *Goldberg Variationen 30+2* wurden 75.730 Zeilen MIDI Code verarbeitet. Die resultierenden Farben wurden in einem zweidimensionalen Koordinatensystem angeordnet. Jede Zeile innerhalb des Koordinatensystems entspricht einer Variation. Jede Variation beginnt an der linken Kante der Leinwand und endet an der rechten Kante.

Diabelli Variationen

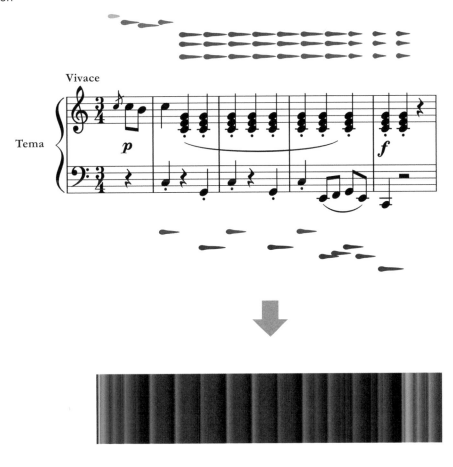

Each note is assigned a colour; notes of different voices sounded simultaneously are mixed together. The notes were initially represented in MIDI format and interpreted by a software programme. The *Diabelli Variationen 33* required the processing of 67,770 lines of MIDI code. The resulting colours were placed within a two-dimensional coordinate system. Each row within the coordinate system corresponds to a single variation. Each variation starts at the left edge of the canvas and ends at the right edge.

Jedem Ton wird eine Farbe zugewiesen, gleichzeitig erklingende Töne unterschiedlicher Stimmen werden gemischt dargestellt. Die Noten wurden ursprünglich im MIDI-Format dargestellt. Bei den *Diabelli Variationen 33* wurden 67.770 Zeilen MIDI Code verarbeitet. Die resultierenden Farben wurden in einem zweidimensionalen Koordinatensystem angeordnet. Jede Zeile innerhalb des Koordinatensystems entspricht einer Variation. Jede Variation beginnt an der linken Kante der Leinwand und endet an der rechten Kante.

Harmonic Structure
Harmonische Struktur

Average Colour for All Variations
Durchschnittliche Farben aller Variationen

Goldberg Variationen

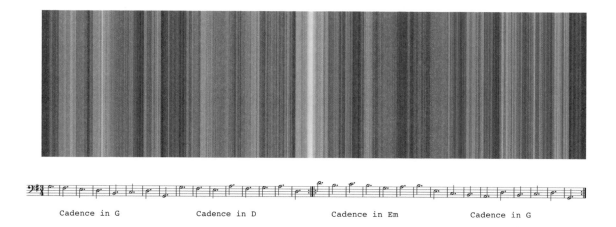

Cadence in G Cadence in D Cadence in Em Cadence in G

"Framed as if by two terminal pylons"

Glenn Gould on Bach's *Goldberg Variations*

The *Goldberg Variationen 30+2* shows the variations' rigid basic harmony: each variation begins and ends with a cadence in G major, visible in the two blue columns along the left and right edges of the image. Towards the middle, at the end of the second cadence in D major, a golden central axis appears, dividing the entire work symmetrically. It is tempting to take the words of Glenn Gould literally, who, in the liner-notes to his famous 1956 recording of the *Goldberg Variations*, described the musical work as if "framed by two terminal pylons".

Die rigide Grundharmonik der Goldberg Variationen entfacht sich sehr deutlich in den *Goldberg Variationen 30+2*: Jede Variation beginnt und endet mit einer Kadenz in G-Dur, im Werk deutlich sichtbar durch die beiden hervorstechenden blauen Säulen, jeweils am linken und rechten Rand des Bildes. In der Mitte am Ende der zweiten Kadenz in D-Dur, entpuppt sich eine Mittelachse, im strahlenden Gold leuchtend, die das Werk spiegelsymmetrisch gliedert. Bei diesem Anblick ist man verführt, die Worte Glenn Goulds wörtlich zu nehmen, der im Begleittext zu seiner berühmten Schallplatten-Aufnahme aus dem Jahre 1956 die Variationen mit einer phantasievollen, architektonischen Analogie beschrieb: „Gerahmt wie von zwei begrenzenden Pylonen".

Diabelli Variationen

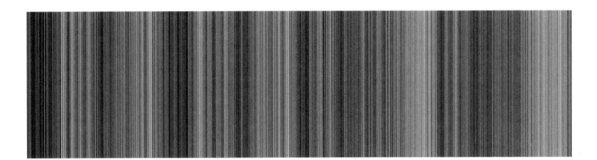

"Unchained virtuosity next to lyrical points of rest; coloured planes alternate with sections in which rugged accents brush the theme against the grain."

Volker Scherliess on Beethoven's *Diabelli Variations*

In contrast *Diabelli Variationen 33* could not appear more different; devoid of pylons or a golden axis, the architectural rigor of a Baroque composer such as Bach gives way to spirited technique. German musicologist Volker Scherliess perceptively described the *Diabelli Variations* in detail: "unchained virtuosity next to lyrical points of rest; coloured planes alternate with sections in which rugged accents brush the theme against the grain."

Hingegen könnten Beethovens *Diabelli Variationen* nicht verschiedener sein: Weder blaue Pylonen noch eine goldene Mittelachse treten hervor, die architektonische Strenge eines Barock-Komponisten Bachs weicht einer ungezügelten Methodik. Ebenso wörtlich vermag man die Empfindung des deutschen Musikologen Volker Scherliess verstehen, der die *Diabelli Variationen* eingehend beschrieb: „Entfesselte Virtuosität neben lyrischen Ruhepunkten; farbige Flächigkeit wechselt mit Abschnitten, in denen schroffe Akzente das Thema gleichsam gegen den Strich kämmen".

```
0, 0, Header, 1, 17, 480
1, 0, Start_track
1, 0, Title_t,
„Goldberg Variationen Aria"
1, 0, Time_signature, 3, 4, 24, 8
1, 0, Key_signature, 1, „major"
1, 0, Tempo, 1200000
1, 92160, End_track
2, 0, Start_track
2, 0, MIDI_port, 0
2, 0, Note_on_c, 0, 79, 100
2, 480, Note_on_c, 0, 79, 0
2, 480, Note_on_c, 0, 79, 100
2, 960, Note_on_c, 0, 79, 0
2, 960, Note_on_c, 0, 81, 100
2, 1020, Note_on_c, 0, 81, 0
2, 1020, Note_on_c, 0, 79, 100
2, 1080, Note_on_c, 0, 79, 0
2, 1080, Note_on_c, 0, 81, 100
2, 1320, Note_on_c, 0, 81, 0
2, 1320, Note_on_c, 0, 83, 100
2, 1440, Note_on_c, 0, 83, 0
2, 1440, Note_on_c, 0, 81, 100
2, 1680, Note_on_c, 0, 81, 0
2, 1680, Note_on_c, 0, 79, 100
2, 1800, Note_on_c, 0, 79, 0
2, 1800, Note_on_c, 0, 78, 100
2, 1920, Note_on_c, 0, 78, 0
2, 1920, Note_on_c, 0, 76, 100
2, 2160, Note_on_c, 0, 76, 0
2, 2160, Note_on_c, 0, 74, 100
2, 2880, Note_on_c, 0, 74, 0
2, 2880, Note_on_c, 0, 67, 100
2, 2940, Note_on_c, 0, 67, 0
2, 2940, Note_on_c, 0, 66, 100
2, 3000, Note_on_c, 0, 66, 0
2, 3000, Note_on_c, 0, 67, 100
2, 3360, Note_on_c, 0, 67, 0
2, 3360, Note_on_c, 0, 69, 100
2, 3420, Note_on_c, 0, 69, 0
2, 3420, Note_on_c, 0, 67, 100
2, 3480, Note_on_c, 0, 67, 0
2, 3480, Note_on_c, 0, 66, 100
2, 3540, Note_on_c, 0, 66, 0
2, 3540, Note_on_c, 0, 67, 100
2, 3600, Note_on_c, 0, 67, 0
2, 3600, Note_on_c, 0, 69, 100
2, 3660, Note_on_c, 0, 69, 0
2, 3660, Note_on_c, 0, 67, 100
2, 3720, Note_on_c, 0, 67, 0
2, 3720, Note_on_c, 0, 69, 100
2, 3780, Note_on_c, 0, 69, 0
2, 3780, Note_on_c, 0, 67, 100
2, 3840, Note_on_c, 0, 67, 0
2, 3840, Note_on_c, 0, 69, 100
2, 3880, Note_on_c, 0, 69, 0
2, 3880, Note_on_c, 0, 67, 100
2, 3920, Note_on_c, 0, 67, 0
2, 3920, Note_on_c, 0, 69, 100
2, 3960, Note_on_c, 0, 69, 0
2, 3960, Note_on_c, 0, 67, 100
2, 4000, Note_on_c, 0, 67, 0
2, 4000, Note_on_c, 0, 69, 100
2, 4040, Note_on_c, 0, 69, 0
2, 4041, Note_on_c, 0, 67, 100
2, 4080, Note_on_c, 0, 66, 100
2, 4081, Note_on_c, 0, 67, 0
2, 4200, Note_on_c, 0, 66, 0
2, 4200, Note_on_c, 0, 67, 100
2, 4320, Note_on_c, 0, 67, 0
2, 4320, Note_on_c, 0, 69, 100
2, 4380, Note_on_c, 0, 69, 0
2, 4380, Note_on_c, 0, 67, 100
2, 4440, Note_on_c, 0, 67, 0
2, 4440, Note_on_c, 0, 66, 100

2, 4560, Note_on_c, 0, 66, 0
2, 4560, Note_on_c, 0, 67, 100
2, 4620, Note_on_c, 0, 67, 0
2, 4620, Note_on_c, 0, 66, 100
2, 4680, Note_on_c, 0, 66, 0
2, 4680, Note_on_c, 0, 64, 100
2, 4800, Note_on_c, 0, 64, 0
2, 4800, Note_on_c, 0, 64, 100
2, 5040, Note_on_c, 0, 64, 0
2, 5040, Note_on_c, 0, 62, 100
2, 5760, Note_on_c, 0, 62, 0
2, 5760, Note_on_c, 0, 74, 100
2, 6240, Note_on_c, 0, 74, 0
2, 6240, Note_on_c, 0, 74, 100
2, 6720, Note_on_c, 0, 74, 0
2, 6720, Note_on_c, 0, 76, 100
2, 6780, Note_on_c, 0, 76, 0
2, 6780, Note_on_c, 0, 74, 100
2, 6840, Note_on_c, 0, 74, 0
2, 6840, Note_on_c, 0, 76, 100
2, 7080, Note_on_c, 0, 76, 0
2, 7080, Note_on_c, 0, 77, 100
2, 7200, Note_on_c, 0, 77, 0
2, 7200, Note_on_c, 0, 76, 100
2, 7440, Note_on_c, 0, 76, 0
2, 7440, Note_on_c, 0, 74, 100
2, 7560, Note_on_c, 0, 74, 0
2, 7560, Note_on_c, 0, 72, 100
2, 7680, Note_on_c, 0, 72, 0
2, 7680, Note_on_c, 0, 71, 100
2, 7920, Note_on_c, 0, 71, 0
2, 7920, Note_on_c, 0, 69, 100
2, 8400, Note_on_c, 0, 69, 0
2, 8400, Note_on_c, 0, 79, 100
2, 8460, Note_on_c, 0, 79, 0
2, 8460, Note_on_c, 0, 78, 100
2, 8520, Note_on_c, 0, 78, 0
2, 8520, Note_on_c, 0, 76, 100
2, 8580, Note_on_c, 0, 76, 0
2, 8580, Note_on_c, 0, 78, 100
2, 8640, Note_on_c, 0, 78, 0
2, 8640, Note_on_c, 0, 79, 100
2, 8700, Note_on_c, 0, 79, 0
2, 8700, Note_on_c, 0, 78, 100
2, 8880, Note_on_c, 0, 78, 0
2, 8880, Note_on_c, 0, 81, 100
2, 8940, Note_on_c, 0, 81, 0
2, 8940, Note_on_c, 0, 79, 100
2, 9120, Note_on_c, 0, 79, 0
2, 9120, Note_on_c, 0, 78, 100
2, 9180, Note_on_c, 0, 78, 0
2, 9180, Note_on_c, 0, 76, 100
2, 9360, Note_on_c, 0, 76, 0
2, 9360, Note_on_c, 0, 74, 100
2, 9420, Note_on_c, 0, 74, 0
2, 9420, Note_on_c, 0, 72, 100
2, 9600, Note_on_c, 0, 72, 0
2, 9600, Note_on_c, 0, 72, 100
2, 9720, Note_on_c, 0, 72, 0
2, 9720, Note_on_c, 0, 81, 100
2, 9960, Note_on_c, 0, 81, 0
2, 9960, Note_on_c, 0, 72, 100
2, 10080, Note_on_c, 0, 72, 0
2, 10080, Note_on_c, 0, 71, 100
2, 10140, Note_on_c, 0, 71, 0
2, 10140, Note_on_c, 0, 67, 100
2, 10440, Note_on_c, 0, 67, 0
2, 10440, Note_on_c, 0, 66, 100
2, 10560, Note_on_c, 0, 66, 0
2, 10560, Note_on_c, 0, 66, 100
2, 10800, Note_on_c, 0, 66, 0
2, 10800, Note_on_c, 0, 67, 100
2, 10860, Note_on_c, 0, 67, 0
2, 10860, Note_on_c, 0, 66, 100
2, 10920, Note_on_c, 0, 66, 0

2, 10920, Note_on_c, 0, 67, 100
2, 11520, Note_on_c, 0, 67, 0
2, 11520, Note_on_c, 0, 71, 100
2, 12000, Note_on_c, 0, 71, 0
2, 12000, Note_on_c, 0, 71, 100
2, 12480, Note_on_c, 0, 71, 0
2, 12480, Note_on_c, 0, 73, 100
2, 12540, Note_on_c, 0, 73, 0
2, 12540, Note_on_c, 0, 71, 100
2, 12600, Note_on_c, 0, 71, 0
2, 12600, Note_on_c, 0, 73, 100
2, 12840, Note_on_c, 0, 73, 0
2, 12840, Note_on_c, 0, 74, 100
2, 12960, Note_on_c, 0, 74, 0
2, 12960, Note_on_c, 0, 74, 100
2, 13080, Note_on_c, 0, 74, 0
2, 13080, Note_on_c, 0, 73, 100
2, 13200, Note_on_c, 0, 73, 0
2, 13200, Note_on_c, 0, 71, 100
2, 13320, Note_on_c, 0, 71, 0
2, 13320, Note_on_c, 0, 69, 100
2, 14310, Note_on_c, 0, 69, 0
2, 14310, Note_on_c, 0, 67, 100
2, 14340, Note_on_c, 0, 71, 100
2, 14370, Note_on_c, 0, 76, 100
2, 14400, Note_on_c, 0, 79, 100
2, 14790, Note_on_c, 0, 67, 0
2, 14820, Note_on_c, 0, 71, 0
2, 14850, Note_on_c, 0, 76, 0
2, 14880, Note_on_c, 0, 79, 0
2, 14880, Note_on_c, 0, 81, 100
2, 14940, Note_on_c, 0, 81, 0
2, 14940, Note_on_c, 0, 79, 100
2, 15000, Note_on_c, 0, 79, 0
2, 15000, Note_on_c, 0, 78, 100
2, 15060, Note_on_c, 0, 78, 0
2, 15060, Note_on_c, 0, 79, 100
2, 15120, Note_on_c, 0, 79, 0
2, 15120, Note_on_c, 0, 81, 100
2, 15180, Note_on_c, 0, 81, 0
2, 15180, Note_on_c, 0, 79, 100
2, 15240, Note_on_c, 0, 79, 0
2, 15240, Note_on_c, 0, 81, 100
2, 15300, Note_on_c, 0, 81, 0
2, 15300, Note_on_c, 0, 79, 100
2, 15360, Note_on_c, 0, 79, 0
2, 15360, Note_on_c, 0, 81, 100
2, 15400, Note_on_c, 0, 81, 0
2, 15400, Note_on_c, 0, 79, 100
2, 15440, Note_on_c, 0, 79, 0
2, 15440, Note_on_c, 0, 81, 100
2, 15480, Note_on_c, 0, 81, 0
2, 15480, Note_on_c, 0, 79, 100
2, 15520, Note_on_c, 0, 79, 0
2, 15520, Note_on_c, 0, 81, 100
2, 15560, Note_on_c, 0, 81, 0
2, 15560, Note_on_c, 0, 79, 100
2, 15600, Note_on_c, 0, 79, 0
2, 15600, Note_on_c, 0, 78, 100
2, 15720, Note_on_c, 0, 78, 0
2, 15720, Note_on_c, 0, 79, 100
2, 15840, Note_on_c, 0, 79, 0
2, 15840, Note_on_c, 0, 79, 100
2, 16080, Note_on_c, 0, 79, 0
2, 16080, Note_on_c, 0, 78, 100
2, 16200, Note_on_c, 0, 78, 0
2, 16200, Note_on_c, 0, 76, 100
2, 16320, Note_on_c, 0, 76, 0
2, 16320, Note_on_c, 0, 74, 100
2, 16380, Note_on_c, 0, 74, 0
2, 16380, Note_on_c, 0, 73, 100
2, 16440, Note_on_c, 0, 73, 0
2, 16440, Note_on_c, 0, 71, 100
2, 16500, Note_on_c, 0, 71, 0
```

```
0, Header, 1, 9, 192
0, Start_track
0, Title_t,
iabelli Variationen Thema"
0, Time_signature, 3, 2, 24, 8
0, Key_signature, 0, „major"
0, Tempo, 250000
36864, End_track
0, Start_track
22, Note_on_c, 4, 74, 0
24, Note_on_c, 4, 72, 100
96, Note_on_c, 4, 72, 0
96, Note_on_c, 4, 71, 100
190, Note_on_c, 4, 71, 0
192, Note_on_c, 4, 72, 127
192, Note_on_c, 4, 48, 127
240, Note_on_c, 4, 72, 0
286, Note_on_c, 4, 48, 0
384, Note_on_c, 4, 60, 100
384, Note_on_c, 4, 64, 100
384, Note_on_c, 4, 67, 100
504, Note_on_c, 4, 67, 0
504, Note_on_c, 4, 64, 0
504, Note_on_c, 4, 60, 0
576, Note_on_c, 4, 60, 100
576, Note_on_c, 4, 64, 100
576, Note_on_c, 4, 67, 100
576, Note_on_c, 4, 43, 110
696, Note_on_c, 4, 67, 0
696, Note_on_c, 4, 60, 0
696, Note_on_c, 4, 64, 0
718, Note_on_c, 4, 43, 0
768, Note_on_c, 4, 60, 100
768, Note_on_c, 4, 64, 100
768, Note_on_c, 4, 67, 100
768, Note_on_c, 4, 48, 127
862, Note_on_c, 4, 48, 0
888, Note_on_c, 4, 60, 0
888, Note_on_c, 4, 64, 0
888, Note_on_c, 4, 67, 0
960, Note_on_c, 4, 60, 100
960, Note_on_c, 4, 64, 100
960, Note_on_c, 4, 67, 100
1080, Note_on_c, 4, 67, 0
1080, Note_on_c, 4, 64, 0
1080, Note_on_c, 4, 60, 0
1152, Note_on_c, 4, 60, 100
1152, Note_on_c, 4, 64, 100
1152, Note_on_c, 4, 67, 100
1152, Note_on_c, 4, 43, 110
1272, Note_on_c, 4, 67, 0
1272, Note_on_c, 4, 60, 0
1272, Note_on_c, 4, 64, 0
1294, Note_on_c, 4, 43, 0
1344, Note_on_c, 4, 60, 100
1344, Note_on_c, 4, 64, 100
1344, Note_on_c, 4, 67, 100
1344, Note_on_c, 4, 48, 127
1438, Note_on_c, 4, 48, 0
1464, Note_on_c, 4, 60, 0
1464, Note_on_c, 4, 64, 0
1464, Note_on_c, 4, 67, 0
1536, Note_on_c, 4, 60, 100
1536, Note_on_c, 4, 64, 100
1536, Note_on_c, 4, 67, 100
1536, Note_on_c, 4, 40, 127
1632, Note_on_c, 4, 40, 0
1632, Note_on_c, 4, 41, 110
1656, Note_on_c, 4, 60, 0
1656, Note_on_c, 4, 67, 0
1656, Note_on_c, 4, 64, 0
1728, Note_on_c, 4, 41, 0
1728, Note_on_c, 4, 60, 100
1728, Note_on_c, 4, 64, 100

6, 1728, Note_on_c, 4, 43, 110
6, 1776, Note_on_c, 4, 67, 0
6, 1776, Note_on_c, 4, 60, 0
6, 1776, Note_on_c, 4, 64, 0
6, 1824, Note_on_c, 4, 43, 0
6, 1824, Note_on_c, 4, 40, 110
6, 1918, Note_on_c, 4, 40, 0
6, 1920, Note_on_c, 4, 60, 110
6, 1920, Note_on_c, 4, 64, 110
6, 1920, Note_on_c, 4, 67, 110
6, 1920, Note_on_c, 4, 36, 127
6, 1968, Note_on_c, 4, 67, 0
6, 1968, Note_on_c, 4, 60, 0
6, 1968, Note_on_c, 4, 64, 0
6, 2062, Note_on_c, 4, 36, 0
6, 2112, Note_on_c, 4, 60, 110
6, 2112, Note_on_c, 4, 64, 110
6, 2112, Note_on_c, 4, 67, 110
6, 2160, Note_on_c, 4, 67, 0
6, 2160, Note_on_c, 4, 64, 0
6, 2160, Note_on_c, 4, 60, 0
6, 2304, Note_on_c, 4, 76, 100
6, 2326, Note_on_c, 4, 76, 0
6, 2328, Note_on_c, 4, 74, 100
6, 2400, Note_on_c, 4, 74, 0
6, 2400, Note_on_c, 4, 73, 100
6, 2494, Note_on_c, 4, 73, 0
6, 2496, Note_on_c, 4, 74, 127
6, 2496, Note_on_c, 4, 43, 127
6, 2528, Note_on_c, 4, 74, 0
6, 2590, Note_on_c, 4, 43, 0
6, 2688, Note_on_c, 4, 62, 100
6, 2688, Note_on_c, 4, 65, 100
6, 2688, Note_on_c, 4, 67, 100
6, 2808, Note_on_c, 4, 67, 0
6, 2808, Note_on_c, 4, 65, 0
6, 2808, Note_on_c, 4, 62, 0
6, 2880, Note_on_c, 4, 62, 100
6, 2880, Note_on_c, 4, 65, 100
6, 2880, Note_on_c, 4, 67, 100
6, 2880, Note_on_c, 4, 38, 110
6, 3000, Note_on_c, 4, 67, 0
6, 3000, Note_on_c, 4, 62, 0
6, 3000, Note_on_c, 4, 65, 0
6, 3022, Note_on_c, 4, 38, 0
6, 3072, Note_on_c, 4, 62, 100
6, 3072, Note_on_c, 4, 65, 100
6, 3072, Note_on_c, 4, 67, 100
6, 3072, Note_on_c, 4, 43, 127
6, 3166, Note_on_c, 4, 43, 0
6, 3192, Note_on_c, 4, 62, 0
6, 3192, Note_on_c, 4, 65, 0
6, 3192, Note_on_c, 4, 67, 0
6, 3264, Note_on_c, 4, 62, 100
6, 3264, Note_on_c, 4, 65, 100
6, 3264, Note_on_c, 4, 67, 100
6, 3384, Note_on_c, 4, 67, 0
6, 3384, Note_on_c, 4, 65, 0
6, 3384, Note_on_c, 4, 62, 0
6, 3456, Note_on_c, 4, 62, 100
6, 3456, Note_on_c, 4, 65, 100
6, 3456, Note_on_c, 4, 67, 100
6, 3456, Note_on_c, 4, 38, 110
6, 3576, Note_on_c, 4, 67, 0
6, 3576, Note_on_c, 4, 62, 0
6, 3576, Note_on_c, 4, 65, 0
6, 3598, Note_on_c, 4, 38, 0
6, 3648, Note_on_c, 4, 62, 100
6, 3648, Note_on_c, 4, 65, 100
6, 3648, Note_on_c, 4, 67, 100
6, 3648, Note_on_c, 4, 43, 127
6, 3742, Note_on_c, 4, 43, 0
6, 3768, Note_on_c, 4, 62, 0
6, 3768, Note_on_c, 4, 65, 0

6, 3840, Note_on_c, 4, 62, 100
6, 3840, Note_on_c, 4, 65, 100
6, 3840, Note_on_c, 4, 67, 100
6, 3840, Note_on_c, 4, 35, 127
6, 3936, Note_on_c, 4, 35, 0
6, 3936, Note_on_c, 4, 36, 110
6, 3960, Note_on_c, 4, 62, 0
6, 3960, Note_on_c, 4, 67, 0
6, 3960, Note_on_c, 4, 65, 0
6, 4032, Note_on_c, 4, 36, 0
6, 4032, Note_on_c, 4, 62, 100
6, 4032, Note_on_c, 4, 65, 100
6, 4032, Note_on_c, 4, 67, 100
6, 4032, Note_on_c, 4, 38, 110
6, 4080, Note_on_c, 4, 67, 0
6, 4080, Note_on_c, 4, 62, 0
6, 4080, Note_on_c, 4, 65, 0
6, 4128, Note_on_c, 4, 38, 0
6, 4128, Note_on_c, 4, 35, 110
6, 4222, Note_on_c, 4, 35, 0
6, 4224, Note_on_c, 4, 62, 110
6, 4224, Note_on_c, 4, 65, 110
6, 4224, Note_on_c, 4, 67, 110
6, 4224, Note_on_c, 4, 31, 127
6, 4272, Note_on_c, 4, 67, 0
6, 4272, Note_on_c, 4, 62, 0
6, 4272, Note_on_c, 4, 65, 0
6, 4366, Note_on_c, 4, 31, 0
6, 4416, Note_on_c, 4, 62, 110
6, 4416, Note_on_c, 4, 65, 110
6, 4416, Note_on_c, 4, 67, 110
6, 4464, Note_on_c, 4, 67, 0
6, 4464, Note_on_c, 4, 65, 0
6, 4464, Note_on_c, 4, 62, 0
6, 4608, Note_on_c, 4, 60, 127
6, 4608, Note_on_c, 4, 64, 127
6, 4608, Note_on_c, 4, 46, 127
6, 4800, Note_on_c, 4, 46, 0
6, 4800, Note_on_c, 4, 64, 0
6, 4800, Note_on_c, 4, 65, 127
6, 4800, Note_on_c, 4, 45, 110
6, 4848, Note_on_c, 4, 45, 0
6, 4848, Note_on_c, 4, 65, 0
6, 4848, Note_on_c, 4, 60, 0
6, 4992, Note_on_c, 4, 69, 100
6, 4992, Note_on_c, 4, 41, 110
6, 5040, Note_on_c, 4, 41, 0
6, 5040, Note_on_c, 4, 69, 0
6, 5184, Note_on_c, 4, 60, 127
6, 5184, Note_on_c, 4, 64, 127
6, 5184, Note_on_c, 4, 46, 127
6, 5376, Note_on_c, 4, 46, 0
6, 5376, Note_on_c, 4, 64, 0
6, 5376, Note_on_c, 4, 65, 127
6, 5376, Note_on_c, 4, 45, 110
6, 5424, Note_on_c, 4, 45, 0
6, 5424, Note_on_c, 4, 65, 0
6, 5424, Note_on_c, 4, 60, 0
6, 5568, Note_on_c, 4, 69, 100
6, 5568, Note_on_c, 4, 41, 110
6, 5616, Note_on_c, 4, 41, 0
6, 5616, Note_on_c, 4, 69, 0
6, 5760, Note_on_c, 4, 62, 127
6, 5760, Note_on_c, 4, 66, 127
6, 5760, Note_on_c, 4, 48, 127
6, 5952, Note_on_c, 4, 48, 0
6, 5952, Note_on_c, 4, 66, 0
6, 5952, Note_on_c, 4, 67, 127
6, 5952, Note_on_c, 4, 47, 110
6, 6000, Note_on_c, 4, 47, 0
6, 6000, Note_on_c, 4, 67, 0
6, 6000, Note_on_c, 4, 62, 0
6, 6144, Note_on_c, 4, 71, 100
6, 6144, Note_on_c, 4, 43, 110
```

Keyboard Instruments during the Baroque and Classical Era
Tasteninstrumente des Barocks und der Klassik

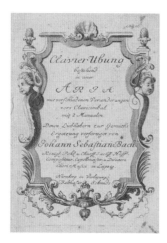

Goldberg Variations
BWV 988, title page of
the original edition, 1741
Goldberg-Variationen
BWV 988, Titelseite der
Originalausgabe, 1741

Bach House Eisenach, Harpsichord with two manuals,
copy of an instrument by Johann Heinrich Harrass,
Breitenbach / Thuringia, 1705
Bach-Haus Eisenach, Cembalo mit zwei Manualen,
Kopie eines Instruments von Johann Heinrich Harrass,
Breitenbach / Thüringen, 1705

Bach wrote the *Goldberg Variations*, as indicated by the original score's title page, for "harpsichord with 2 manuals," a popular instrument during the Baroque era. In *Goldberg Variations 30+2*, the brightness of each note played is held constant, in agreement with the clear sound of baroque keyboard instruments.

Bach schrieb die *Goldberg Variationen*, wie dem Titelblatt der Originalausgabe zu entnehmen ist, fürs „Clavicimbal mit 2 Manualen", ein beliebtes Instrument seiner Zeit. Dem beständigen Klang barocker Tasteninstrumente entsprechend, bleibt in den *Goldberg Variationen 30+2* die Helligkeit der erklingenden Töne konstant.

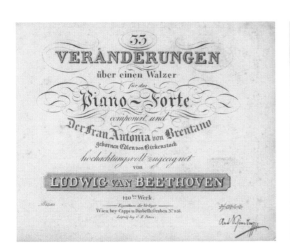

Diabelli Variations op. 120, title page of the original edition, 1823
Diabelli-Variationen op. 120, Titelseite der Originalausgabe, 1823

Beethoven House Bonn, Beethoven's last grand piano built by Conrad Graf, 1826
Beethoven-Haus Bonn, Beethovens letzter Flügel, erbaut von Conrad Graf, 1826

Beethoven wrote the *Diabelli Variations* for the modern "piano-forte", which used leather-covered hammers, enabling the pianist to subtly influence the sound. In the *Diabelli Variations 33*, the brightness of each note played is varied using ADSR-envelopes, curves which modify the sound in time, in agreement with the more expressive sound of classical and romantic keyboard instruments. This technique is also applied in modern synthesizer sound production, emulating the characteristic sounds of various instruments.

Beethoven schrieb die *Diabelli Variationen* für das moderne Piano-Forte, dessen lederüberzogene Hammer und feine Mechanik es dem Pianisten ermöglichten, den Klang während des Spielens auf subtile Weise zu beeinflussen. Den expressiven Tasteninstrumenten der Klassik und Romantik entsprechend, wird in den *Diabelli Variationen 33* mit Hilfe von Hüllkurven, mathematische Kurven, die die Lautstärke in der Zeit modulieren, die Helligkeit der erklingenden Töne variiert. Diese Technik wird auch in modernen Synthesizern angewendet, um den charakteristischen Klang verschiedener Instrumente zu emulieren.

A conversation with
pianist Uri Caine

VARIATIONS
ON A

25 April 2015
Brussels, Belgium

VARIATION

Ein Gespräch mit dem
Pianisten Uri Caine

VARIATIONEN
EINER

25. April 2015
Brüssel, Belgien

VARIATION

Uri Caine, an American pianist and composer, is known for his comprehensive and eclectic attitude to music. For over thirty years, his diverse approach took him from classical compositions and traditional jazz trio performances to explorations into electronic synthesizers, klezmer, funk and fusion. His classical explorations include recordings of both the *Goldberg Variations* and the *Diabelli Variations*. The following interview took place on 25 April 2015, after his performance of the *Goldberg Variations* at Flagey's Bach Festival in Brussels, Belgium.

Uri Caine, ein amerikanischer Pianist und Komponist, ist für seine eklektische musikalische Herangehensweise bekannt. Seit über dreißig Jahren beschäftigt er sich mit klassischen Kompositionen und traditionellem Jazz, taucht aber auch in Experimente mit elektronischen Synthesizern, Klezmer, Funk und Fusion ein. Seine Erforschung der klassischen Musik brachte bedeutende Aufnahmen hervor, wie zum Beispiel die *Goldberg* und die *Diabelli Variationen*. Das folgende Interview wurde am 25. April 2015 gehalten, nach seinem Konzert der *Goldberg Variationen* im Rahmen eines Bach-Festivals im Flagey Konzerthaus in Brüssel.

BENJAMIN SAMUEL Do you remember the first time you heard the *Goldberg Variations*?

URI CAINE Yes, I do. I had a piano teacher when I was about 13 years old. He told me to get this record by Glenn Gould. When I got home I was stunned. It was so amazing — so swinging. The way Gould was playing was full of rhythmic energy and beauty, and very eccentric.

BS Was there anything about the music itself that struck you, or was it mainly Gould's style of playing?

UC I think it was the music itself. As a young jazz musician, I was looking at the variations and analysing the harmony. Bach was using substitutions the way jazz musicians do. In other words, you embellish the harmonic progression of the music by putting in richer harmonies. The idea of being able to study it as if he were a jazz improviser made that connection for me.

BS Bach's meticulous structure, the harmonic framework of the piece, has often been talked about ...

UC Yes, what makes it a remarkable piece, first of all, is the division in thirds; you have canons that expand at every interval, then you have these pieces with two crossing hands, but you also have references to national dances — Bach is trying to show how universal he is. He has French music, he has folk songs, in the end, sort of as a joke, he has a drinking party. He had a lot of different associations.

BS Yes, on the one hand, you have the cultural connotations; but on the other hand, it's also pure music, the harmonic framework of it.

UC Yes, of course it's that; it's music even though it's following this harmonic grid. It's how much you can pour into the variation form, how much variety you can get into it. It's a different type of form than the developmental sonata form, for example.

BS When you perform the *Goldberg Variations*, like you did tonight, how do you yourself structure the piece? How much is actually improvised?

UC It's mostly improvised.

BS ... Except for the first few seconds of the aria when you were sight-reading? Very soon thereafter, your attention shifted away from the page onto your hands, and you began to take it away!

UC That is also a form of improvisation. Because when I am reading Bach, I am adding things, maybe slowing it down, or trying to do different things with the text. So I guess I am playing the text — but I'm never playing it straight. But the rest of it is an attempt to mirror what Bach did; he has gigues and sarabandes, and I have mambos and tangos.

BS So every single time you play the *Goldberg Variations*, the concert is a completely different performance?

UC Yes, on some level, because I don't do it that much as a soloist. I base it on some of what I wrote for the record I did in 2000. It is more a general feel.

BS And how do you plan out your performance? Tonight it seemed as though, every once in a while, you briefly reverted to playing the piece more traditionally; to anchor it, allowing the audience to recognise familiar passages of the music, only to shift soon thereafter back into improvisation.

UC Yes — I tried to make it develop in another way. Sometimes I play it as thirty pieces, but I don't usually do that. Generally, when I play the *Goldberg Variations*, I play it with a group. And the group is usually an octet or a septet, with gospel singers and a DJ, a trumpet, clarinet, violin and rhythm section. There is always someone improvising while someone else is playing the text. So we try different things. For example, on the record I have a klezmer variation called *Luther's Nightmare Variation*. Some of it I try to relate to Bach's life, things that would be ridiculous, things Bach would never do. The reason I did 70 variations [1] for the record is because in New York City, I live on 72nd street and my whole musical career happens around my street. Literally!

The way Gould was playing was full of rhythmic energy and beauty, and very eccentric.

BS I read that Mahler once lived on your street ...

UC Mahler lived there. I also found out Irving Berlin lived on my street after I did the Tin Pan Alley record. After I did *Othello*, I realised there is a big statue of Verdi on 72nd and Broadway. There's a big statue of Beethoven in Central Park if you walk in from 72nd street. I try not to do that kind of arbitrary thinking anymore, but I did when I was in that phase of being enthralled with New York, especially when I did the Tin Pan Alley record. But New York has changed a lot and I don't have any illusions about it. But for artists, for individuals who came and struggled there — I can totally relate to that.

BS How about the *Diabelli Variations*? When I created my work *Diabelli Variationen 33*, it was immediately visually apparent that, compared to Bach's meticulous structure of the Goldberg, that Beethoven was much more fluid and free in his arrangement.

UC People have tried to make plans of it. And there is a really beautiful book by William Kinderman in which he studied the order of Beethoven's sketches. Part of the cliché about the story is that Beethoven wrote an angry sarcastic response, making fun Diabelli's theme. Beethoven made fun of all the little dumb things, the repeated notes, the trills. But then he stopped and began

writing the *Missa Solemnis* and other pieces. Once he returned to it, Beethoven had fallen in love with Bach and the idea of the love of the archaic in music, although not in an academic way. He moves away from satire to a veneration of music history. He has this very strange Haydn-like ending after all the references to Bach. He does the same thing that Bach did, though: he uses substitutions, he uses humour, he alludes to other forms of music, to piano exercises, to the banality of other composers in Vienna ... You can do a lot with the variation form.

BS How about your recording of the *Diabelli Variations*? What was that like compared to your recording of the *Goldberg Variations*?

UC In my version of the Goldberg I was playing mostly with my ensembles that I played with in New York and many of them were great improvisers. I also played with some German choirs and baroque specialists playing ancient instruments. Some of these classical musicians wouldn't play with the improvisers when they saw what was going on. They left the recording session. They said it is so disrespectful, that I should be ashamed of this. The Diabelli project was different because I wrote it specifically for Concerto Köln who are not really improvisers—I met a lot of those musicians before, when I was doing Goldberg. So I decided that I could orchestrate Beethoven's piano piece for them, they can play what they know, and I will improvise over it, which wasn't always so successful, because it is quite difficult to improvise against a Beethovenian mountain of orchestral music. I have played it with many different orchestras and it's gotten crazier the more I play it.

SHIRA STANTON Were there any groups that were especially memorable?

UC Yes, in good and in bad ways. I did it with a big American orchestra, where the director was very famous and rather heavy. He kept on saying that we have to do it like Beethoven. I said, "I know, but maybe not? Maybe try to lighten it up so we can play together". It is interesting to see what different musicians bring to it. Some are offended by it, but most of them not. One of the best concerts I've done was with students in London. They played it so beautifully. I also did it with a lot of people from the New York City ballet; they were great because they play with rhythm and swing. I've played it in China, in Russia, in Australia, in Sweden. Now I'm working on a Mozart piano concerto, for example, but often I really just like doing my own music as a composer or pianist, in jazz groups, or playing different styles like electronic or funk. In the end though, people interested in classical music might enjoy my classical projects. Like tonight—it fits into a programme even though the audience knew it would not really be like Bach.

SS I don't know if you heard the audience's reaction from the stage, but people audibly reacted throughout with "oh, wow" and "ohhhhhh" ...

BS ... and I noticed something else: I never heard so many people laugh in a concert. People laughed out of amazement, by the acrobatics of your playing or out of surprise by the unanticipated juxtaposition of hearing Bach played as a tango or ragtime. Humour is hard to achieve in any art form.

UC There is a lot of humour in the *Goldberg Variations*, as there is in a lot of music. But everyone's humour is different; Mahler doesn't have the same type of humour as Beethoven. The humour can be misinterpreted by many people, though, and if you try to explain it, it is like trying to explain a joke —you either get it or you don't. If you don't get it—that's cool. And actually, if you don't even know the music—that's also cool. In general though, there is a long tradition of basing new music on classical music. Naturally, because a lot of musicians grow up playing classical music and that is how they start learning about harmony and the mechanics of playing the piano.

In music, you can do everything.

BS You are well known in the music world as the guy who bridges the classical and jazz worlds. How did that come about?

UC How that happened is a mystery. When I was younger, I was already doing this kind of music, but I didn't think it had an outlet. When I first moved to New York, my goal would have been to be on Blue Note records playing with people like Freddie Hubbard. But then Stefan Winter approached me and others and told us that we could just do what we wanted. I first did Mahler, and all of sudden, maybe for wrong and right reasons, people recognised me as someone who could do that. So I started playing a lot, especially in Europe, in jazz festivals, in Bach festivals, in avant-garde festivals. I played in Israel, in China, and tried to adapt and to communicate ... and the music got stronger as we played it night after night. After a while it just all flows out, I just do it.

BS Do you see that development as something positive?

UC I see it as a wave that happens. After those CDs came out, one experience sort of follows into the next, and I didn't realise it until later. There is no straight path.

BS You also have a great interest in digital music, working with electronic instruments, with synthesizers and software samplers. In the arts, people have a tendency to mistrust new technology.

UC In music, you can do everything. I first started working with synthesizers when I was younger.

BS Isn't the synthesizer is a bizarre emulation of a piano?

UC I don't think so. A keyboard synthesizer has the same keyboard layout as the piano, but the touch and the ability to create different sounds make it a very different instrument.

BS Can electronic and digital technology offer something new to music?

49

UC Yes—the new sound! Music is based on sound. For instance, in jazz there was a big debate. Some people saw it as a betrayal when some who played pianos switched to keyboard. I never saw that—it's a completely different instrument. It's like saying, "I can speak Spanish and French". But the next technological phase is the laptop. The first foray into the laptop for me happened because I was writing out so many parts, and my hands were getting cramped. So I got software to write out a score and it print out the parts, saving a lot of labour. But from that, I moved on to using Logic and all these software instruments. It's a new aesthetic, in the sense that I can make a whole record in my hotel room ... and frequently I do! So that is different than when I was younger.

BS Take the Hammond organ, for example. The Hammond organ was, at first, an emulation of a church organ, then it reached the next phase, and now we have an emulation of an emulation in the form of software plug-ins that recreate the Hammond organ in the computer. Is this new plug-in creating a new sound?

UC It is both.

BS Is better or worse than the original?

UC Well, a lot of that stuff is created for people who don't want to schlep around an organ, and that has a lot of advantages. I guess you could say that if you are working and someone calls you up and says "I want this thing that sounds like an organ", you say, "Ok, here it is". But there are two things: for instance, you talk about the Hammond organ. I grew up in Philadelphia, where the organ has a very specific sound. Even though it's an emulation – it was made as a church instrument—that is not the way it was being played in the jazz bars by people like Shirley Scott and Jimmy Smith. That is not what we heard as young people! I mean ... whoa! It was so swinging! The second thing is that you can take the Hammond organ sound and distort it beyond what would sound like an emulation. A lot of the music that I was doing did just that. I took sounds that started out conventionally and distorted them. Changing them and adding things until they are unrecognisable. Until someone's footsteps become a drum and bass beat or until some baby crying becomes some lead sound. That's part of the thrill of working with electronic music.

BS Is the advantage of digital technology just about new sounds and saving time? What about the potential for new types of compositions?

UC It is everything. There is convenience as you work with it, but there is also doing something that no person could play. Like Conlon Nancarrow, an American composer who was exiled for joining the Spanish army during the Civil war. He then moved to Mexico and composed for player pianos. He would have pieces where there were eight glissandos going every way, or 88-note chords, having things that nobody could play—*(Uri imitates the sound)*—it's all punched out and calibrated. So 7/16th versus 6/16th ... It is sort of a forerunner for what you can do with a computer.

BS There is an album by Frank Zappa called "Francesco Zappa", where he did something similar; he took the music of a Baroque composer called Francesco Zappa, and he created an album using electronic instruments. This was music that couldn't possibly be played by any human.

UC Exactly. There are other records that Zappa did. Zappa had the Synclavier, which first came out in the late seventies and early eighties and is now is a dinosaur. Laptops could easily do that now. It was like a $100,000 when it came out and now you can get a programme for $40. I remember when those came out. It had a sequencer memory, so you could have a whole orchestra piece and do things rhythmically that had been impossible even if you had written them out. Zappa was liberated by that. Like a lot of composers, Zappa had very bad experiences standing in front of orchestra musicians. They told him: "You cannot play that on the trumpet," and he answered, "Of course it can be played on a trumpet, but *you* can't play it. Work on it. Practice." He got into the machine, and the machine liberated him.

When you improvise, you go for it. Afterwards, it's over —you went for it, you went for the feeling and it's over.

BS That is a very optimistic way of looking at the machine.

UC Of course like any tool it can be used artistically or to create commercial dreck. A lot of people use it really creatively today. And there is a debate about it, because there are things that you can do that are so easy to do now. For instance, DJs used to spend hours trying to match tempos between two records; now you just put your sound into Ableton Live and it's always coordinated. When we were young, we had to splice the tape and it would take three months to make two minutes of music, and now you just use Protools. You are still using your ears, but you have so many more possibilities. You can try it eight different ways. You are never committed to one way, so you have choices. Sometimes too many choices. So from that point of view, it is very positive. But obviously it has to be used with imagination. For me, a lot of the pop music that uses it is really imaginative. I've had a lot of experiences both playing and listening, where it's like, "Man this is so great". I don't have a problem with that.

BS Can you point out any musician in particular who uses this technology creatively?

UC Someone like Squarepusher. He creates these rhythms and drum beats that are beautiful. It's always developing, churning out amazing sounds coming out of nowhere. There are some jazz fusion groups that use this. It's not to everybody's taste, but when you actually see someone who is a great keyboard player, it is very fluid. And there are a lot of really great musicians like that.

BS In my work, there is also this constant tension between traditional means and digital technology. It can be difficult to define if it doesn't fit into a neat category, like photography or painting.

UC It sounds like a cliché, but don't worry about what people say. I know it is easier to say than to do, but just keep on experimenting and you will see that after awhile, people will get used to it. A lot of it has to do with people's frame of reference. I see that all the time in my music, because some nights, you feel really judged, they tell you that you are a terrible musician, and it makes you feel bad. The next night, nobody has a problem with it. I don't want to say I don't care what people think, I do care. But you have to find your way and not everyone will like that.

BS I suppose what comes through in your music, in your playing, is that you have a genuine love and passion for music and a profound respect for the composers whose material you work with. I guess you wouldn't just play anything?

UC No, I wouldn't play just anything, but what I do is not for everyone. Both the classical and jazz music worlds can be very conservative. For example, I did a concert in Florida last December, where some guy wrote a review and he wrote that this was literally the worst concert that he had ever heard, ever in his whole life. People then responded to him, asking: "Really? The worst? Really? Ever??" Then they got into this argument and somebody sent it to me and it made me laugh. Part of me wasn't happy what that guy wrote, but, you know, here we are sitting today in Brussels and all is fine. There is this great book by Nicolas Slonimsky, called the "Lexicon of Musical Invective", in which he compiled a list of bad reviews that great composers have gotten. It is great: "Tchaikovsky can't write a melody", "Brahms doesn't know how to write for the violin", "Beethoven is an idiot, he is crazy and should go to a mental institution", "This music sounds like barn animals", and then he indexes the insults in the back and you realise that people have been saying the same thing about music that they don't like for ages.

BS Critique can sometimes be like a Rorschach test; it tells you more about the psychological state of mind of the critic than about the artistic value of the work under scrutiny.

UC Good point. You have to know how to handle criticism, because it can be brutal. A lot of people cannot stand up to it, especially in an academic environment. I endured that, and it actually made me stronger. I went to an academic university that was into twelve-tone music, they didn't even teach jazz. Jazz *(Uri laughs)* was in the folklore department! This one professor told me that I should get a teaching job. I told him that I wanted to go to New York and play. He replied that I would be wasting my life, and that I would end up like one of those guys playing in restaurants at the age of forty. I asked him: What was wrong with that? But all that stuff evaporated. Now you have to be really careful as you get older yourself, to be more humble and say "I want to learn from you, I don't want to tell you what to do. Just do your own thing". If people don't like it—it's cool, it's alright.

BS That's a good philosophy.

UC It will serve you well. It doesn't mean that you don't think about changing course, and not learn to take criticism well. It starts to get like a muscle. You become honest with yourself in how you judge your own work. I enjoy the contrasts, I still work on my piano playing and also spend a lot of time composing new music. One of the good things about being an improviser is that you are not sitting and writing a symphony for a whole year, agonising over what should change and what should remain, although I also enjoy that process. When you improvise, you go for it. Afterwards, it's over —you went for it, you went for the feeling and it's over.

[1] The 70 variations do not include the two arias. Including the two arias adds up to 72—hence Uri points out the reference to 72nd street.

BENJAMIN SAMUEL Erinnern Sie sich noch genau an den Zeitpunkt, als Sie die *Goldberg Variationen* zum ersten Mal hörten?

URI CAINE Ja, ich weiß es noch ganz genau. Als ich dreizehn Jahre alt war, empfahl mir mein Klavierlehrer die Aufnahme von Glenn Gould. Als ich sie zu Hause hörte, war ich wie vom Donner gerührt. Der Klang war so extravagant, so beschwingt. Die Art, wie Gould sie interpretierte, war voller pulsierender Rhythmik, sehr exzentrisch.

BS Hat Sie die Interpretation Glenn Goulds oder die Komposition Bachs bestochen?

UC Ich glaube es war allgemein die Musik. Als junger Jazz-Musiker interessierte ich mich dafür Harmonien zu analysieren. Bach arbeitete mit harmonischen Substitutionen, so wie es auch Jazz-Musiker gewöhnt sind. Mit anderen Worten, du verschönerst den harmonischen Fluss, indem du ihn mit vielfältigen Harmonien anreicherst. Die *Goldberg Variationen* zu untersuchen, als ob Bach sie mit den Mitteln eines improvisierenden Jazz-Musikers geschrieben hätte, hat mir den Zugang zu dieser Musik verschafft.

BS Bachs akribische Struktur und das harmonische Gerüst dieser Arbeit sind oft untersucht und interpretiert worden.

UC Ja, es ist ein außergewöhnliches Stück. Zuerst die Aufteilung in Dreier-Gruppen, dann gibt es die regelmäßigen, kanonischen Sätze, deren Stimmen stetig wachsen und nicht zuletzt die Variationen, die überkreuz gespielt werden. Es gibt aber auch noch Hinweise auf bekannte regionale Tanzstücke. So zeigte Bach seine Universalität. Er benutzte französische Musik, er griff in die Schatzkammer der Volkslieder, am Ende erschuf er humorvoll die lockere Atmosphäre eines ländlichen Trinkgelages. Er schwelgte in den mannigfaltigsten Assoziationen.

BS Ja, auf der einen Seite griff er in den Kulturfundus, aber auf der anderen Seite folgte er streng den abstrakten Regeln purer Musik.

UC Ja, natürlich ist es so; es ist Musik, angelegt in einem strengen, harmonischen Raster. Die Kunst der Variationsform liegt in der Vielfalt – darin, wieviel man in diese Form gießen kann. Es ist ganz anders als die Struktur einer Sonate.

BS Als Sie heute Abend die *Goldberg Variationen* spielten, auf welche Art und Weise strukturierten sie selber das Musikstück? Wieviel Improvisation steckte in Ihrer Darbietung?

UC Das meiste ist improvisiert.

BS Außer in den ersten Sekunden der Aria, als Sie sie vom Blatt spielten? Danach verlagerte sich schnell Ihre Aufmerksamkeit vom Blatt zu Ihren Händen herüber und es entschwebte mit Ihnen dahin!

UC Das ist auch eine Art der Improvisation. Denn wenn ich Bach spiele, füge ich Dinge hinzu oder verlangsame das Tempo oder spiele mit den Noten. Ich glaube, ich experimentiere mit den Noten, aber niemals in einer strengen Abfolge. Ansonsten spornt es mich an, Bachs Handwerk zu spiegeln;

er hatte Giguen und Sarabanden und ich habe Mambos und Tangos.

BS Das bedeutet, jedes Mal, wenn Sie die *Goldberg Variationen* spielen, ist die Darbietung eine andere?

UC Ja, irgendwie schon, aber der musikalische Geist ist der gleiche. Auch interpretiere ich es selten als Solist. Oft nehme ich meine Aufnahme aus dem Jahre 2000 als Ausgangspunkt.

BS Wie planen Sie Ihren Auftritt? Während Ihrer Darbietung heute Abend schien es, als ob Sie in regelmäßigen Abständen kurze Passagen in traditioneller Weise spielten. Fast so, als wollten Sie das Publikum wieder einfangen, indem Sie es ihm erlaubten bekannte Passagen zu entdecken, um kurz danach wieder zurück zu Ihrer Improvisation, also in unbekannte Gefilde zu schweifen.

Die Art, wie Gould es interpretierte, war voller pulsierender Rhythmik, sehr exzentrisch.

UC Ja – ich versuche, dass das Musikstück sich ganz anders entfaltet. Manchmal spiele ich es in dreißig Teilen, aber das mache ich nicht sehr oft. Meistens spiele ich die Goldberg Variationen mit einer Gruppe, einem Oktett oder einem Septett mit Gospel-Sängern und einem DJ, einer Trompete, Klarinette, Violine und nicht zu vergessen einer Rhythmusgruppe. Es gibt immer jemanden, der improvisiert, während ein anderer die Noten spielt. Wir probieren verschiedene Dinge aus. Zum Beispiel, in meiner Aufnahme habe ich eine Klezmer-Variation die ich *Luthers Albtraum* betitelte. Manchmal beziehe ich mich auf das Leben Bachs. Der Grund warum ich 70 Variationen [1] einspielte, ist persönlicher Natur, denn in New York wohne ich auf der 72nd Street und meine gesamte musikalische Karriere spiegelt sich in dieser Gegend wider. Buchstäblich!

BS Ich las, dass auch Mahler in dieser Straße lebte …

UC Mahler lebte tatsächlich dort. Ich fand auch heraus, dass Irving Berlin in meiner Straße lebte, nachdem ich das *Tin Pan Alley* Album aufnahm. Als ich *Othello* einspielte, entdeckte ich ein großes Denkmal von Verdi auf der Kreuzung der 72nd Street und Broadway. Heute versuche ich mich von diesen Zufällen, dieser willkürlichen Denkweise zu distanzieren, anders als damals, als ich bezaubert war von der Atmosphäre New Yorks, vor allem in der Zeit, als ich *Tin Pan Alley* aufgenommen habe. Aber New York hat sich sehr verändert und ich mache mir über diese Stadt keine Illusionen mehr. Aber Künstler, Individualisten, die dort ums Überleben kämpften – mit ihnen kann ich mich sehr gut identifizieren.

BS Wie steht es mit den *Diabelli Variationen*? Als ich mein Werk, die *Diabelli Variationen 33* kreierte, fiel es mir direkt auf, dass, verglichen mit Bachs akribischer Struktur der *Goldberg Variationen*, Beethoven fließender und freier in seinem Arrangement war.

UC Einige Menschen haben versucht den Aufbau zu untersuchen. Es gibt ein wunderbares Buch von William Kinderman, in dem er die Ordnung der Skizzen Beethovens untersucht. Ein Teil des Klischees ist, dass Beethoven eine sarkastische Antwort auf Diabellis Thema schrieb. Er machte sich einfach über die kleinen Dinge lustig, wie zum Beispiel über die albernen Wiederholungen der Noten oder der Triller. Dann aber legte er die Arbeit zur Seite und komponierte die Missa solemnis und andere Stücke. Als er sich wieder den *Diabelli Variationen* widmete, hatte er sich bereits in Bachs Werke verliebt und war begeistert von der archaischen Musik. Er entfernte sich von der ursprünglichen Satire hin zur Verehrung der Musikgeschichte. Nach all den Hinweisen auf Bach hat er dieses merkwürdige, Haydn'sche Ende. Er machte jedoch das gleiche wie Bach, er verwendete harmonische Substitutionen, verwendete humorvolle Einlagen, deutete andere Formen der Musik an, von einfachen Klavierübungen bis hin zur Banalität anderer Wiener Komponisten. Wie schon gesagt, man kann mit der Variationsform viel anfangen.

BS Wie steht es mit Ihrer Aufnahme der *Diabelli Variationen*, im Vergleich zu den *Goldberg Variationen*?

UC Meine Version der *Goldberg Variationen* spielte ich mit Gruppen ein, mit denen ich häufig in New York auftrete. Viele von ihnen können wunderbar improvisieren. Ich arbeitete auch mit deutschen Chören und Spezialisten für Barock-Musik, die auf altertümliche Instrumente spezialisiert sind. Einige dieser Musiker wollten nicht mehr mit uns Improvisatoren zusammen spielen, als es ihnen klar wurde, was vor sich ging. Sie verließen erbost und entsetzt die Aufnahmesitzungen. Sie sagten, unsere Darbietung wäre respektlos und sie würden sich für uns schämen. Das Diabelli-Projekt war anders, weil ich es extra für das Concerto Köln komponierte, die auch keine Improvisatoren sind. Ich traf diese Musiker schon einige Zeit vorher, während der Aufnahmen der *Goldberg Variationen*. So entschied ich, dass ich Beethovens Klavierstück für sie orchestriere. Sie konnten das Stück vom Blatt spielen, während ich darüber frei improvisierte, was leider nicht immer so einfach war, denn es ist sehr schwer gegen einen Beethoven'schen Berg improvisatorisch anzukommen. Ich habe es schon mit verschiedenen Orchestern gespielt und jedes Mal wird es verrückter.

SHIRA STANTON Gab es irgendwelche Gruppen, die ihnen denkwürdig in Erinnerung geblieben sind?

UC Ja, im guten und im schlechten Sinn. Ich spielte es mit einem großen amerikanischen Orchester, das einen sehr berühmten aber auch komplizierten Direktor hat. Er sagte, wir sollten es wie Beethoven spielen. Ich sagte: „Aber vielleicht auch lieber nicht? Wir könnten es auflockern und dann zusammen spielen." Es ist interessant zu sehen, wie verschieden Musiker sich dieser Musik annähern. Einige sind gekränkt, aber die meisten sind begeistert. Eines meiner besten Konzerte spielte ich mit Studenten in London, sie spielten es wunderschön. Auch trat ich einst mit Leuten vom New Yorker Ballett auf, die es rhythmisch ganz außergewöhnlich mit Swing ausdrückten. Ich spielte in China, in Russland, in Australien, in Schweden. Derzeit arbeite ich an einem Mozart-Klavierkonzert, aber am liebsten kreiere ich meine eigene Musik, als Komponist oder Pianist, in Jazz-Gruppen eingebettet, wo wir verschiedene Stile ausprobieren können wie elektronische Musik oder Funk. Am Ende aber interessieren sich die meisten Leute für meine klassischen Projekte und sind davon begeistert, wie heute Abend. Es passte zum Programm des Bach-Festivals, obwohl das Publikum erahnen konnte, dass ich die *Goldberg Variationen* nicht wie Bach spielen werde.

In der Musik kann man alles machen und sich alles trauen.

SS Ich weiß nicht, ob Sie die Reaktion des Publikums von der Bühne wahrgenommen haben, aber die Zuhörer reagierten buchstäblich mit begeisterten „ahhh's" und „ohhh's" …

BS … und ich nahm etwas ganz Anderes wahr: Ich hörte selten so viel freudiges Staunen in einem Konzert. Die Zuhörer lachten wohl aus reiner Verwunderung heraus über die Art und Weise, wie Sie Ihre Finger fast schon akrobatisch bewegten oder als Sie mühelos einen Tango oder Ragtime, völlig unerwartet, über Bachs Harmonien legten. Ist es nicht wahnsinnig schwer Humor in jeglichem Bereich der Kunst darzustellen?

UC Es gibt sehr viel Humor in den *Goldberg Variationen*, wie wohl in sehr vielen Musikstücken. Aber jeder empfindet Humor anders. Mahler hatte nicht den gleichen Humor wie Beethoven. Humor kann auch von vielen Leuten falsch interpretiert werden, und wenn du den Humor erklären möchtest, ist es so, als wenn du einen Witz erklären müsstest – entweder du verstehst die Pointe auf Anhieb oder gar nicht. Wenn du ihn nicht kapierst, dann ist es auch in Ordnung, auch wenn du tatsächlich keinerlei Ahnung von diesem Musikstück hast. Obwohl, es existiert ja eine lange Tradition, moderne Musik auf klassischer Musik aufzubauen. Viele Musiker sind mit klassischer Musik aufgewachsen, und haben durch sie einiges über die Harmonielehre und die Technik des Klavierspiels gelernt.

BS Sie sind in der Musikwelt dafür bekannt, als derjenige, der die klassische und die Jazzwelt miteinander verbindet. Wie kam es dazu?

UC Wie so etwas entsteht ist ein wahres Rätsel. Als ich jünger war, habe ich bereits diese Art der Musik gemacht, aber nie daran gedacht, dass es einen Bedarf dafür gibt. Als ich zum ersten Mal nach New York kam, war wohl mein erster Wunsch, bei Blue Note Records mit Leuten wie Freddie Hubbard zu arbeiten. Aber dann kam Stefan Winter auf mich zu, der mir sagte, ich könnte einfach tun, was ich wollte. Ich spielte zuerst Mahler und plötzlich sprach es die Leute an. Ich spielte in dieser Zeit sehr viel, besonders in Europa, auf Jazz- und Avantgarde-Festivals. Ich spielte in Israel, in China, und versuchte die Musik anzupassen und sie zu kommunizieren … und die Musik wurde Nacht für Nacht wirksamer. Nach einer Weile floss die Musik einfach so heraus.

BS Sehen Sie diese Entwicklung positiv an?

53

UC Ich sehe es als eine Welle, die über mich kam. Als diese CDs erschienen sind, folgte eine Erfahrung auf die Nächste.

BS Sie interessieren sich auch für digitale Musik, Sie beschäftigen sich gerne mit elektronischen Instrumenten, mit Synthesizern und Software-Samplern. In der Kunst sind Leute anfangs eher skeptisch und neigen dazu, neuen Technologien zu misstrauen.

UC In der Musik kann man alles machen und sich alles trauen. Ich begann in meiner Jugend mit Synthesizern zu experimentieren.

BS Kann man sagen, dass der Synthesizer eine eigenartige Nachahmung des Klaviers ist?

UC Ich glaub es nicht. Der Synthesizer hat zwar die gleiche Tastatur wie ein Klavier, aber die Möglichkeiten viele verschiedene Sounds darauf zu kreiiren, macht es zu einem eigenständigen Instrument.

BS Können elektronische und digitale Technologien der heutigen Musik etwas Neues anbieten?

UC Ja – den neuen Sound! Es gab in der Jazzwelt einst eine hitzige Debatte. Einige Leute empfanden es als Verrat, als einige Musiker vom Klavier zum Keyboard wechselten. Ich habe es niemals so empfunden, es ist ja doch ein völlig anderes Instrument. Es ist so, als ob ich sagen würde, ich kann sowohl Französisch als auch Spanisch sprechen. Die nächste Entwicklungsstufe war jedoch der Laptop. Der erste Ausflug für mich in die Welt des Laptops war, als ich darauf Stücke orchestrierte, weil mir beim Abschreiben meine Hände, im wahrsten Sinne, verkrampften. Ich besorgte mir daraufhin ein Software-Programm, mit dem ich meine Stücke orchestrierte und sie gleich ausdrucken konnte, ich habe mir somit viel Arbeit erspart. Von da an habe ich die verschiedensten Programme benutzt. Es ist eine neue Ästhetik, in dem Sinne, dass ich ein ganzes Album in meinem Hotelzimmer aufnehmen kann ... und ich mache es häufig so! Es ist anders als in meiner Jugend.

BS Nehmen Sie zum Beispiel die Hammond-Orgel, die Hammond-Orgel war zuerst eine Nachahmung der Kirchenorgel, dann erreichte es die nächste Stufe und heute haben wir eine Nachahmung einer Nachahmung in der Form eines Software Plug-Ins, der die Hammond-Orgel im Computer simuliert. Kann man sagen, solch ein Plug-In kreiert überhaupt einen neuen Sound?

UC Es ist beides.

BS Ist es besser oder schlechter als das Original?

UC Tja, viele dieser Dinge wurden für Menschen erfunden, die keine schwere Orgel mit sich herum schleppen wollen und das hat viele Vorteile. Ich glaube man kann es so sagen, wenn du arbeitest und dich ruft plötzlich jemand an, der da sagt: „Ich möchte einen Sound, der wie eine Orgel klingt", dann kannst du es sofort liefern. Aber da gibt es zwei Dinge, die man beachten muss. Erstens, Du sprichst von einer Hammond-Orgel: Ich bin in Philadelphia aufgewachsen, wo die Hammond-Orgel einen ganz besonderen Klang

hatte. Obwohl man sie ursprünglich als eine Nachahmung eines Kircheninstruments entwickelte, wurde sie nicht so in den Jazzclubs gespielt! Was Shirley Scott und Jimmy Smith dem Instrument entlocken konnten, war überwältigend, einfach toll! Dieser Swing! Zweitens kannst du den Sound der Hammond-Orgel soweit verzerren, dass er weit über den Klang einer Nachahmung hinausgeht. In meiner Musik mache ich es häufig so, ich bearbeite Klänge, die sich am Anfang noch sehr konventionell anhören und entstelle sie, bis sie nicht mehr erkennbar sind. Bis Fußstapfen zu einer Trommel oder zu einem Bassrhythmus mutieren oder bis der Schrei eines Babys zur Melodie wird. Es ist wirklich spannend mit elektronischer Musik zu arbeiten.

BS Liegt der Vorteil in der digitalen Technik einzig darin, neue Klänge zu erschaffen und Zeit einzusparen oder schafft es auch Potential für neue Arten der Komposition?

UC Es beinhaltet alles. Es ist natürlich erst mal eine Erleichterung damit zu arbeiten, aber es kann auch Dinge ermöglichen, die kein menschlicher Musiker mehr vollbringen kann. Sowie Conlon Nancarrow, ein amerikanischer Komponist, der aus seinem Land vertrieben wurde, als er sich der Armee während des spanischen Bürgerkrieges anschloss. Er zog nach Mexiko und komponierte für das Pianola, ein selbstspielendes Klavier. Er komponierte Stücke, in denen acht Glissandos in alle Richtungen laufen oder setzte Akkorde bestehend aus 88 Noten ein. Kein Mensch konnte das so spielen *(Uri immitiert den Sound)* – die gesamte Musik wurde auf Lochstreifen notiert, ein Vorläufer des Computers.

BS Es gibt ein Album von Frank Zappa aus den 80er-Jahren, das *Francesco Zappa* heißt, indem er so etwas Ähnliches ausprobierte; er nahm die Musik von einem Barock-Komponisten, der Francesco Zappa hieß, und gab ein Album heraus, das er ausschließlich von elektronischen Instrumenten abspielen ließ – Musik, die von menschlicher Hand nicht mehr gespielt werden kann.

UC Genau. Es gab auch andere Aufnahmen von Frank Zappa. Er hatte das Synclavier, das in den späteren siebziger und frühen achtziger Jahren herauskam. Heute ist es ein Dinosaurier. Heute können Laptops das gleiche herstellen. Es kostete damals etwa 100.000 $, heute kostet ein Programm, das das gleiche kann, nur noch 40 $. Ich erinnere mich noch genau daran, als es herauskam. Es hatte einen Speicher, auf dem man ein gesamtes Orchesterstück speichern konnte, es war möglich rhythmische Dinge auszuprobieren, die in der Wirklichkeit unmöglich gewesen wären. Für Zappa war das wie eine Befreiung, wie für viele andere Komponisten auch. Zappa hatte sehr schlechte Erfahrungen gesammelt, oft stand er vor dem Orchester und forderte die Musiker heraus. Sie protestierten: „Das kann man so auf der Trompete nicht spielen" und er antwortete: „natürlich kann es auf der Trompete so gespielt werden, aber du kannst es nicht. Arbeite daran, übe solange, bis es klappt." Zappa setzte dann irgendwann die Maschine ein und sie erlöste ihn.

BS Das ist ein sehr optimistischer Zugang zur Maschine.

UC Natürlich, wie jedes andere Instrument auch. Es kann

künstlerisch angewandt werden oder kommerziellen Dreck erzeugen. Heute arbeiten viele Musiker mit dem Computer und gehen wirklich kreativ damit um. Es gibt heute eine Debatte darüber, denn es ist so einfach geworden bestimmte Dinge auszuprobieren. DJs mussten früher stundenlang experimentieren und üben, um das Tempo zweier Schallplatten zu synchronisieren; heute lädst du deinen Sound in das Programm Ableton Live und das Tempo passt sich wie von selbst an. Als wir jung waren, mussten wir Tonbänder spleißen und es dauerte drei Monate, um zwei Minuten Musik herzustellen. Heute benutzt du einfach Protools. Du verlässt dich natürlich immer noch auf dein Ohr, aber du hast so viele verschiedene Möglichkeiten. Du kannst dein Arrangement auf acht Wege ausprobieren, und dich nicht immer nur auf einen Weg festlegen. Manchmal hat man viel zu viele Möglichkeiten. Von diesem Standpunkt aus ist es sehr positiv. Aber offensichtlich muss man diese Dinge mit Phantasie und Vorstellungskraft handhaben. Meiner Meinung nach ist die Pop-Musik heute sehr phantasievoll. Ich habe viel Erfahrung sie zu spielen und sie anzuhören, dass ich oft sehr erstaunt bin, wie großartig sie ist. Ich habe überhaupt kein Problem mit der Pop-Musik.

BS Können Sie mir Musiker nennen, die digitale Technologien kreativ anwenden?

UC So jemanden wie Sqarepusher. Er kreiert wunderbar klingende Rhythmen und Drum Beats. Die Musik entwickelt sich ständig und stößt unglaubliche Klänge aus. Es scheint, als ob sie aus dem Nichts heraus entstehen. Es gibt einige Jazz-Fusion-Gruppen, die digitale Technologien überzeugend anwenden. Es ist nicht jedermanns Geschmack, aber ein hervorragender Keyboard-Spieler kann sehr flüssig spielen. Es gibt wirklich sehr viele gute Musiker auf diesem Gebiet.

BS In meiner Arbeit gibt es auch diese konstante Spannung zwischen traditionellen Mitteln und digitaler Technik. Es ist manchmal sehr schwer Werke zu definieren, wenn sie nicht in eine Kategorie passen.

UC Es klingt wie ein Klischee, aber hör' nicht hin, was Leute so sagen. Ich weiß, es ist einfacher darüber zu sprechen als es zu tun, aber bleibe beim Experimentieren und du wirst sehen, dass sich die Leute nach einer Weile daran gewöhnen. Es hat sehr viel mit Verständnis zu tun. Ich erlebe das ständig in meiner Musik, denn einige Abende fühlst du dich wirklich abgeurteilt, sie sagen dir, dass du ein miserabler Musiker bist und du fühlst dich richtig mies. Am nächsten Abend hat niemand ein Problem damit. Ich möchte nicht sagen, dass mir die Meinung Anderer egal ist. Du musst deinen Weg finden und dich einfach nicht nach Anderen richten.

BS Was durch Ihre Musik und Ihrer Darbietung durchschimmert ist die Leidenschaft zur Musik und der tiefe Respekt für die Komponisten, die Sie interpretieren. Sie würden sicher nicht alles spielen?

UC Nein, ich würde nicht alles spielen, aber womit ich mich beschäftige, ist nicht jedermanns Geschmack. Die Welt der klassischen und der Jazz-Musik können beide sehr konservativ sein. Vergangenen Dezember hielt ich ein Konzert in Florida. Danach schrieb ein Journalist in seiner Rezension, dass es buchstäblich das schlimmste Konzert war, das er

je in seinem Leben gehört hat. Die Leser antworteten ihm und fragten: „Wirklich?" „Das Schlechteste?" „Wirklich?" „Seit je?" Sie stießen eine Diskussion an und das Resultat schickte mir jemand und ich musste einfach lachen. Aber ein Teil von mir war nicht gerade glücklich darüber, was dieser Mensch geschrieben hatte, aber, weißt du, heute sitzen wir in Brüssel und alles ist gut. Es gibt ein Buch von Nicolas Slonimsky, der ein Musik-Lexikon der Beschimpfungen geschrieben hat, darin verfasste er eine Liste schlechter Kritiken über große Komponisten. Es ist wunderbar: „Tschaikowski kann keine Melodie schreiben", „Brahms weiß nicht, wie man Stücke für Geige komponiert", „Beethoven ist ein Idiot, er ist verrückt und sollte sich in eine Anstalt begeben", und „diese Musik hört sich wie das Brüllen der Tiere im Viehstall an" und dann hat er die Beschimpfungen in einer Tabelle hinten im Buch noch einmal aufgeführt und es wird klar, dass die Leute sich seit ewigen Zeiten über Musik negativ auslassen.

BS Kritik ist manchmal wie ein Rorschach-Test, sie erzählt uns mehr über den mentalen Zustand der Kritiker als über den künstlerischen Wert des Werkes.

UC Ein sehr guter Punkt. Du musst mit Kritik richtig umgehen können, denn sie kann brutal sein. Viele Leute können es, gerade im akademischen Umfeld, nicht ertragen. Ich habe es ertragen müssen und es machte mich wirklich stärker. Ich besuchte eine Universität, deren Schwerpunkt die Zwölfton-Musik war. Sie unterrichteten noch nicht einmal Jazz-Musik. Jazz (Uri lacht) befand sich in der Folklore Abteilung! Ein Professor riet mir, ich solle unbedingt Lehrer werden. Ich erklärte ihm, dass ich nach New York gehen möchte, um zu spielen. Er antwortete mir, dass ich mein Leben damit verschwende und als Vierzigjähriger in irgendeinem Restaurant als Klavierspieler enden werde. Ich fragte ihn: „Was ist denn falsch daran?" Je älter du wirst umso demütiger musst du werden. Mach einfach dein Ding und wenn die Leute es nicht mögen – ist es cool, es ist ok.

BS Das ist wirklich eine gute Philosophie.

UC Sie wird dir sehr nützlich sein. Es soll nicht heißen, dass du nicht jemals darüber nachdenken sollst, deinen Kurs zu ändern und dich nicht sträubst, Kritik anzunehmen. Du trainierst es wie einen Muskel. Du begutachtest deine Arbeit ehrlich. Ich genieße den Kontrast. Ich kann einerseits am Klavier arbeiten und andererseits viel Zeit mit Komponieren neuer Musik verbringen. Als Improvisator musst du nicht das ganze Jahr herumhängen und an einer Sinfonie arbeiten. Du musst dich nicht ständig damit quälen, welche Noten du behältst und welche du weglassen kannst – obwohl ich diesen Prozess sehr mag. Wenn du improvisierst, musst du ganz dahinter stehen. Nach dem Konzert ist es vorbei. Du hast dich dafür entschieden, du hast deinen Gefühlen freien Lauf gelassen und dann ist es vorbei.

55

[1] Die 70 Variationen beinhalten nicht die beiden Arien. Werden die Arien zu den Variationen hinzugezählt ergibt die Gesamtzahl 72. Daher spricht Uri Caine den Zufall an, dass er auf der 72nd Street lebt.

DEUTSCHER AKTIENINDEX

30 + 1

DOW JONES INDUSTRIAL

30 + 1

DEUTSCHER AKTIENINDEX

30+1

60

Deutscher Aktienindex 30+1
2010, duraclear transparency in lightbox, 105 × 157.5 cm

DOW JONES
INDUSTRIAL
30 + 1

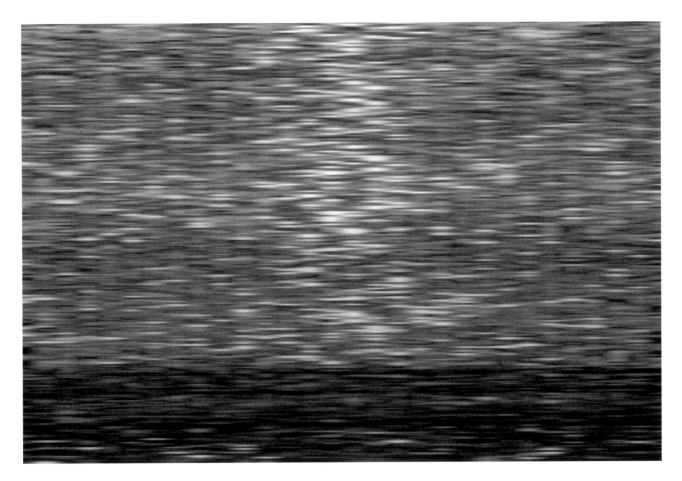

Dow Jones Industrial 30 + 1
2010, duraclear transparency in lightbox, 105 × 157.5cm

Transformation Process
Übersetzungsprozess

Deutscher Aktienindex (DAX)
2008

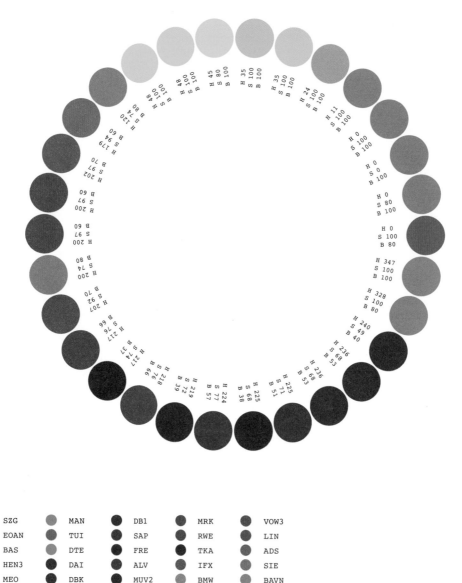

DPW	SZG	MAN	DB1	MRK	VOW3	
DPB	EOAN	TUI	SAP	RWE	LIN	
CBK	BAS	DTE	FRE	TKA	ADS	
CON	HEN3	DAI	ALV	IFX	SIE	
LHA	MEO	DBK	MUV2	BMW	BAVN	

The dataset for this work is based on the stock market values of the thirty DAX-listed companies during the global financial crisis in 2008. The colour palette is defined using each company's primary corporate colour. Leaders and laggards are sorted on a daily basis.

Die Datengrundlage basiert auf Börsenwerten der 30 DAX Firmen im globalen Finanzkrisenjahr 2008. Die Farbpalette wird durch die Farbtöne der primären Hausfarben der Unternehmen definiert. Gewinner und Verlierer werden tagesweise sortiert.

Dow Jones Industrial Index (DJIA)
2008

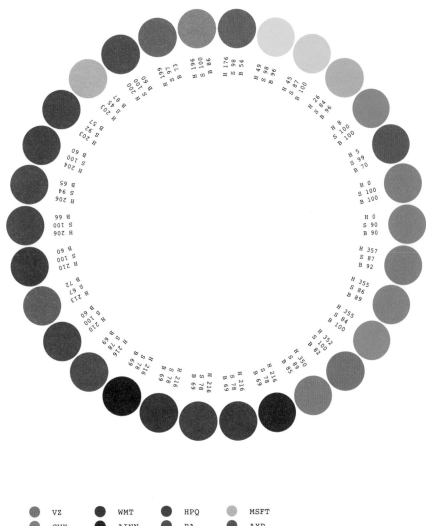

63

●	MCD	●	C	●	VZ	●	WMT	●	HPQ	●	MSFT
●	CAT	●	DD	●	CVX	●	AINN	●	BA	●	AXP
●	HD	●	BAC	●	DIS	●	JPM	●	INTC	●	PFE
●	MMM	●	KO	●	PG	●	GM	●	IBM	●	T
●	JNJ	●	XOM	●	ALU	●	GE	●	UTX	●	MRK

The dataset for this work is based on the stock market values of the thirty Dow Jones-listed companies during the global financial crisis in 2008. The colour-palette is defined using each company's primary corporate colour. Leaders and laggards are sorted on a daily basis.

Die Datengrundlage basiert auf Börsenwerten der 30 Dow Jones Firmen im globalen Finanzkrisenjahr 2008. Die Farbpalette wird durch die Farbtöne der primären Hausfarben der Unternehmen definiert. Gewinner und Verlierer werden tagesweise sortiert.

Colour Coding
Farbgebung

Dow Jones Industrial Index (DJIA)
2008

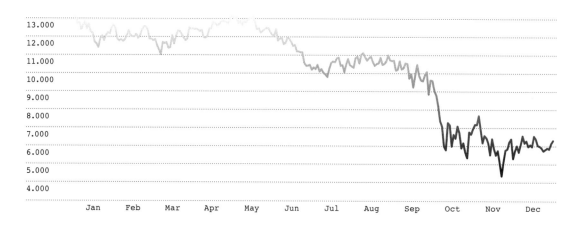

BAC
2008

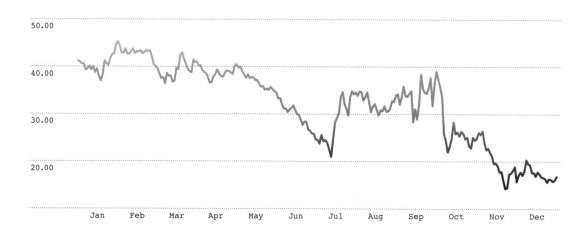

The brightness of each company colour is linked to the price of the stock throughout the year.

Die Helligkeit der Farbe wird durch die Höhe des Aktienkurses bestimmt.

			OPEN	HIGH	LOW	CLOSE	VOLUME	ADJ CLOSE
n	02,	2008	13.261,82	13.279,54	12.991,37	13.043,96	239.580.000	13.043,96
n	03,	2008	13.044,12	13.137,93	13.023,56	13.056,72	200.620.000	13.056,72
n	04,	2008	13.046,56	13.046,72	12.789,04	12.800,18	304.210.000	12.800,18
n	07,	2008	12.801,15	12.884,15	12.733,84	12.827,49	306.700.000	12.827,49
n	08,	2008	12.820,90	12.906,42	12.565,41	12.589,07	322.690.000	12.589,07
n	09,	2008	12.590,21	12.738,64	12.501,76	12.735,31	332.900.000	12.735,31
n	10,	2008	12.733,11	12.931,29	12.632,15	12.853,09	325.330.000	12.853,09
n	11,	2008	12.850,74	12.851,14	12.543,87	12.606,30	301.890.000	12.606,30
n	14,	2008	12.613,78	12.794,57	12.613,70	12.778,15	245.370.000	12.778,15
n	15,	2008	12.777,50	12.777,50	12.488,76	12.501,11	339.700.000	12.501,11
n	16,	2008	12.476,81	12.613,13	12.392,27	12.466,16	500.040.000	12.466,16
.n	17,	2008	12.467,05	12.517,61	12.125,56	12.159,21	439.830.000	12.159,21
.n	18,	2008	12.159,94	12.341,54	12.022,48	12.099,30	483.300.000	12.099,30
.n	22,	2008	12.092,72	12.092,72	11.634,82	11.971,19	506.500.000	11.971,19
.n	23,	2008	11.969,08	12.276,67	11.644,81	12.270,17	536.520.000	12.270,17
.n	24,	2008	12.272,69	12.399,18	12.241,80	12.378,61	387.900.000	12.378,61
.n	25,	2008	12.391,70	12.486,89	12.183,68	12.207,17	393.660.000	12.207,17
.n	28,	2008	12.205,71	12.386,01	12.112,14	12.383,89	278.990.000	12.383,89
.n	29,	2008	12.385,19	12.503,15	12.346,99	12.480,30	285.090.000	12.480,30
.n	30,	2008	12.480,14	12.681,41	12.406,17	12.442,83	334.680.000	12.442,83
.n	31,	2008	12.438,28	12.702,38	12.249,93	12.650,36	394.330.000	12.650,36
eb	01,	2008	12.638,17	12.767,74	12.602,32	12.743,19	379.580.000	12.743,19
eb	04,	2008	12.743,11	12.749,78	12.621,83	12.635,16	237.410.000	12.635,16
eb	05,	2008	12.631,85	12.631,93	12.264,07	12.265,13	334.380.000	12.265,13
eb	06,	2008	12.257,25	12.390,32	12.178,15	12.200,10	296.360.000	12.200,10
eb	07,	2008	12.196,20	12.332,52	12.120,44	12.247,00	326.200.000	12.247,00
eb	08,	2008	12.248,47	12.281,88	12.103,37	12.182,13	262.200.000	12.182,13
eb	11,	2008	12.181,89	12.252,12	12.069,47	12.240,01	268.100.000	12.240,01
eb	12,	2008	12.241,56	12.469,41	12.241,56	12.373,41	256.970.000	12.373,41
eb	13,	2008	12.368,12	12.573,13	12.367,80	12.552,24	236.300.000	12.552,24
eb	14,	2008	12.551,51	12.557,61	12.361,46	12.376,98	233.790.000	12.376,98
eb	15,	2008	12.376,66	12.376,66	12.278,62	12.348,21	289.800.000	12.348,21
eb	19,	2008	12.349,59	12.505,25	12.304,08	12.337,22	257.550.000	12.337,22
eb	20,	2008	12.333,31	12.464,06	12.227,72	12.427,26	297.990.000	12.427,26
eb	21,	2008	12.426,85	12.503,46	12.247,34	12.284,30	293.420.000	12.284,30
eb	22,	2008	12.281,09	12.397,79	12.155,26	12.381,02	307.090.000	12.381,02
eb	25,	2008	12.380,77	12.584,62	12.341,04	12.570,22	288.600.000	12.570,22
eb	26,	2008	12.569,48	12.734,18	12.512,41	12.684,92	291.760.000	12.684,92
eb	27,	2008	12.683,54	12.756,56	12.609,37	12.694,28	263.720.000	12.694,28
eb	28,	2008	12.689,28	12.689,44	12.536,43	12.582,18	247.270.000	12.582,18
eb	29,	2008	12.579,58	12.580,15	12.223,57	12.266,39	351.870.000	12.266,39
ar	03,	2008	12.264,36	12.281,37	12.161,05	12.258,90	259.730.000	12.258,90
ar	04,	2008	12.259,14	12.259,23	12.032,42	12.213,80	347.720.000	12.213,80
ar	05,	2008	12.204,93	12.349,67	12.140,53	12.254,99	304.570.000	12.254,99
ar	06,	2008	12.254,59	12.254,59	12.026,07	12.040,39	283.100.000	12.040,39
ar	07,	2008	12.039,09	12.094,21	11.819,69	11.893,69	307.580.000	11.893,69
ar	10,	2008	11.893,04	11.926,50	11.731,60	11.740,15	312.020.000	11.740,15
ar	11,	2008	11.741,33	12.160,80	11.741,01	12.156,81	372.330.000	12.156,81
ar	12,	2008	12.148,61	12.303,35	12.092,25	12.110,24	288.130.000	12.110,24
ar	13,	2008	12.096,49	12.215,35	11.875,78	12.145,74	336.260.000	12.145,74
ar	14,	2008	12.146,39	12.193,61	11.832,72	11.951,09	380.810.000	11.951,09
ar	17,	2008	11.946,45	12.076,22	11.756,60	11.972,25	382.890.000	11.972,25
ar	18,	2008	11.975,92	12.392,66	11.975,84	12.392,66	367.780.000	12.392,66
ar	19,	2008	12.391,52	12.461,53	12.095,10	12.099,66	328.460.000	12.099,66
ar	20,	2008	12.102,43	12.378,74	12.097,87	12.361,32	502.650.000	12.361,32
ar	24,	2008	12.361,97	12.622,07	12.361,97	12.548,64	264.320.000	12.548,64
ar	25,	2008	12.547,34	12.571,84	12.449,08	12.532,60	237.650.000	12.532,60
ar	26,	2008	12.531,70	12.531,95	12.376,70	12.422,86	235.020.000	12.422,86

HITCHCOCK

30

KUBRICK

13 + 9 +10

HITCHCOCK
30

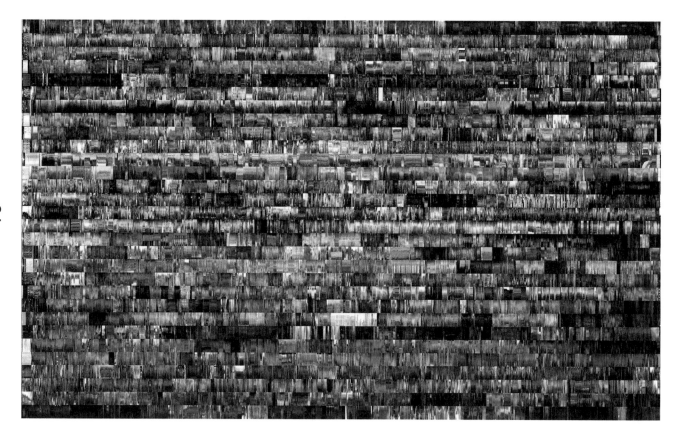

Hitchcock 30
2011, duraclear transparency in lightbox, 105 × 174 cm

KUBRICK

13 + 9 +10

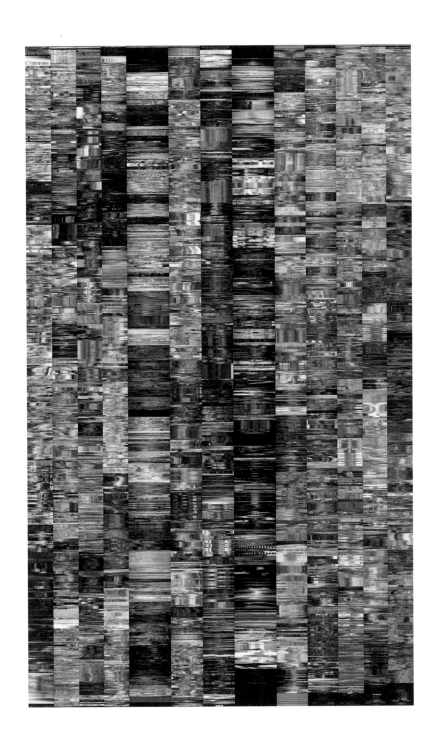

Kubrick 13 + 9 + 10
2012, duraclear transparency in lightbox, 174 × 105 cm

Alfred Hitchcock

"Hitch paints a picture in his films, colour is as important to him as it is to any artist."

Edith Head on Hitchcock

The "Master of Suspense" was a film director and producer.
He was born in England in 1899 and moved to the US in 1939.
Der „Master of Suspense" war Filmregisseur und Produzent.
Er ist 1899 in England geboren und 1939 in die USA ausgewandert.

Stanley Kubrick

"It's funny how the colours of the real world only seem really real when you viddy them on the screen."

Alex DeLarge in *A Clockwork Orange*

The "Master of All Genres" was a film director, producer and screenwriter.
He was born in the US in 1928 and moved to England in the 1960s.
Der „Master of All Genres" war Filmregisseur, Produzent und Drehbuchautor.
Er ist 1928 in den USA geboren und in den 60er-Jahren nach England gezogen.

Movies Used
Verwendete Filme

30 films by Alfred Hitchcock
30 Filme von Alfred Hitchcock

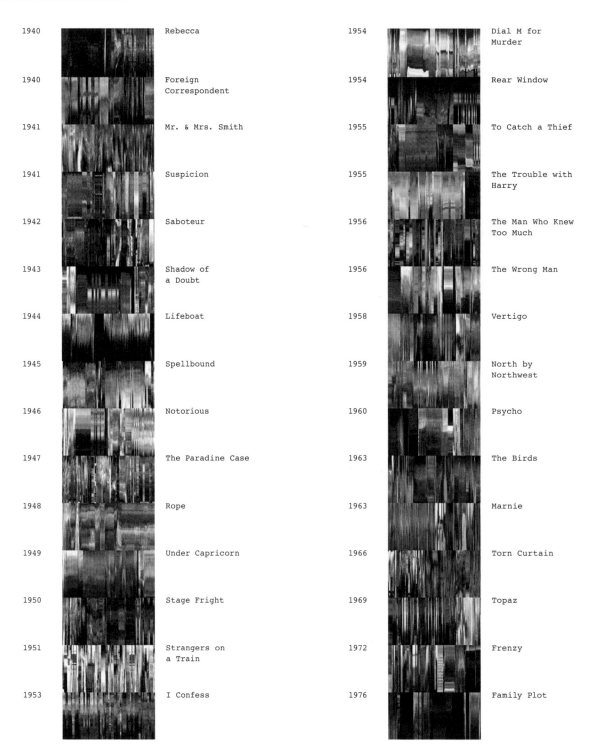

1940	Rebecca	1954	Dial M for Murder
1940	Foreign Correspondent	1954	Rear Window
1941	Mr. & Mrs. Smith	1955	To Catch a Thief
1941	Suspicion	1955	The Trouble with Harry
1942	Saboteur	1956	The Man Who Knew Too Much
1943	Shadow of a Doubt	1956	The Wrong Man
1944	Lifeboat	1958	Vertigo
1945	Spellbound	1959	North by Northwest
1946	Notorious	1960	Psycho
1947	The Paradine Case	1963	The Birds
1948	Rope	1963	Marnie
1949	Under Capricorn	1966	Torn Curtain
1950	Stage Fright	1969	Topaz
1951	Strangers on a Train	1972	Frenzy
1953	I Confess	1976	Family Plot

The 13 films by Stanley Kubrick
Die 13 Filme von Stanley Kubrick

1953 1955 1956 1957 1960 1962

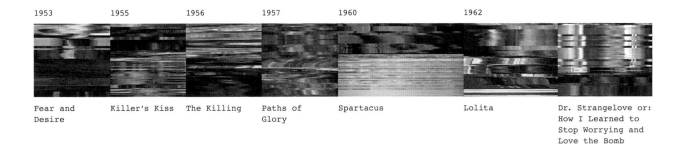

Fear and Desire Killer's Kiss The Killing Paths of Glory Spartacus Lolita Dr. Strangelove or: How I Learned to Stop Worrying and Love the Bomb

1968 1971 1975 1980 1987 1999

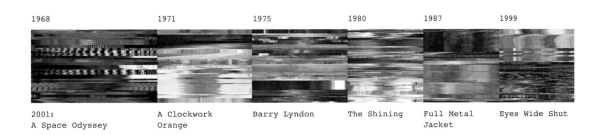

2001: A Space Odyssey A Clockwork Orange Barry Lyndon The Shining Full Metal Jacket Eyes Wide Shut

75

Aspect Ratios Kubrick Preferred
Kubricks bevorzugte Bildformate

1.37:1	1.66:1	2.20:1	2.35:1
ACADEMY RATIO	EUROPEAN WIDESCREEN	SUPER PANAVISION 70	SUPER TECHNIRAMA 70

ACADEMY RATIO	EUROPEAN WIDESCREEN	SUPER PANAVISION 70	SUPER TECHNIRAMA 70
Fear and Desire	Lolita	2001: A Space Odyssey	Spartacus
Killer's Kiss	Dr. Strangelove		
The Killing	A Clockwork Orange		
Paths of Glory	Barry Lyndon		
The Shining			
Full Metal Jacket			
Eyes Wide Shut			

Transformation Process
Übersetzungsprozess

Hitchcock 30
Vertigo

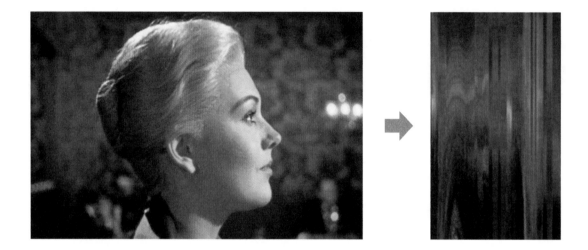

The dataset for this work is based on Alfred Hitchcock's 30 feature-length films completed from the time he moved from Great Britain to Hollywood in 1939 until his death in 1980. The colour palette is based on the chromaticity of a total of 15 black-and-white and 15 colour-movies. A total of 283,500 still-frames are extracted, each film cut into 9,450 frames at equal intervals. The mean colour value of each row of pixels is calculated and abstracted into a colour-column, then placed in temporal sequence.

Als Datengrundlage dienen die 30 Spielfilme Alfred Hitchcocks, die er ab seinem Umzug nach Hollywood im Jahre 1939 bis zu seinem Lebensende geschaffen hat. Die Farbpalette basiert auf der Farbigkeit von insgesamt 15 Schwarzweiß- und 15 Farbfilmen. Insgesamt sind 283.500 Standbilder ausgewertet, jedem Film werden 9.450 Standbilder in zeitlich gleichen Abständen entnommen. Der Mittelwert der Farbe jeder Zeile eines digitalisierten Standbildes wird errechnet, zu einer Farbsäule abstrahiert, und in zeitlicher Folge aneinander gereiht.

Kubrick 13 + 9 +10
2001: A Space Odyssey

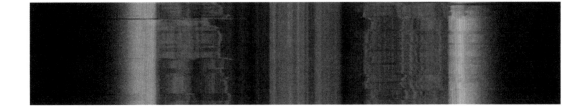

The dataset for this work is based on Stanley Kubrick's 13 feature length films. The colour palette is based on the chromaticity of a total of 6 black-and-white and 7 colour-movies. A total of 107,445 still-frames are extracted, each film cut into 8,265 frames at equal intervals. The mean colour value of each pixel column is calculated and abstracted into a colour-row and placed in temporal sequence.

Als Datengrundlage dienen die 13 Spielfilme Stanley Kubricks. Die Farbpalette basiert auf der Farbigkeit von insgesamt 6 Schwarzweiß- und 7 Farbfilmen. Insgesamt sind 107.445 Standbilder ausgewertet, jedem Film werden 8.265 Standbilder in zeitlich gleichen Abständen entnommen. Der Mittelwert der Farbe jeder Reihe eines digitalisierten Standbildes wird errechnet, zu einer Farbreihe abstrahiert und in zeitlicher Folge aneinander gereiht.

78

Hitchcock 30
Filmmuseum Frankfurt

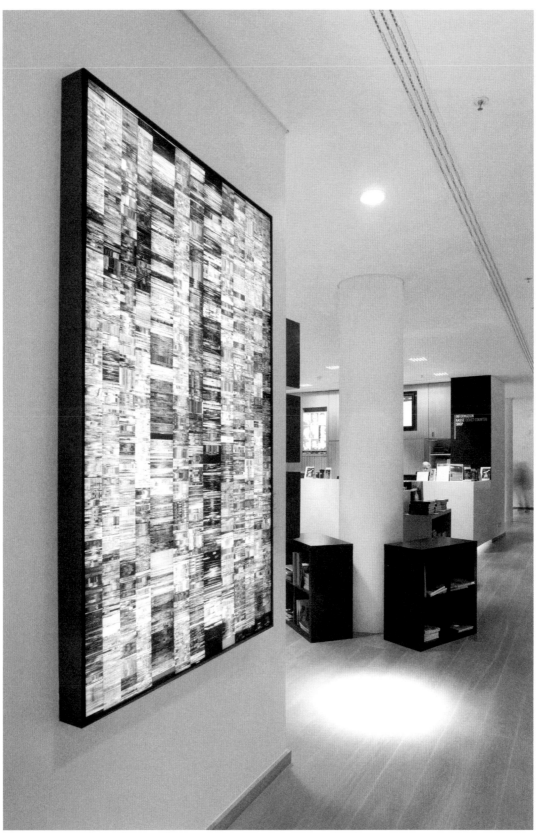

Kubrick 13+9+10
Filmmuseum Frankfurt

A conversation with
film historian Dan Auiler

RED FLASHES

AND

On Hitchcock's
use of colour

GREEN FOG

Ein Gespräch mit dem
Filmhistoriker Dan Auiler

ROTE BLITZE

UND

Über Hitchcock
und seine Farben

GRÜNER NEBEL

Dan Auiler is the author of the books *Vertigo: The Making of a Hitchcock Classic* and *Hitchcock's Notebooks*. He is a leading expert on Hitchcock and film history, and appears regularly in documentaries, television and radio programmes discussing Hitchcock, film history, and contemporary cinema. He runs the blog *Hitchcock's Vertigo* (www.hitchcocksvertigo.com).

Dan Auiler ist der Autor der Bücher *Vertigo: The Making of a Hitchcock Classic* und *Hitchcock's Notebooks*. Als Filmhistoriker und führender Hitchcock-Experte tritt er regelmäßig in Fernseh- und Radioprogrammen auf, um über Hitchcocks Werke, Filmgeschichte und zeitgenössisches Kino zu diskutieren. Er betreibt den Blog *Hitchcock's Vertigo* (www.hitchcocksvertigo.com).

DAN AUILER When you think about Hitchcock and colour, it's instructive to start with his first colour film, *Rope*. He was very particular of the colour scheme of the film and the backdrop; they even had to shoot a couple of reels over because the colour was not right. I think as you progress to *Dial M for Murder*, his next major colour film, he began his experimentation with the format. What could he do with colour? What could he do with three dimensions? How could he use colour to separate his characters? It's like looking through a View-Master® as he maintains that colour deep depth of field through most of his films, a unique look.

BENJAMIN SAMUEL *Rope* is a good example. Already in his first colour film, you sense that Hitchcock didn't want to use colour non-realistically, that he always wanted to have a reason to have a specific colour on the screen. In *Rope*, he used a muted, grey colour scheme. As the evening sky grows darker, so does the entire film, and towards the end, you begin to see a flashing tint of bright red and green light engulfing the characters. This alternating red-green light shows up quite noticeably in my work *Hitchcock 30*, coming from the flashing neon sign right outside of the apartment window.

DA You're right. There is a moment in the film when the pulsing becomes the dominant colour impression. Also in *Vertigo*, Judy is sitting in a hotel and a neon sign outside her window is bathing her in green colour. There is something about green that Hitchcock found very effective, providing an almost black and white look, but also a supernatural effect, something that came from another realm. Especially Judy in the window: she ceases to look human, looking almost Martian in the shadow of her profile.

In *Rope*, I find it amazing how Hitchcock would consistently use the same technique, taking a natural lighting source from outside the window to bathe the drama of the moment. In *Rope* particularly, there is the challenge of it all happening in a single moment in time and needing to build drama. He did this partially with colour; as the evening descends in *Rope*, the drama progresses, and the light subtly changes accordingly. Hitchcock had a very counter punctual way of putting together a film. You have one person going down as the action or the drama increases. Think of all the stairs, people descending is actually an ascending motion for the film; the long, suspenseful descent which is really when the action is cranked up. I think he did the same with colour. First, it begins naturally and then, as the drama increases, we move into a different colour range. In *Vertigo*, for example, there is a general move through the spectrum from the lower colour range to the tower, where we're dealing with darker colours. It's a consistent movement.

BS With the green fog in the hotel room in *Vertigo*, Hitchcock is self-referencing a similar scene in *To Catch a Thief*, in which the Kelly / Grant characters of John Robie and Frances Stevens talk, embrace and kiss in a hotel room on the French Riviera. In that scene, there is also a green tint that bathes Grace Kelly's character, simulating a night-time effect. Scottie's loss of Madeleine in *Vertigo* parallels Hitchcock's loss of his leading actress Grace Kelly, who became Princess Grace soon after appearing in *To Catch a Thief*.

When I read your book on *Vertigo*, I had somewhat of an epiphany regarding that hotel scene in *Vertigo* and the colour green, beginning with the discussion on the movie's title between Hitchcock and the movie executives. Hitchcock preferred the title "Vertigo", while the movie executives wanted "Face in the Shadow" [1]. Hitchcock was very adamant about his choice and was of course triumphant. Soon after that discussion, you go on to describe the production of the hotel room sequence [2] and Hitchcock's specific vision of the green-fog effect. I read your book while in Brussels, Belgium, and maybe it was due to being immersed in a French-speaking environment that it dawned on me: Hitchcock refers to the colour green even in the title of the movie! The French word for green is vert! Hitchcock's insistence on the title *Vertigo*, his specific vision of the green-fog effect, and even the fact that the book was based on a French novel, means that this couldn't have been an accident. Green is definitely the defining colour in *Vertigo*.

DA I like that, that's quite good, I never thought of that. It's the same in Spanish: verde. David Dodge, who wrote the book on which they based *To Catch a Thief*, wrote another novel called "How Green Was My Father", which is a comedy about his father's jealousy. In Mexico, there is a phrase the goes "qué verde mi papa", which really means "how jealous my father is". Green is often connected to the emotion of jealousy. In Shakespeare's *Othello*, Iago says jealousy is a "green-eyed monster".

Hitchcock had a very counter punctual way of putting together a film.

BS You don't think Hitchcock is using the colour green to refer to jealousy?

DA It is important as a film critic and historian to consider the fact that we are not sure what his intent was. Autobiographically, he often said that the green fog was from a production of the play *Mary Rose* he saw, in which Mary Rose stepped out of a green fog. The constant use of that green colour in a mystical way comes from that deep connection to *Mary Rose*. The use of green is a sort of supernatural world that Scottie sees. Hitchcock was very Catholic in the most supernatural sense of hell and heaven, and another life or reality that separates our own. Chris Marker talked about the green from *Vertigo* as an eternal symbol. Green is often a symbol of eternity. Scottie says in the forest scene: "Sequoia Sempervirens: always green, ever-living". So for Scottie, anything that has no death, that is constantly alive, has a green colour to it. Same goes for Judy/Madeleine, as she walks out of her grey world into that green hue which brings her back to eternal life.

What makes Hitchcock, or Shakespeare or Picasso—pick a genius of your choice—so extraordinary, is that no matter what scene, what moment you are talking about, they could

be so overwhelmingly meaningful to the viewer. Think of Shakespeare's *The Winter's Tale* and the strong desire of the lover who has made a mistake and lost his love, and somehow bring that love back to life. Even all the way back to *Gilgamesh*, in that extraordinary moving moment, where Gilgamesh is able to have his friend come back briefly to life after he has died after so many years. That incredible feeling of longing and of loss is all compiled into that single packed moment. You can pull the colours out, you can pull the themes out, you can pull the characters and actors out, and it's a wonderful marvel of Jungian or Freudian possibilities.

Another important moment in *Vertigo*, to a certain extent, is the desaturating colour at the Golden Gate Bridge. He uses a fog filter, in the sort of way we would see it in a dream, not in an imposing way, but subtle. San Francisco is actually foggy, and the Golden Gate Bridge is often seen through the same sort of haze. The same goes for Mission Dolores. When you visit it today, that intense white-blue haze created by the white stucco on the building—it's amazing how accurate my impression is at the Mission Dolores to what is transcribed to the screen in *Vertigo*, because they had to use special filters to achieve that effect. Again, it's a natural lighting effect that occurs specifically at that location that Hitchcock wanted to capture, rather than impose an unnatural effect. I guess, the same goes for the evening sequence in *To Catch a Thief*; I've never been to Cannes or that area, but in the San Diego harbour, the lighting there makes the greens have more of a pastel green to them. I never noticed the green haze in *To Catch a Thief*, because I am so used to it from being in San Diego or La Jolla where it's very noticeable—the light itself changes because of the presence of the ocean. Hitchcock's use of colour is indeed deliberate, but he never betrays the basic rule that the colour must come from the setting itself, and that it cannot be imposed.

BS The setting around Midge seems to be dominated by the colour yellow. Everything in her apartment is yellow, the wallpaper, her shirt, the stool …

DA Yes, the amount of yellow is almost sickening, I think! *(laughs)* Also, after Madeleine jumps into the bay in *Vertigo*, we see her at Scottie's apartment. He took off her dark suit and put her under this oppressive yellow blanket, covered all the way up to her neck. After she wakes up, he offers her a bright red robe and to sit by the fire. The colours in *Vertigo* are really playing the scene here. Scottie moves from the yellow category that Midge is in—yellow, this sort of non-sexual, friendly colour, to the red category of Madeleine. Come to think of it, if you are dating a girl in America, if you send her a yellow rose, it means you want to be her friend, if you send her a red rose, it basically signals her you want to get romantically involved *(laughs)* and isn't that exactly what Hitchcock is showing in the scene? At first, Madeleine is underneath a yellow blanket, then Scottie pulls out a red robe and says "I'd rather see you in this".

BS There is another scene in *Vertigo* where red is quite forceful: in the scenes at Ernie's Restaurant, the red walls behind Madeleine's profile are dominant. It almost creates a counter-weight to the green haze around Judy's profile in the hotel. I noticed in *Hitchcock 30*, that the film is almost symmetrical in time; the location of the red restaurant sequence is about as far into the movie in time as the hotel sequence is from the end. It seems Hitchcock wanted to emphasise the red-green, Madeleine-Judy duality.

DA I actually visited Ernie's. It looks exactly like it does in the movie … the red velvet walls … it was amazing! One of the things that I noticed when I did the Vertigo-tour in San Francisco, back when Ernie's was still around, was that even in the locations that were rebuilt in the studio down in Hollywood, there is almost zero difference between what he created and what exists. I am working on a book with a photographer at the moment on locations that Hitchcock used, and it's interesting that even he as a photographer would confuse what is location and what is studio. But Ernie's was just like that, it was old-school, that kind of Old San Francisco style. There used to be a chain of restaurants in the United States called the "San Francisco Steak House" that used the same colours: red dominant wallpaper, heavy curtains. For some reason, I'm not sure why, but they also had a girl on a swing, swinging over the patrons, in a very 19th century way. I don't know how it was possible with hygiene and spreading diseases to have a girl swinging over your food *(laughs)*.

I have to point out, sometimes the dialogue gives the clue; think about what Judy says right before they leave her hotel: "Do you want to go to Ernie's?" That could be translated into: Do you want to go to the red place where they serve these red, juicy steaks?

BS Red is a colour that Hitchcock seems to have used often for effect. The disturbing effect of red is an obvious choice for a director who is so keen on suspense, shock and horror, carrying notions of blood and alarm.

I found short flashes of red frames that Hitchcock liked to use throughout his career; at the end of *Rear Window*, when the murderer enters the room, Jeff, Jimmy Stewart's character, tries to blind him with the flash of his photography equipment, igniting a series of short, red colour frames. *Dial M for Murder* is a very red film, with a sequence of Grace Kelly's character against a red backdrop standing before a judge, as though she is in hell. In *Marnie*, the lead character has these recurring flashbacks, which are brief and always tinted in red.

DA In *Dial M for Murder*, Grace Kelly has that beautiful red dress that she wears.

BS Hitchcock's very first colour frame, I think, was red; it actually came before *Rope* in *Spellbound*, which was a black and white movie. In the end of the movie, when the gun turns towards the screen, after it fires, a couple of red frames were hand-coloured to intensify the shock.

DA Yes, though Hitchcock actually always made colour movies. Most of the silent films of his era were either hand painted or dyed to match time of day or to create an effect. His original version of *The Lodger* is a beautiful movie, and the tinting is pretty extraordinary. I was really impressed how colour was used, not only for indicating time of day but also for setting the mood. In the silent films, Hitchcock

would have definitely been involved in that. But colour for him was always something added for effect. Just as the way he considered sound.

BS *To Catch a Thief* is dominated by the colour blue. It's a rare instance of an optimistic, summer-blue in a Hitchcock movie, very relevant, I suppose, for a director, who was at the height of his art at the time.

DA Hitchcock himself described happiness as a "clear horizon", not a cloud in the blue sky. Interesting that, besides in *To Catch a Thief*, this image so rarely appears in his films. Think of all of the other skies that appear in his films: The scene where the agent Gromek is killed in *Torn Curtain*, the sky outside is sort of pale, white-washed blue. In *North by Northwest*, the scene in the cornfields, the sky has this almost oppressive, dusty blue as opposed to the Warner Bros. blue, the symbol of tranquillity and peace. I find it intriguing that his own personal colour reel, in which happiness is blue and the pastel colours associated with a blue and a spring day, versus a world of deceit, terror and anarchy that is darkness and white greys, with splashes of colour that come strictly from the inside of the characters, the former so rarely appears in his films.

BS Especially his later films, it seems, the older Hitchcock got, the more his films lost in colour. His themes became much darker too: *Torn Curtain, Topaz, Frenzy, Family Plot*—the colour palette becomes very subdued and deal with heavy subject matter, such as the Cold War and serial killers.

DA You have a much more subdued, almost pinkish colour range that occurred from *Torn Curtain* on. If I think about his later movies, I think almost only in red and black and white, the strong red of the Russian flag, against the black and white images in the beginning of *Topaz*.

BS Hitchcock was of the generation of filmmakers who were constantly confronted with new technology. He was first confronted with sound in 1929 with *Blackmail*, with colour in 1948 for *Rope*, then with 3D in 1954 for *Dial M for Murder*. It's interesting how a director responds when confronted with a new medium that opens up his or her choice of effects.

Hitchcock himself described happiness as a "clear horizon", not a cloud in the blue sky.

DA If you have access to *Hitchcock's Notebooks*, there is a long letter that Hitchcock's wrote to Sidney Bernstein about the struggle with form and content, what he was trying to do, and what the studios were trying to do. There is this sense that because television was still black and white, the saturated colours and the 3D-technique were deliberate attempts by Hitchcock's studios to catch the audience that was being lured away by television.

BS Yes, and some of his scenes really seem at first like crowd-pleasers, where Hitchcock wanted to stun the audience with Technicolor explosions that you couldn't create on a black and white TV-screen in those days. For example, the flower shop in *Vertigo* and the flower market scene in *To Catch a Thief*—another interesting parallel between the two movies—with those the colourful explosions of flowers!

DA They are always so beautiful, like a Monet explosion! If you think of the main characters in each of the scenes, however, they are dressed in grey or dark colours, it's the world around them that is full of colour. Especially Madeleine, wearing a grey suit walking through a cacophony of colour in the flower shop, or Cary Grant with a dark, striped shirt, or John Williams wearing a dark suit walking through an incredible bank of colours in the market. We never notice Scottie's colour, as he is wearing a brown suit most of the time. You almost have to wonder if Hitchcock is making a comment about the life of the characters versus the world that's going on around them. There is something Jungian about the spirits being dark in a world full of colour.

It seems to be that the central character, who is lost in his identity, like Scottie and Roger Thornhill, are people who are without colour. They are falling through the spectrum of colour, sometimes in a beautiful market; sometimes in the hues of the colour of the mind ... but for the most part, they are grey, without colour. They are surrounded by all these choices, and intensity, that they somehow cannot become a part of. In a way, having colour as a character, having these personal colours provides a real dynamic animus which they are lacking.

BS Why do you think the lead characters are grey?

DA It is much easier to build a strong connection to a grey person, it makes them readily identifiable and approachable for the audience. Suddenly I am Roger Thornhill in the cornfield, because the entire colour-palette I have projected on him is my own, and I am providing colour to the main character. If the character was connected with a strong colour pattern, only a certain kind of person will identify with that person. It's really magic how it happens.

BS The lead characters are being drawn into this Technicolor dream world like us, the audience, who are being drawn into the colourful dream world of films. Isn't this also a comment on the very essence of cinema?

DA You do get the sense that Hitchcock's move from black and white to colour is almost like Dorothy's move from Kansas to a more hyper-realistic world of Technicolor in *The Wizard of Oz*.

BS I had to think about the long sequence that leads up to the flower shop: Scottie tails Madeleine through the streets of San Francisco in his car—it's really us who are in the car, chasing Madeleine, being lured into the fantasy by Hitchcock like Scottie has been by Gavin Elster. The car's front window literally becomes the movie screen.

DA You mention the car: there is another scene where Midge is in the car with Scottie. It's the only time I felt she is in-

trusive and kind of rude. She brought him to the core of the story, to the sequence in the antique bookstore, where Hitchcock noticeably drives the lights down. Whatever colours we had are driven down to become almost black and white, and it becomes very hard to see. The next scene in the movie where we become almost blind because it's too dark to see is in the tower scene.

It is much easier to build a strong connection to a grey person, it makes them readily identifiable and approachable for the audience.

BS Do you think Hitchcock did it on purpose? What effect would he have tried to achieve?

DA I think he did it on purpose. If you think about it, both of those sequences are equal in effect in that what is being said sounds almost like an incantation. It's almost like Ovid or Homer telling us the story, the basic, primal story that we are dealing with here. Think about Scottie's primordial cry in the tower scene: "Why me? Why pick on me?" How many characters in literature have turned to the gods, or their wife or husband or lover and asked: Why me? Why is this happening to me? Why did I have to kill my father and marry my mother? *(laughs)* Why do I have to avenge my father who has been killed by his brother?—It really becomes the essence of existence. The answer Shakespeare tantalises us with in *Othello* is that there is no answer—the world just chooses, viciously, without any recognisable motive. It's the same in *Psycho*: Why her?—Who really knows? She definitely doesn't know. It certainly comes as a shock to her in the shower, in that moment of baptismal renewal when she realises she has been a bad person. Her remorse is shattered by this incoherent moment from the gods, protected only with a shower curtain. What kind of protection is that anyway, a shower curtain? It barely holds the water in! *(laughs)* It's not going to stop the wielding knives of the gods and fate.

BS Is Hitchcock still relevant today because his movies deal with universal themes?

DA Yes, Hitchcock is still relevant because, like the great storytellers of the past, he works in that primordial soup of anxieties and fears. He intuitively created new myths about the modern world. The real anxieties of identity. Think about how keenly observant that is in our times. You and I live in a world in which identity can be stolen, can be manipulated, can be canvassed for an audience, or reduced for our personal, private consumption. It is a plaything.

BS Do you think Hitchcock was being observant of the world around him, or was it also a personal issue for him?

DA If there is a lack of colour from the main characters' point in a world of colours, I think that also says something about his own personal life: I am the fat boy in the corner watching life go by—that's how he described himself to Truffaut. He was the quiet little boy who never participated, who always watched, and that sort of colourless position is the position he paints us in. Hitchcock's one smart marketing move was to be an introvert and make it publically so. So that all the other introverts of the world like you and me *(laughs)*, artists, are going to be so attracted to that like moths to a flame. Here is just another introvert, just like us, and he paints it in such a way that we can identify with.

When I was a young man, I just assumed that everyone had a very personal relationship with the writers and the filmmakers they enjoyed. That everyone couldn't wait to see another Hitchcock film or read another book by Isaac Asimov or Graham Green, all gods of my childhood. As I grew up, I realised that, for the most part, most people are totally unaware of the author of a creative work. It is so important for so many people like yourself and many others to identify the work with the artist. Because it is almost a life or death understanding—what is it of Hitchcock that remains in the movies? What is it that is yours? It is the profound answer the artist has to answer. The general public, however, will probably wonder why the hell are we talking about Hitchcock right now? *(laughs)* There is just a limited group of people who would be interested in discussing what we are discussing, because for them it's either going to be entertaining or it is not. Hitchcock, Poe, Dickens or Shakespeare—they were those few creatures who were able to passively entertain, who created something entertaining that is at the same time profound. Sometimes I wish that people could see Hitchcock's world of anxiety and loss of identity, and I wish I had my own way of articulating it. It's like what Grace Kelly says in *Rear Window*: "Tell me everything you know," *(laughs)*, "Tell me everything you saw and what you think it means". *(fades out)*

[1] "Hitchcock and Coleman had been cabled from the New York office: 'No execs like Vertigo and believe it handicap to selling and advertising picture … believe decidedly better title would be 'Face in the Shadow.' Hitchcock remained adamant: Vertigo was his preferred title." (Auiler, Dan. Vertigo: The Making of a Hitchcock Classic. St. Martin's Press, 2001. Page 113.)

[2] "Hitchcock changed strategies, conceiving of the scene so that the final transformation happens off-screen … giving the director the opportunity to realize her re-emergence in a single breath-taking shot. … After filming Scottie, they got on film three takes of what they had longed to see— the emerging Madeleine 'bathed in green'." (Auiler, Dan. Vertigo: The Making of a Hitchcock Classic. St. Martin's Press, 2001. Page 116–117.)

DAN AUILER Wenn man über Hitchcock und seine Farbgebung nachdenkt, sollte man bei seinem ersten Farbfilm beginnen, *Cocktail für eine Leiche*. In diesem Film wollte er ganz bestimmte Farbnuancen erzielen, der Hintergrund war für ihn sehr wichtig. Es mussten sogar ein paar Einstellungen nachgefilmt werden, weil die Farbe in den ersten Aufnahmen nicht auf Anhieb gelungen war. Bei Anruf Mord, seinem nächsten großen Farbfilm, begann er seine Experimente mit Farben weiterzuführen. Welchen Effekt konnte er mit Farbe erzielen? Welchen mit 3D? Wie konnte er mit Hilfe der Farbgebung die Schauspieler voneinander abheben? Es ist wie der Blick durch einen View-Master®, er erreichte mit den Farben eine Art Tiefenschärfe, die seine Filme visuell ganz einzigartig machten.

BENJAMIN SAMUEL *Cocktail für eine Leiche* ist ein gutes Beispiel. Bereits in seinem ersten Farbfilm bemerkt man, dass Hitchcock keine artifiziellen Farben anwenden wollte, da er schon damals einen Grund suchte, eine bestimmte Farbe auf der Leinwand zu zeigen. In *Cocktail für eine Leiche* verwendete er ein graues, gedämpftes Farbschema. Während es im Film immer später wird und der Abendhimmel langsam heranbricht, wird auch der gesamte Film dunkler. Zum Ende hin umhüllen abwechselnd rot-grün blinkende Farbtöne die Schauspieler. Dieses flackernde, rot-grüne Licht hebt sich auch deutlich in meiner Arbeit *Hitchcock 30* ab. Das Licht stammt von einer Neon-Reklame, die direkt vor dem Wohnungsfenster angebracht ist.

DA Du hast vollkommen Recht. Ab einem bestimmten Moment im Film wird das pulsierende Licht sehr dominant. Auch in *Vertigo* sitzt Judy in einem Hotelzimmer, eine Leuchtreklame vor ihrem Fenster badet sie in grüne Farbe. Hitchcock hatte eine Vorliebe für Grün, eine sehr effektvolle Farbe. Er setzte sie nicht nur dafür ein, um fast schon einen Schwarz-Weiß-Eindruck zu erzeugen, sondern auch um eine übernatürliche Wirkung zu erzielen, etwas, das von unbekannten Gefilden herrührt. Insbesondere Judys Profil im Fenster, die wie ein Geschöpf vom Mars und nicht wie ein Erdenbewohner aussieht.

Hitchcocks Art und Weise einen Film zusammenzustellen könnte man kontrapunktisch bezeichnen.

Ich finde es erstaunlich, wie konsequent Hitchcock die gleiche Strategie verwendete, die er schon in *Cocktail für eine Leiche* eingesetzt hatte, nämlich eine natürliche Lichtquelle vor einem Fenster zu platzieren, die er dafür nutzt, um den dramatischen Augenblick farbig zu untermalen. In *Cocktail für eine Leiche* bestand die Herausforderung darin, eine gewisse Dramatik aufzubauen, in einem Film, der dafür bekannt ist, wie in Echtzeit zu verlaufen. Um dies zu erreichen, bediente er sich auch der Farbe; in *Cocktail für eine Leiche* bricht der Abend heran und parallel zur Dämmerung und der subtilen Veränderung der Farben und des Lichts baut sich das Drama langsam auf. Hitchcocks Art und Weise einen Film zusammenzustellen könnte man kontrapunktisch bezeichnen. Während eine Person Treppen herunterläuft, spitzt sich die Spannung zu. Überleg mal, all die Treppen in seinen Filmen, herabsteigende Personen gehen immer mit einer Spannungssteigerung einher; der langsame Abstieg ist der Moment, in dem der Film mehr an Spannung gewinnt. Ich glaube, Hitchcock verfolgte eine ähnliche Strategie mit den Farben. Zuerst beginnt der Film in einer natürlichen Farbgebung, dann, während die Spannung sich langsam aufbaut, bewegen wir uns in einen neuen Farbbereich. Zum Beispiel durchläuft *Vertigo* ein großangelegtes Farbspektrum, den Höhepunkt bildet die dunkel anmutende, finale Kirchturm-Sequenz.

BS Zitiert Hitchcock mit der grünen Hotelzimmer-Szene in *Vertigo* sich nicht selber? Es gibt eine ähnliche Sequenz in *Über den Dächern von Nizza*. In dieser Szene unterhalten, küssen und umarmen sich John Robie und Frances Stevens, die Kelly / Grant-Charaktere. Sie befinden sich in einem Hotelzimmer an der französischen Riviera. Diese Sequenz wurde von Hitchcock auch grün ausgeleuchtet, um eine Nachtwirkung zu erzielen. Scotties Verlust von Madeleine in *Vertigo* spiegelt hier offensichtlich auch Hitchcocks Verlust seiner Hauptdarstellerin Grace Kelly wider, die kurz nach Erscheinen von *Über den Dächern von Nizza* zur Fürstin Gracia Patricia wurde.

Übrigens, als ich ihr Buch über *Vertigo* gelesen habe, hatte ich einen Geistesblitz, der Hotelzimmer-Sequenz in *Vertigo* und der Farbe Grün betreffend. In Ihrem Buch geben Sie zuerst die Diskussion zwischen Hitchcock und seinen Filmproduzenten wieder, die sich über den Filmtitel stritten. Hitchcock bevorzugte den Titel „Vertigo", die Filmproduzenten den Titel „Face in the Shadow"[1]. Hitchcock war unnachgiebig und setzte sich letztendlich mit seiner Wahl durch. Direkt nach Schilderung dieser Diskussion gehen Sie auf die Hotelzimmer-Sequenz[2] und Hitchcocks Vision des grünen Nebeleffekts ein. Als ich Ihr Buch gelesen habe, befand ich mich im Restaurant la Boule D'or in Brüssel. Vielleicht lag es daran, dass ich mich in einer französischsprechenden Umgebung befand, als mir plötzlich auffiel, dass Hitchcock sich sogar im Titel auf die Farbe Grün bezog: Das französische Wort für Grün ist vert! Hitchcocks Entschlossenheit, was die Wahl des Titels betraf, seine Vision des grünen Nebels, sowie die Tatsache, dass das Drehbuch auf einem französischen Roman basierte, sind sicher keine Zufälle. Grün ist die dominierende Farbe in *Vertigo*.

DA Das gefällt mir! Das ist mir noch nie aufgefallen. Auch in Spanisch heißt Grün verde. David Dodge, der das Buch, auf dem das Drehbuch von *Über den Dächern von Nizza* basiert, schrieb ein anderes Buch mit dem Titel „So grün war mein Vater", eine Komödie über die Eifersucht seines Vaters. In Mexiko gibt es den Ausdruck „qué verde mi papa", was übersetzt so viel bedeutet wie „wie eifersüchtig doch mein Vater ist". Grün symbolisiert häufig Eifersucht. In Shakespeares Othello beschreibt Jago die Eifersucht als „grünäugiges Monster".

BS Sie glauben aber nicht, dass Hitchcock Grün als Symbol für die Eifersucht verwendete?

DA Als Filmkritiker und Historiker ist es wichtig, sich einzugestehen, dass man es mit Sicherheit nicht wissen kann, welche Absicht Hitchcock verfolgte. Autobiographisch gibt es jedoch mehrere Hinweise, dass der grüne Nebel von einer Aufführung des Theaterstückes *Mary Rose* von J.M. Barrie stammt, die Hitchcock als junger Mann in London sah. Hitchcocks Verhältnis zur Farbe Grün ist mystischer Art und entspringt der tiefen Verbindung zu *Mary Rose*. Das Grün, das Scottie sieht, rührt aus einer übernatürlichen Welt heraus. Hitchcocks Zugang zu Himmel und Hölle war wohl sehr katholisch inspiriert, an den Glauben an eine andere Realität von unserer eigenen Welt getrennt. Chris Marker sah das Grün aus *Vertigo* als ein Symbol für die Ewigkeit. Scottie sagt in der Waldszene zu Madeleine: „Das sind sogenannte Sequoia sempervirens – immergrün, ewig lebend." Also für Scottie ist alles, was unsterblich ist, grün. Das gleiche gilt für Judy / Madeleine in der Hotelzimmer-Sequenz, sie schreitet aus ihrer grauen Welt in dieses grüne Licht, das sie zurück in das ewige Leben bringt.

Was Hitchcock, Shakespeare oder Picasso – nimm ein Genie deiner Wahl – so außergewöhnlich macht, ist, dass egal welchen Aspekt man betrachtet, dieser unendlich sinnreich sein kann. In Shakespeares *Das Wintermärchen* gibt es den starken Wunsch des Liebhabers seine verlorene Liebe wieder zum Leben erwecken zu können. Auch in *Gilgamesch* gibt es diesen außergewöhnlichen, bewegenden Moment, in dem Gilgamesch kurzzeitig in der Lage ist, seinen vor vielen Jahren verstorbenen Freund wieder zum Leben zu erwecken. Dieses unglaubliche Gefühl der Sehnsucht und des Verlustes verdichtet sich in diesem einzigen Moment. Du kannst die Farben herausziehen, du kannst die Themen herausziehen, die Symbole oder Charaktere, alles wird zu einem großartigen Wunder Freud'schen oder Jung'schen Potentials.

Ein weiterer, wichtiger Moment in *Vertigo* ist die Szene mit den sattarmen Farben an der Golden Gate Bridge. Hitchcock benutzte hier einen Nebel-Filter, um die Atmosphäre eines Traumes subtil nachzuempfinden. San Francisco ist in Wirklichkeit häufig so neblig wie im Film, die Golden Gate Bridge wird oft durch einen Dunstschleier gesehen. Das gleiche gilt für die Kapelle der Mission Dolores. Wenn du den Ort besuchst, hüllt das Sonnenlicht, das von den weißen Putzwänden der Kapelle reflektiert wird, die Umgebung in ein weiß-blaues Licht, genauso wie im Film. Es ist erstaunlich, wie ähnlich der realistische Eindruck der Mission Dolores ist im Vergleich zu dem, was Hitchcock in *Vertigo* auf der Leinwand zeigt, obwohl er einen speziellen Filter einsetzen musste. Wieder ist es eine natürliche Lichtquelle, die Hitchcock einsetzte, anstatt einen artifiziellen Effekt auf die Szene überzustülpen. Ich vermute, dasselbe gilt in der erwähnten Abend-Sequenz in *Über den Dächern von Nizza*. Ich war noch nie in Cannes, aber im Hafen von San Diego ergibt sich ein ähnliches Phänomen, denn die Nähe zum Ozean färbt die Promenade lindgrün. Mir ist der Grünschleier in *Über den Dächern von Nizza* nie aufgefallen, vielleicht weil er mir aus San Diego oder La Jolla so vertraut ist. Farben sind in Hitchcocks Filmen in der Tat sorgfältig durchdacht, er verletzt jedoch nie die Grundregel die Farbe der Szene aus der Umgebung zu entnehmen.

BS Die ganze Umgebung um Midge in *Vertigo* scheint durch die Farbe Gelb dominiert. Alles, was sich in ihrer Wohnung befindet ist gelb: Die Wände, ihre Bluse, der Stuhl …

DA Ja, die Fülle an Gelb in Midges Wohnung ist fast schon ekelerregend! *(lacht)* Auch nachdem Madeleine am Rande der San Francisco Bay sich ins Wasser fallen lässt, sehen wir sie kurze Zeit später in Scotties Wohnung wieder. Er hatte ihr durchnässtes, indigoblaues Kleid ausgezogen und sie mit einer beklemmenden, gelben Decke zugedeckt, die sie bis zum Hals einhüllt. Nachdem sie aufwacht, reicht er ihr einen roten Morgenmantel und bietet ihr an, sich an das wärmende Kaminfeuer zu begeben. Die Farben in *Vertigo* bestimmen maßgeblich das Szenario. Scottie bewegt sich weg von der gelben Anmutung Midges, dieser asexuellen, freundlichen Farbenwelt, in die leidenschaftliche, rote Welt Madeleines. Wenn ich so darüber nachdenke: Wenn du mit einem Mädchen in Amerika ausgehst und ihr eine gelbe Rose schenkst, bedeutet es, dass du mit ihr befreundet sein möchtest: Wenn du ihr eine rote Rose überreichst, signalisierst du ihr, dass du mit ihr eine Beziehung eingehen möchtest *(lacht)*. Ist es nicht genau das, was Hitchcock mit dieser Szene zeigen möchte? Zunächst liegt Madeleine unter einer gelben Decke, dann bietet Scottie ihr einen roten Morgenmantel an und sagt sinngemäß: „Hier, ich möchte dich lieber darin sehen."

BS Es gibt noch eine andere rote Szene in *Vertigo*. In Ernie's Restaurant sind die roten Wände extrem dominant. Diese Szene, in der die Hauptdarstellerin zum ersten Mal im Profil vor der samt-roten Tapete gezeigt wird, erzeugt in gewisser Weise ein Gegenpol zur Hotel-Szene mit dem grünen Schimmer, das das Profil von Judy rahmt. In meiner Arbeit *Hitchcock 30* sieht man sehr deutlich, dass der Film zeitlich fast schon symmetrisch gegliedert ist. Die rote Sequenz in Ernie's Restaurant ist ungefähr so weit vom Anfang des Films entfernt wie die grüne Sequenz vom Ende. Hitchcock wollte wohl die rot-grüne, Judy-Madeleine Dualität hervorheben.

DA Ich habe Ernie's Restaurant noch besucht. Es sah genauso aus wie im Film … die roten Samtwände … es war unglaublich! Als ich zum ersten Mal die Vertigo-Tour in San Francisco unternahm, damals, als es Ernie's noch gab, fiel mir gleich auf, dass selbst bei den Orten, die im Studio nachgebaut wurden, so gut wie kein Unterschied zur Realität bestand. Ich arbeite gerade an einem Buch mit einem Fotografen über Standorte, die Hitchcock in seinen Filmen verwendet hat. Es ist interessant, dass sogar er als Fotograf manchmal verwirrt ist, ob es sich bei Hitchcocks Szenen um Studio- oder Außenaufnahmen handelt. Ernie's sah genauso aus wie im Film. Das Restaurant war in diesem alten, San Francisco-Stil eingerichtet. Früher gab es eine Kette von Restaurants in den USA, die „San Francisco Steak House" hießen, die genau so eingerichtet waren: Rote Samtwände und schwere Vorhänge. Aus irgendeinem mir unerklärlichen Grund gab es in diesen Restaurants Mädchen, die auf einer Schaukel, wie im 19. Jahrhundert, über den Köpfen der Gäste hin und her schaukelten. Wie sich das mit den Hygienevorschriften vereinbaren ließ – kann man sich heute schwer vorstellen *(lacht)*. Manchmal gibt der Dialog im Film Aufschluss; was sagt Judy zu Scottie, bevor sie das Hotel verlassen: „Wollen wir zu Ernie's gehen?" Das kann direkt übersetzt werden in: Möchtest du zu diesem roten

Ort gehen, wo sie diese roten, saftigen Steaks servieren?

BS Rot ist eine Farbe, die Hitchcock häufig verwendete, um eine bestimmte Wirkung zu erzielen. Die Vorliebe für die Signalfarbe Rot, mit der man Blut und Alarm assoziiert, scheint für einen Regisseur, der als Meister der Spannung berühmt ist, wohl auf der Hand zu liegen.

Ich fand viele Bespiele roter Blitze, die Hitchcock im Laufe seiner Karriere verwendet hat. Am Ende von *Fenster zum Hof* gibt es die berühmte Szene, in der Jimmy Stewarts Charakter den Mörder mit Blitzen seines Fotoapparates zu blenden versucht. Jedes Foto, das er schießt, löst einen kurzen, rot-farbigen Blitz hervor. In *Bei Anruf Mord* gibt es die Szene, in der Grace Kelly vor einem roten Hintergrund steht, als ob sie sich in der Hölle befindet. In *Marnie* leidet die Hauptdarstellerin wiederholt an Flashbacks, die sehr kurz und immer rot eingefärbt sind.

DA In *Bei Anruf Mord* trägt Grace Kelly dieses wunderschöne, rote Kleid ...

BS Ich glaube, Hitchcocks erstes farbiges Standbild war rot. Es kam noch vor *Cocktail für eine Leiche* in *Ich kämpfe um dich*, der natürlich in Schwarz-Weiß gedreht wurde. Am Ende des Films, wenn die Pistole langsam auf den Zuschauer zielt, wurden rote, handgefärbte Standbilder hineingeschnitten, um den Schock zu intensivieren.

Hitchcock definierte das Glück als „klaren Horizont", keine Wolke am blauen Himmel.

DA Das ist richtig, so gesehen hat Hitchcock schon immer Farbfilme gedreht. Die meisten der Stummfilme seiner Zeit wurden von Hand gefärbt, um eine bestimmte Tageszeit zu simulieren oder einen Effekt zu erzielen. Seine ursprüngliche Fassung von *Der Mieter* ist ein wunderschöner Film, die Farbtönung ist wirklich außergewöhnlich. Ich war wirklich beeindruckt, wie er die Farben verwendet hat, nicht nur um die Tageszeit zu bestimmen, sondern auch die Stimmung zu steuern. In der Stummfilmära war Hitchcock als Regisseur mit Sicherheit an der Auswahl der Farbtönung beteiligt. Farbe bedeutete für Hitchcock einen Effekt – ähnlich hat er es mit der Tonspur gehandhabt.

BS In dem Film *Über den Dächern von Nizza* dominiert die Farbe Blau. Das tiefe Azurblau der Côte d'Azur ist ein seltenes Beispiel eines optimistischen, sommerlichen Blautons in einem Hitchcock Film. Die Farbpracht des Films scheint relevant zu sein, für einen Regisseur, der sich auf der Höhe seiner Karriere befand.

DA Hitchcock definierte das Glück als „klaren Horizont", keine Wolke am blauen Himmel. Es ist in der Tat interessant, dass neben *Über den Dächern von Nizza* dieses Bild nur selten in seinen Filmen vorkommt. Denk an all die anderen Himmel, die er in seinen Filmen zeigt: Zum Beispiel die

Szene in *Der Zerrissene Vorhang*, in der der Agent Gromek getötet wird. Der Himmel vor dem Fenster hat ein blassweiß-getünchtes Blau. In der staubigen Kornfeld-Szene in *Der unsichtbare Dritte* wirkt der Himmel bedrückend, eingefärbt in ein stumpfes Blau, im Gegensatz zum glückbringenden Blau der Warner Bros. Filme, das Symbol der Ruhe und des Friedens.

In Hitchcocks persönlichem Farbspektrum ist die Welt der Täuschung, des Terrors, der Finsternis und der Anarchie grau, mit Farbspritzern durchsetzt, die aus den Tiefen des Unterbewusstseins der Charaktere entspringen, während das Glück blau ist, gepaart mit den Pastellfarben eines Frühlingstages. Ich finde es faszinierend, dass Letzteres in seinen Filmen nur sehr selten vorkommt.

BS Insbesondere in seinen letzten Filmen. Es scheint, je älter Hitchcock wurde, desto eher haben seine Filme an Farbe verloren und umso dunkler wurden seine Themen: *Der zerrissene Vorhang*, *Topas*, *Frenzy* und *Familiengrab* – die Farbpalette wurde dumpfer, die Filme befassten sich mit schweren Themen wie dem Kalten Krieg oder Serienmördern.

DA Die Farben seiner letzten Filme sind definitiv gedämpfter. Ab dem Film *Der zerrissene Vorhang* wird die Tönung fast schon rosafarben. Wenn ich an seine letzten Filme denke, kommt mir sofort Rot und Schwarz-Weiß in Erinnerung; das dominierende Rot der russischen Flagge vor dem schwarzweißen Hintergrund in der Eröffnungsszene in *Topas*.

BS Hitchcock gehörte einer Generation von Filmemachern an, die ständig mit der Erfindung neuer Technologien herausgefordert wurden. Hitchcock selber wurde 1929 mit seinem Film Erpressung mit der Tontechnik konfrontiert, 1948 mit dem Farbfilm in *Cocktail für eine Leiche* und schließlich mit der 3D-Technik im Jahre 1954 in *Bei Anruf Mord*. Es ist sehr interessant zu untersuchen, wie ein Regisseur wie Hitchcock mit den neuen Techniken umzugehen lernte.

DA In meinem Buch *Hitchcock's Notebooks* ist ein Brief abgebildet, den Hitchcock an den Medien-Mogul Sidney Bernstein schrieb. Darin schilderte Hitchcock seinen Streit mit den Filmstudios um die Form und den Inhalt seiner Filme. Da das Fernsehen seiner Zeit noch immer schwarzweiß war, lag die Besonderheit des Kinos in den satten Farben und der 3D-Technik. Hitchcocks Filmstudios verfolgten mit Absicht die Strategie, das Publikum mit neuen Techniken vom Fernseher wegzulocken.

BS Ja, einige seiner Szenen scheinen richtige Publikumsmagnete gewesen zu sein, in denen Hitchcock das Publikum mit regelrechten Farbexplosionen ins Staunen brachte, damit konnte das Schwarzweißfernsehen nicht konkurrieren. Zum Beispiel das Blumengeschäft in *Vertigo* und die Blumenmarkt-Szene in *Über den Dächern von Nizza* – wiederum eine andere interessante Parallele der beiden Filme, die Augenblicke farbenreicher Blumenpracht.

DA Diese Farbenfluten sind immer so wundervoll, wie Gemälde von Monet! Die Hauptpersonen in den jeweiligen Szenen sind allerdings eher in Grau oder gar in dunklen Farben gekleidet, es ist die Welt um sie herum, die bunt ist. Madeleine trägt in *Vertigo* ein hellgraues Kostüm, während

sie im Blumengeschäft durch die bunten Farben wandelt, Cary Grand trägt einen dunklen Streifenpulli und John Williams einen dunklen Anzug in *Über den Dächern von Nizza*, als sie durch den farbenfrohen Markt laufen. Scotties Farben nehmen wir nicht wahr, die meiste Zeit trägt er einen braunen Anzug. Man muss sich fragen, welchen Kommentar sich Hitchcock über das Leben seiner Charaktere und ihrer Umwelt erlaubte? Es hat etwas mit der Ansichtsweise Jung's zu tun, ein dunkler Geist in einer bunten Welt zu sein.

Die Hauptcharaktere, wie Scottie oder Roger Thornhills, scheinen ihre Identität verloren zu haben, daher sind sie fast farblos. Sie wandern durch das Spektrum der Farben, manchmal auf einem wunderschönen Blumenmarkt, manchmal in der Färbung ihres Gemüts, aber die meiste Zeit sind sie auf der Leinwand grau. Sie sind vielen Verlockungen ausgesetzt und können diese dennoch nicht erreichen. Denn ein farbenfroher Charakter ist kennzeichnend für einen dynamischen Animus, der ihnen gänzlich abhandengekommen ist.

BS Warum meinen Sie, dass die Hauptcharaktere grau sind?

DA Es ist viel leichter für das Publikum sich mit einer grauen Person zu identifizieren, dadurch ist sie zugänglicher. Plötzlich schlüpfe ich als Zuschauer in die Rolle Roger Thornhills im Kornfeld, weil die gesamte Farbpalette, die ich auf ihn projiziert habe, meiner eigenen entspricht. Ich fülle seine fehlenden Farben selber aus. Wird die Hauptperson zu Beginn an eine starke Farbgebung geknüpft, spricht dies nur bestimmte Personen an. Es grenzt fast schon an Zauberei, wie das funktioniert.

Es ist viel leichter für das Publikum sich mit einer grauen Person zu identifizieren, dadurch ist sie zugänglicher.

BS Die Hauptcharaktere werden in die zauberhafte Welt des Technicolors katapultiert, wie auch wir, als Zuschauer, in die Traumwelt des Films gesogen werden. Ist das nicht auch ein Kommentar über die Essenz des Kinos an sich?

DA Ja, man hat das Gefühl, dass Hitchcocks Wechsel von Schwarz-Weiß in die Welt der Farben fast wie Dorothys Weg von Kansas in die hyper-realistische Welt des Technicolors in *Der Zauberer von Oz* ist.

BS Es gibt diese faszinierende Szene in *Vertigo*, die lange Sequenz, in der Scottie in seinem Auto, Madeleine, in ihrem grünen Jaguar, durch die Straßen von San Francisco verfolgt, die mit der Farbenexplosion im Blumengeschäft ihren Höhepunkt findet. Es ist so, als ob wir selbst das Auto steuern und Madeleine verfolgen. Wir werden von Hitchcock in eine Phantasiewelt gelockt, genauso wie Scottie von Gavin Elster. Die Windschutzscheibe wird quasi zur Leinwand.

DA Du erwähnst das Auto, da gibt es noch eine andere Szene, in der Midge und Scottie im Auto sitzen. Es ist der einzige Moment im Film, in dem sie aufdringlich und barsch wird. Sie führte ihn bis zum Kern des Rätsels in der Sequenz im Antiquariat, wo Hitchcock die Lichter bemerkbar herunterdimmte. Fast alle Farben wurden auf Schwarz reduziert, bis hin zur Unkenntlichkeit. Die nächste ähnliche Szene, in der man fast nichts sieht, ist die Turmsequenz, wo alles rabenschwarz wird.

BS Meinen Sie Hitchcock machte es absichtlich? Was wollte er damit bezwecken?

DA Ich glaube, er machte es absichtlich. Beide Sequenzen sind in ihrer Wirkung gleich, die gesprochenen Wörter klingen fast wie eine Heraufbeschwörung. Es ist fast so, als ob uns ein Ovid oder Homer diese Ur-Geschichte erzählt. Nimm Scotties primitiven Ur-Schrei in der Turmsequenz: „Warum ich? Warum passiert das ausgerechnet mir?" Wie viele Helden der Literaturgeschichte haben sich aus Verzweiflung an die Götter, ihre Frauen, Männer oder Liebhaber gewandt und aus der Not heraus lamentiert: „Warum passiert das gerade mir? Warum?" „Warum musste ich ausgerechnet meinen Vater töten und meine Mutter heiraten? Warum?" *(lacht)* „Warum muss ich meinen Vater rächen, der von seinem Bruder getötet wurde? Warum nur?" Es wird zur Existenzfrage. Shakespeare quält uns in *Othello* mit der Schlussfolgerung, dass es keine Antwort auf diese Fragen gibt. Das Schicksal wählt einfach aus, unmoralisch, ohne jeglichen Grund. Es ist das Gleiche in *Psycho*: „Warum sie? Warum ausgerechnet sie?" Wer weiß das schon? Sie wusste es bestimmt nicht, als es sie schockartig in der Dusche überkam, in diesem heiligen Moment der erfrischenden Taufe, just in dem Moment, in dem sie erkannte, dass sie eine schlechte Person war. Ihre Reue wird in diesem wirren Moment von den Göttern zerschmettert, nur durch einen spärlichen Duschvorhang geschützt. Was ist das nur für ein Schutz, ein Duschvorhang? Er hält ja kaum das Wasser in der Dusche auf. *(lacht)* Wie soll der Vorhang vor den wetzenden Messern der Götter und des Schicksals schützen?

BS Bedeutet das, dass Hitchcock heute noch zeitgemäß ist, weil er sich mit universellen Themen beschäftigt hat?

DA Ja, Hitchcock hat nichts an Relevanz verloren, weil er, wie die großen Geschichtenerzähler der Vergangenheit, in der Ur-Suppe der Ängste und der Sorgen rührte. Intuitiv hat er neue Mythen der modernen Welt geschaffen, die wahren Ängste unserer Identität. Überleg mal wie scharfsinnig diese Beobachtung ist; wir leben in einer Welt, in der Identitäten gestohlen oder manipuliert werden können, in der sie für ein Publikum auf eine Leinwand gebannt oder so weit zerkleinert werden, dass man sie häppchenweise konsumieren kann. Identitäten sind zum Spielzeug geworden.

BS Meinen Sie, Hitchcock schuf dadurch ein Abbild seiner Umwelt, oder entsprangen diese Themen seiner Filme auch aus der eigenen, persönlichen Erfahrung des Regisseurs?

DA Wenn die grauen, farblosen Hauptcharaktere in seinen Filmen in einer bunten Welt wandeln, dann sagt es auch etwas über sein eigenes Leben aus: „Ich bin der fette Junge, der in der Ecke sitzt und beobachte das Leben, wie es an

69

mir vorübergeht", so beschrieb sich Hitchcock selber gegenüber Truffaut. Er war der kleine, ruhige Junge, der nie mitmachte, der fortwährend zuschaute und es ist diese farblose Position, in die Hitchcock das Publikum führt. Hitchcocks geniale Marketingstrategie war es, introvertiert zu sein, und dies öffentlich zu bekunden. Somit konnten alle introvertierten Menschen auf dieser Welt, wie Du und ich *(lacht)* von dieser Idee angezogen werden, wie Motten vom Licht.

Als ich ein junger Mann war, dachte ich immer, jeder hätte ein persönliches Verhältnis zu den Autoren, die er gerne hat. Dass es jeder kaum erwarten könne einen neuen Hitchcock Film zu sehen oder ein neu erschienenes Buch von Isaac Asimov oder Graham Green zu lesen, alles Helden meiner Kindheit. Als ich heranwuchs stellte ich fest, dass sich nur wenige Leute der kreativen Arbeit eines Autors wirklich bewusst sind. Es ist aber enorm wichtig, eine fast lebensnotwendige Aufgabe die Kunst mit seinem Erschaffer in Bezug zu bringen. Was verbleibt von Hitchcock in seinen Filmen? Was verbleibt von uns? Es ist diese tiefgründige Frage, die ein Künstler beantworten muss. Die Allgemeinheit würde sich allerdings sehr darüber wundern, warum wir uns zum Teufel gerade jetzt über Hitchcock unterhalten *(lacht)*. Es gibt ja leider nur eine begrenzte Gruppe von Menschen, die an unserer Diskussion überhaupt interessiert sind, denn für sie ist ein Film entweder unterhaltsam, oder nicht. Hitchcock, Poe, Dickens oder Shakespeare – waren diese seltenen Geschöpfe, die etwas Unterhaltsames erschaffen konnten, das gleichzeitig tiefgründig war. Manchmal wünschte ich, mehr Menschen könnten durch Hitchcocks Augen die Welt der Ängste und der Identitätskrisen sehen und ich wünschte auch, ich hätte Wege, das besser zu kommunizieren. Es ist fast so, wie es Grace Kelly in *Fenster zum Hof* sagte: „Sag mir alles, was du weißt" *(lacht)*, "sag mir alles, was du gesehen hast und meinst, was es bedeutet."
(Abblende)

[1] „Hitchcock and Coleman had been cabled from the New York office: 'No execs like Vertigo and believe it handicap to selling and advertising picture … believe decidedly better title would be 'Face in the Shadow.' Hitchcock remained adamant: Vertigo was his preferred title." (Auiler, Dan. Vertigo: The Making of a Hitchcock Classic. St. Martin's Press, 2001. Seite 113.)

[2] „Hitchcock changed strategies, conceiving of the scene so that the final transformation happens off-screen … giving the director the opportunity to realize her re-emergence in a single breathtaking shot. … After filming Scottie, they got on film three takes of what they had longed to see— the emerging Madeleine 'bathed in green'." (Auiler, Dan. Vertigo: The Making of a Hitchcock Classic. St. Martin's Press, 2001. Seite 116-117.)

ASTERIX

34

TINTIN

23

ASTERIX
34

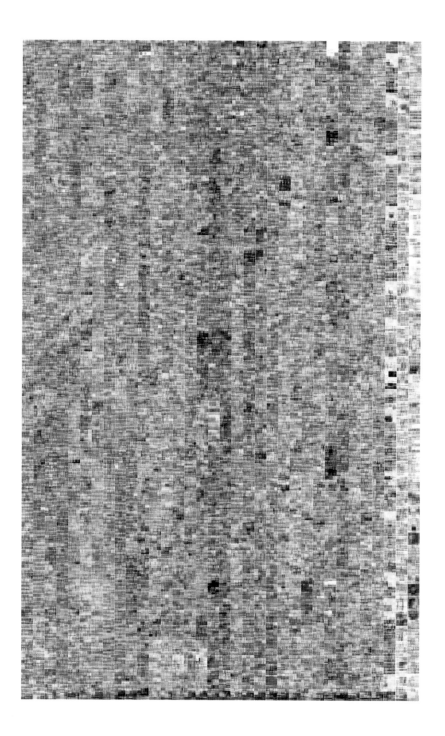

Asterix 34
2015, double duraclear transparencies in lightbox, 168 × 105 cm

TINTIN
23

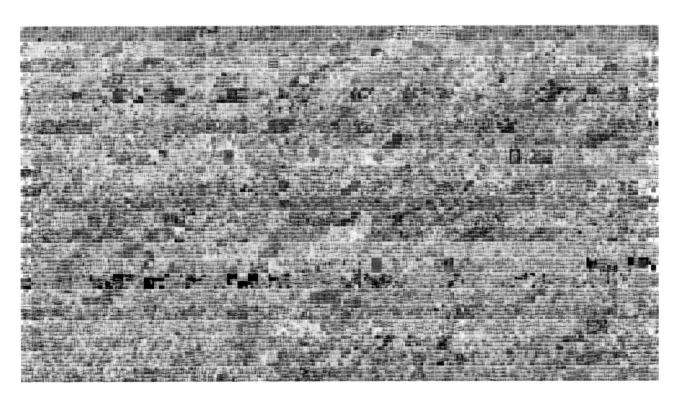

Tintin 23
2015, double duraclear transparencies in lightbox, 97 × 180 cm

Comics Used
Verwendete Comics

The 34 Asterix Volumes
Die 34 Asterix-Bände

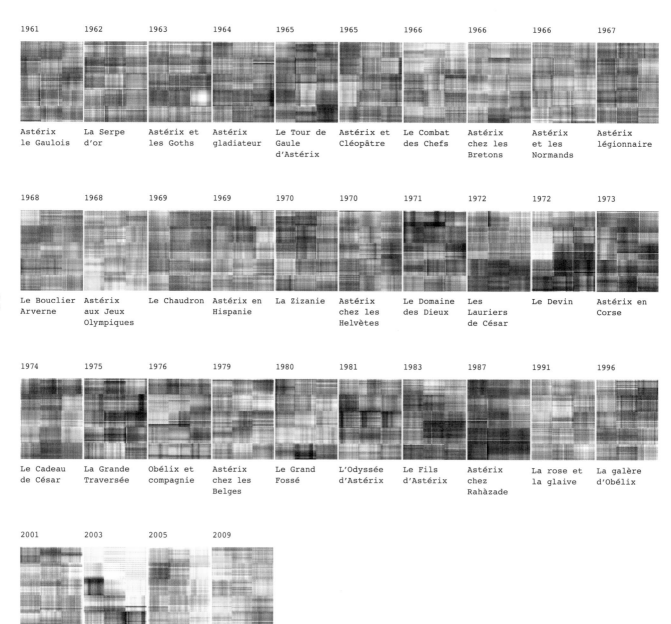

1961 — Astérix le Gaulois
1962 — La Serpe d'or
1963 — Astérix et les Goths
1964 — Astérix gladiateur
1965 — Le Tour de Gaule d'Astérix
1965 — Astérix et Cléopâtre
1966 — Le Combat des Chefs
1966 — Astérix chez les Bretons
1966 — Astérix et les Normands
1967 — Astérix légionnaire

1968 — Le Bouclier Arverne
1968 — Astérix aux Jeux Olympiques
1969 — Le Chaudron
1969 — Astérix en Hispanie
1970 — La Zizanie
1970 — Astérix chez les Helvètes
1971 — Le Domaine des Dieux
1972 — Les Lauriers de César
1972 — Le Devin
1973 — Astérix en Corse

1974 — Le Cadeau de César
1975 — La Grande Traversée
1976 — Obélix et compagnie
1979 — Astérix chez les Belges
1980 — Le Grand Fossé
1981 — L'Odyssée d'Astérix
1983 — Le Fils d'Astérix
1987 — Astérix chez Rahàzade
1991 — La rose et la glaive
1996 — La galère d'Obélix

2001 — Astérix et Latraviata
2003 — Astérix et la rentrée gauloise
2005 — Le ciel lui tombe sur la tête
2009 — L'anniversaire d'Astérix et Obélix

The dataset for this work is based on the 34 *Asterix* volumes by René Goscinny and Albert Uderzo, a total of 1,474 comic book pages.

Die Datengrundlage dieser Arbeit basiert auf den 34 *Asterix*-Bänden von René Goscinny und Albert Uderzo, insgesamt 1.474 Comicbuchseiten.

The 23 Tintin Volumes
Die 23 Tintin-Bände

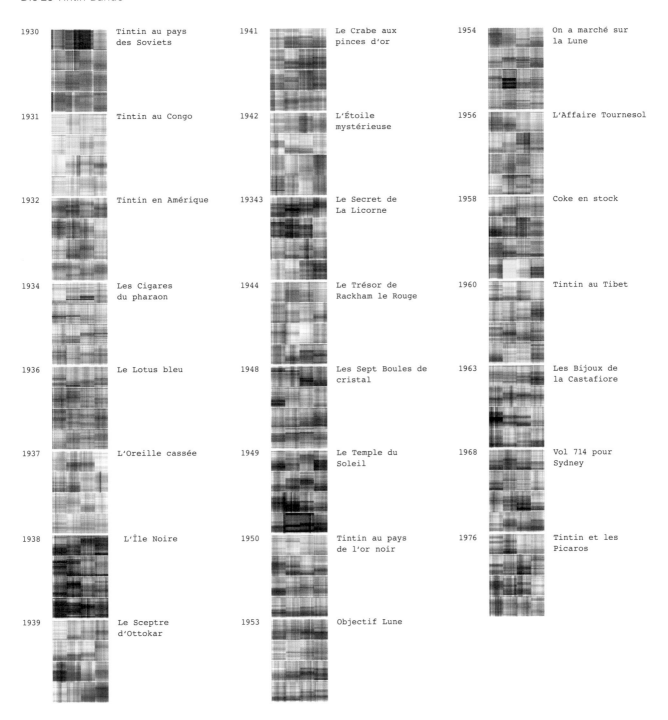

1930	Tintin au pays des Soviets	1941	Le Crabe aux pinces d'or	1954	On a marché sur la Lune
1931	Tintin au Congo	1942	L'Étoile mystérieuse	1956	L'Affaire Tournesol
1932	Tintin en Amérique	19343	Le Secret de La Licorne	1958	Coke en stock
1934	Les Cigares du pharaon	1944	Le Trésor de Rackham le Rouge	1960	Tintin au Tibet
1936	Le Lotus bleu	1948	Les Sept Boules de cristal	1963	Les Bijoux de la Castafiore
1937	L'Oreille cassée	1949	Le Temple du Soleil	1968	Vol 714 pour Sydney
1938	L'Île Noire	1950	Tintin au pays de l'or noir	1976	Tintin et les Picaros
1939	Le Sceptre d'Ottokar	1953	Objectif Lune		

The dataset for this work is based on the 23 *Tintin* volumes by Hergé, a total of 1,422 comic book pages.

Die Datengrundlage dieser Arbeit basiert auf den 23 *Tintin*-Bänden von Hergé, insgesamt 1.422 Comicbuchseiten.

An interview with
translator Anthea Bell

TRANSLATION AS ART, July 2015 ART AS TRANSLATION

Ein Interview mit der
Übersetzerin Anthea Bell

KUNST DER ÜBERSETZUNG, Juli 2015 ÜBERSETZUNG DER KUNST

Anthea Bell OBE is a British translator. She has translated novels, Zweig, Kafka and Freud, children's books, and comics from French, German and Danish into English, including several French and Belgian bandes dessinées (BD), most notably *Astérix*. Her puns in *Astérix* are famous for keeping the original French humour while introducing the brave Gaul to the English-speaking world. She believes to have inherited her talent for wordplay from her father, Adrian Bell, the first compiler of *The Times* cryptic crossword puzzle. In addition to numerous awards for her work, she received an Order of the British Empire in recognition of her "services to literature and literary translations".

Anthea Bell OBE ist eine britische Übersetzerin. Sie übersetzte Romane, Werke von Zweig, Kafka und Freud, Kinder- und Comicbücher, die sie aus dem Französischen, Deutschen und Dänischen ins Englische übersetzte. Sie arbeitete an einigen französischen und belgischen bandes dessinées (BD), am berühmtesten ist ihre Übersetzung von *Asterix*. Ihr sensibles Einfühlungsvermögen und die Bewahrung des französischen Humors ist legendär, sanft brachte sie den gallischen Helden der englischsprechenden Leserschaft näher. Sie glaubt ihr Vater, Adrian Bell, habe ihr das Talent des Wortspieles vererbt, der als erster Verfasser des kryptischen Kreuzworträtsels der *Times* bekannt ist. Zusätzlich zu ihren zahlreichen Auszeichnungen erhielt sie ein Order of the British Empire (OBE) in Anerkennung ihrer Dienste an der Literatur und ihren literarischen Übersetzungen.

BENJAMIN SAMUEL How did the illustrations in *Astérix* influence your work as a translator? Comics are visual and the puns need to not only work on the level of the text, but also correspond to the images on the page. Since in my own work, my "translation process" focusses solely on the visual layer, dealing with colour and shapes, I would like to hear how the images determine your work as a translator.

ANTHEA BELL It's interesting that you are keen on the visual side; I am, perhaps naturally, much more of a verbal person. But of course, where wordplay is concerned, literal translation is impossible if it is to capture the spirit of the matter, so it is a case of reinventing it most of the time. One must suit the expression on the characters' faces, the wording must arise from similar plot developments, and the constraints of length imposed by the size of the original speech bubbles are all important factors in every joke or replacement joke. The text … the words come first, although in spirit rather than the letter, in the case of wordplay and puns.

I'm interested, by the way, in your approach to the BD from the artist's viewpoint. I suppose there is now a lot more material for study in that respect, with the rise of the graphic novel. At an *Astérix* occasion during the Frankfurt Book Fair some years ago, I met the present Finnish translator of the series. She told me that she works entirely on translating comic strips. If she can make a living at it, the Finns must be very fond of the genre indeed.

BS Do you know the past German translator of *Astérix*, Gudrun Penndorf? When you were both working on *Astérix* —were you in contact? Did you ever consult each other about your work on *Astérix*?

AB In fact, I met Gudrun only at about the time when she had already stopped doing the German translations. When she and I met at an *Astérix* occasion in Vienna we were talking about the financial side, but we were not in touch when we would have both been working on the albums. By the way, the Viennese did the best "magic potion" I've been offered, giving off spectacular vapours in the form of dry ice.

BS I'm not surprised to hear that. The Viennese are generally good at all sorts of brews, from *Einspänners* to the *Kapuziners*. Is it not unfair that we don't have an "Asterix and the Noricans" available yet? Especially seeing how successful *Astérix* has been in Germany as well as in Britain. Why do you think *Astérix* resonates so well across cultures? I have heard *Astérix* represents the defiant village in the face of foreign occupation, and that it portrays a very French stance. Comparisons have been made between the Romans and the foreign occupation of France in WWII, as well as between the power of the Romans and the superpower USA during the Cold War (during which Astérix was developed). This was evident not only in *Le Grand Fossé* but also in the large number of spies in many of the stories, recalling the Cold War mentality. Where do you think the success of Astérix comes from in Europe?

AB I think the reason is partly the sure-fire theme of the clever little guy outwitting the great big brute. In a way, *Astérix* is a comic version of Odysseus, far the most appealing of the Greek and Trojan heroes because he lived on

his wits while the others were just bashing each other into next week outside the walls of Troy. And there's also the liking that we Brits and the French share for historical anachronism. I say Brits advisedly, because you may know that the series is not so successful in the USA—and still wasn't when they did separate American versions of a few albums. I work it out that (a) in the States they don't have half as much history as we and the French do to be anachronistic about, and (b) to generalise wildly, irony is not the favourite American form of humour.

I think the reason for Astérix's success is partly the sure-fire theme of the clever little guy outwitting the great big brute.

BS It is interesting you point out the USA … I can also imagine that *Astérix* hasn't been as successful there because the Americans have such a long and strong comic book tradition themselves.

AB When I say to my American friends that I think the humour gap is not the English Channel (or any other European body of water) but the Atlantic Ocean, they protest that they and their kids love the Gauls. But then my American friends tend to be teachers, academics, or in the book trade; the series has never had the broad popular appeal that it has to Europeans.

But one reason, I think, why the series goes down well in the UK and other English-speaking parts of the world (with the possible exception of the US) is that the humour of the original is basically kindly. We see the Roman army comically bruised and battered; we don't see blood flowing and serious agony, let alone dead bodies. And Julius Caesar becomes almost a friend as an opponent; see the final banquet in *Le Fils d'Astérix*, held for a change on board Cleopatra's galley, in thanks to the Gauls for looking after her and Caesar's baby Caesarion. The real-life Caesarion was of course assassinated on the orders of Octavian / Augustus, a pragmatist if ever there was one, after the triumvirate's victory over Antony and the suicides of Antony and Cleopatra.

BS But I have always considered *Astérix* to be somewhat of a cross between a fantastic, US-style superhero story of the *Superman / Batman* type, and a realist European adventure story like *Tintin*. Superhero stories in the US are fantasies, generally revolving around protagonists, and their antagonists, who undergo a transformation process ending up with superhuman powers due to some sort of accident. Think of the Joker in *Batman* who fell into a tank of chemical waste; how is that different to baby Obélix falling into cauldron of magic potion, thus rendering him invincible for life? In that sense, the fantasy of receiving

superpowers, even though this is only temporary, drug-induced superpowers in *Astérix*, is very American, to the point where it becomes a cliché. The framework of the quest, however, the adventure that Astérix and Obélix embark on, I think, is very much in the European tradition. Similar, somehow, to Tintin, who travels to distant places to accomplish a specific task.

It seems as though *Astérix* is a fusion of these two traditions, incidentally from the places in which Goscinny lived at during his life: he once lived in New York City, and even wanted to work for Disney for a time. He also lived in Brussels, didn't he? (Dare I mention: both Obélix and Tintin have cute, little white dogs? That cannot be a coincidence, can it ... ?!)

AB I take your point about the fantastic elements in the story, but there are very many other strands of humour in the series, from the simple (at long last, in *La Galère d'Obélix*, *Astérix and Obélix All At Sea* in English, it was possible to work in the hoary old line, "The slaves are revolting", to which the reply to the messenger bearing this bad news is, "And so are you"), to the other end of the spectrum with the extended cultural gags. This included, for instance, quotations from Victor Hugo on Waterloo in *Chez les Belges*, and a whole page of allusions, in *Le Cadeau de César*, to Rostand's *Cyrano de Bergerac*. Cyrano composed a ballade while engaged in a sword-fight—it is done, in English, with comparable quotations from *Hamlet*, with Hamlet and Laertes providing the best-known sword-fight in English literature. No small child is going to get those in either French or English. However, they are a lot of fun for a translator.

I believe that Hergé, by the way, disapproved of *Astérix*, considering puns beneath the dignity of a BD, which surely is to take the BD genre a little too seriously.

Children's literature is the last acceptable bastion of the politically incorrect joke.

BS So the European element in *Astérix* is also based on the wealth and depth of references to European history and culture?

AB Uderzo seems to me unusually detailed and has gone to the archaeological records of ancient Rome, no doubt somewhat idealised. I am very fond of his little details of animal life carrying on in the margins of human society —and indeed child life as well. Goscinny's other great partner was not in the BD line at all: Jean-Jacques Sempé, of many a *New Yorker* cartoon. Do you know their joint creation *Le Petit Nicolas*? The Nicolas books are still extremely funny although they depict a thoroughly outdated society —in which Maman stays at home, and when she learns to drive, is too nervous to put her new skill into practice, Papa is the breadwinner, ever anxious to please the boss, and below adult waist level, a horde of cheerful little boys are gener-

ally wreaking havoc in an infant underworld of their own.

BS Speaking of an outdated society, Astérix unquestionably portrays a male-dominated world. Two rare exceptions for lead characters are Cleopatra in *Astérix et Cléopâtre* and Maestria in *La Rose et la Glaive*, but other than that, women in *Astérix* are often portrayed as subordinate. Women in the stories are passive, more often than not curvaceous characters who tend to the houses while the male protagonists go on adventures. They are generally the ones who serve food and drink to the heroes at the banquet in the end. How you see and understand the male-dominated world of *Astérix*? Did it have any bearing on translating the text?

AB Have a look at *Le Grand Fossé*, with the Romeo and Juliet couple, Comix and Fanzine in French. Those two names could have stood as they were, but all female Gaulish names in the English by then ended in -a, for instance Impedimenta for Bonnemine, so Fanzine became Melodrama in English, and to keep them as a couple, lover boy became Histrionix. I felt rather apologetic to the beautiful blonde, who in fact had more common sense than anyone else in the warring families. That's the first one Uderzo wrote on his own, and I often quote her as a sensible female character, not melodramatic.

I am always particularly pleased when I hear from girls who enjoy the series, by the way. One Australian teenager wrote to tell me that *Astérix* had kindled her interest in ancient Rome, and where should she go next? (I advised her to try the Roman private-eye novels of Lindsey Davis.)

BS *Astérix* also draws on a lot of other stereotypes, not only regarding gender roles. Think of all the national stereotypes that have entire books dedicated to them, poking fun at what they are respectively known for: the Spanish, the British, the Belgians, the Germans, Native Americans, etc. While the use of stereotypes in other comics is sometimes cringe-worthy (think of *Tintin au Congo*, for example), in *Astérix*, one never gets the sense that the stereotypes cross any lines. Perhaps that is also part of the international success: poking harmless fun at other nations, which somehow allows those nations to laugh, along with *Astérix*, at themselves?

AB The writer Alison Lurie has suggested that children's literature is the last acceptable bastion of the politically incorrect joke, such as laughing at national stereotypes, and that is very relevant to the *Astérix* series.

BS As a British person, how did you respond to the stereotypes depicted in *Astérix chez les Bretons*?

AB The classicist Mary Beard, writing on *Astérix*, is of the opinion that the English version of *Chez les Bretons* replaces sharper mockery of the British cousins in the original by typically British self-deprecation—I can't say that if true, that was intentional!

BS One last question—something I have always wondered about: Do you know the origin of the names of Astérix and Obélix, the only two names that are constant in all translations, while the other names vary creatively? I am

103

aware that an asterisk and obelisk are two typographical symbols, one denoting a star *, the other a cross †. Would you happen to know more about how the two names were chosen?

AB Simply from Asterisk and Obelisk, I think. See the joke about "never being in concord", with reference to the Place de la Concorde in Paris.

BS That is surprising! Do you mean that the two names, Astérix and Obélix, are a reference to the contrast or the duality of the Arc de Triomphe and the Place de la Concorde in Paris? The original name of the Arc de Triomphe was "Place de l'Étoile", because the streets radiate from the arc like a star, or an asterisk. Place de la Concorde has, of course, the Luxor obelisk. There is a direct reference to the Luxor obelisk in *Astérix et Cléopâtre*, where Obélix has the idea to place an obelisk in the village square. The image shows the two obelisks at the entrance at Luxor, one of which is missing today, moved to the Place de la Concorde in Paris ...

AB I think the names of Astérix and Obélix were chosen mainly because asterisk and obelisk could be adapted to end like the real-life Vercingetorix. The ancient British cousins of the Gauls end in –ax, I think because in De Bello Gallico, Caesar mentions a British king called Segovax. Alas, I never asked René Goscinny if that was so when he was alive. His English, by the way, was excellent, and in his lifetime, he checked the English translations. I remember, in Paris, explaining the policy adopted for the British accent, namely, to use an outdated jargon such as might be found in the novels of the humourist P.G. Wodehouse, full of terms like, "I say, what!", "old boy", "jolly good, old fruit", and so on. Goscinny's eyes lit up at "old fruit". "Ah", he said, "I wish I'd thought of that one ... *vieux fruit*".

BENJAMIN SAMUEL Wie haben die Illustrationen von *Asterix* Ihre Arbeit als Übersetzerin beeinflusst? Comics spielen sich vordergründig auf visueller Ebene ab und der Witz sollte nicht nur auf der Text- sondern auch auf der Bildebene funktionieren. In meiner eigenen Arbeit befasse ich mich ja vordergründig mit der visuellen Ebene, da ich mit den Farben und Formen experimentiere. Wie haben die Comicbilder Ihren Übersetzungsprozess beeinflusst?

ANTHEA BELL Es ist sehr interessant, dass Sie die visuelle Seite von *Asterix* hervorheben; ich bin naturgemäß eher ein verbaler Mensch. Aber natürlich, was Wortspiele betrifft, ist es unmöglich mit wortgetreuen Übersetzungen den Geist des Stoffes zu erfassen, man muss ständig neu erfinden. Man muss das Wort dem Gesichtsausdruck des Charakters anpassen. Der Wortlaut muss aus den verschiedenen Entwicklungssträngen hervorgehen und die Größe der vorgegebenen Sprechblase bedingt die Länge und damit den Spielraum des Textes. Das sind wichtige Faktoren, den Witz richtig herüberzubringen. Der Text und die Wörter stehen somit an erster Stelle, wenn auch eher sinngemäß und nicht buchstäblich, was die Wortspiele betrifft.

Ich bin übrigens sehr an Deinem Umgang mit den Comicbüchern, aus der Perspektive des Künstlers heraus, interessiert. Ich bin davon überzeugt, dass jetzt sehr viel mehr Material durch die Verbreitung des grafischen Romans zur Verfügung steht. Bei einer netten Gelegenheit auf der Frankfurter Buchmesse zum Thema *Asterix* traf ich vor einigen Jahren die finnische Übersetzerin dieser Reihe. Sie erzählte mir, dass sie ausschließlich Comics übersetzt. Dass sie davon leben kann, zeugt wohl davon, dass Comics in Finnland wirklich sehr beliebt sind.

BS Kennen Sie die deutsche Übersetzerin der *Asterix* Bücher, Frau Gudrun Penndorf? Als Sie sich beide mit den Übersetzungen beschäftigten, hatten Sie Kontakt miteinander? Tauschten sie sich jemals über Ihre Arbeit an *Asterix* aus?

AB Tatsächlich lernte ich Gudrun erst zu der Zeit kennen, als sie ihre Arbeit an der deutschen Übersetzung von *Asterix* beendet hatte. Als wir uns in Wien auf einer *Asterix* Veranstaltung trafen, sprachen wir über die finanzielle Seite unserer Arbeit. Wir waren aber nie in Kontakt, als wir beide gleichzeitig an den Übersetzungen arbeiteten. Übrigens, die Wiener machten den besten Zaubertrank, der mir je angeboten wurde, spektakulärer Dunst stieg in Form von Trockeneis auf.

BS Das wundert mich nicht, die Wiener sind im Allgemeinen sehr gut in allerlei Gebräu, von dem köstlichen Einspänner zum Kapuziner Kaffee. Es ist fast schon unfair, dass noch kein Band „Asterix und die Noriker" erhältlich ist. Besonders wenn man beachtet, wie erfolgreich *Asterix* in Deutschland und in Großbritannien ist. Weshalb meinen Sie, ist *Asterix* kulturübergreifend so wirksam? Ich habe einmal gelesen, dass die Geschichte des „von unbeugsamen Galliern bevölkerten Dorfes" eine typisch französische Haltung widerspiegelt. Vergleiche wurden zwischen der Besatzung Galliens durch die Römer und der Besatzung Frankreichs im Zweiten Weltkrieg gezogen, wie auch zwischen der römischen Weltmacht und der Supermacht der USA während des Kalten Krieges (in dessen Ära *Asterix* entstanden ist). Die Mentalität des Kalten Krieges wird nicht nur im Band *Der große Graben*, son-

dern auch anhand der zahlreichen Spione, die in den Geschichten auftauchen, heraufbeschworen.

AB Ich denke, der Grund der Popularität von *Asterix* ist die erfolgssichere Geschichte des kleinen Kerlchens, der den mächtigen Brutalo austrickst. *Asterix* ist eine Comicbuchversion von Odysseus, bei weitem einer der klügsten griechischen oder trojanischen Helden, denn er benutzte seinen Verstand, während die anderen sich vor den Mauern von Troja die Köpfe einrannten. Außerdem teilen wir Briten mit den Franzosen unsere starke Affinität für den historischen Anachronismus. Ich sage absichtlich die Briten, denn, wie allgemein bekannt, ist die Serie in den USA nicht so gut angekommen. Es gibt dafür zwei Gründe: Erstens, anders als bei den Franzosen und bei uns, steht den Amerikanern nur halb so viel historisches Potential für den eigenen Anachronismus zur Verfügung und zweitens, ganz frei verallgemeinert, Ironie ist nicht unbedingt die Stärke des amerikanischen Humors.

Der Grund der Popularität von Asterix ist die erfolgssichere Geschichte des kleinen Kerlchens, der den mächtigen Brutalo austrickst.

BS Es ist sehr interessant, dass Sie die USA ansprechen. Ich könnte mir auch vorstellen, dass *Asterix* dort nicht so erfolgreich war, weil die Amerikaner selbst eine lange und bedeutende Comicbuchtradition haben.

AB Wenn ich meinen amerikanischen Freunden sage, unser Humor wird nicht durch den Ärmelkanal, sondern durch den Atlantischen Ozean eingegrenzt, protestieren sie heftig und beteuern, dass sie und ihre Kinder die Gallier lieben. Aber dann sind meine amerikanischen Freunde ja Lehrer, Akademiker, oder im Buchhandel tätig; die Serie hatte niemals die weite, populäre Akzeptanz erlebt wie in Europa.

Aber ich denke, es gibt einen Grund für den allgemeinen Erfolg der Serie in England und anderen englischsprachigen Ländern (mit Ausnahme der USA). Es liegt darin, dass der Humor sehr liebenswürdig ist. Wir sehen, dass die römische Armee so komisch verprügelt wird, ohne jedoch Höllenqualen zu erleiden; es fließt kein Blut und tote Körper gibt es schon gar nicht zu sehen. Julius Caesar wird vom Gegner fast schon zum Freund, schau Dir das finale Festmahl in *Der Sohn des Asterix* an, es wird zu Ehren der Gallier auf einer Galeere Kleopatras gehalten, da sie sich so nett um Caesarion, das gemeinsame Kind von Caesar und Kleopatra, gekümmert haben. Der echte Caesarion wurde natürlich auf Befehl von Octavian/Augustus umgebracht, ein echter Pragmatiker eben, nach dem Sieg des Triumvirats gegen Antonius und Kleopatra.

BS Ich habe *Asterix* immer als eine Kreuzung einer fantasti-

schen, amerikanischen Superhelden-Geschichte, wie es *Superman/Batman* ist, und einer realistischen, europäischen Abenteuergeschichte wie *Tintin* gesehen. Amerikanische Superheldengeschichten sind Phantasien, sie folgen den Protagonisten und ihren Antagonisten, die Verwandlungsprozesse durchmachen, um am Ende übernatürliche Kräfte zu besitzen. Nehmen wir den Joker aus *Batman*, der in einen Tank voller Chemieabfälle fiel, worin unterscheidet sich diese Entwicklung im Vergleich zu Obelix, der als Kleinkind in einen Zaubertrankkessel gefallen ist und dadurch für immer unbesiegbar wurde? Die Phantasie besteht darin, Superkräfte zu erlangen, auch wenn sie nur temporär sind. Diese amerikanische Eigenschaft der Geschichte wird, meiner Meinung nach, fast schon zum Klischee. Auf der anderen Seite orientiert sich die Rahmenhandlung der Abenteuer, die Asterix und Obelix bestehen müssen, stärker an der europäischen Tradition. Ähnlich ist es bei Tintin, der zu fernen Orten reist, um eine gewisse Aufgabe zu meistern.

Es scheint, dass *Asterix* eine Verschmelzung dieser beiden Traditionen ist, der europäischen und der amerikanischen, wohl nicht zufällig von jenen Orten, an denen Goscinny im Laufe seines Lebens gelebt hat. Er wohnte einst in New York und hatte sogar einmal vor für Disney zu arbeiten. Er lebte auch in Brüssel, der Heimatstadt Tintins – dass Obelix und Tintin zwei süße, weiße Hunde haben, wird wohl sicher kein Zufall sein!

AB Ich stimme Dir zu was die fantastischen Elemente der Geschichte anbelangt, allerdings gibt es noch zahlreiche andere Humorstränge in der Serie. Es gibt den einfachen Humor, wie zum Beispiel in *Obelix auf Kreuzfahrt*, wo ich den sehr alten Satz „die Sklaven revoltieren" einbauen konnte, worauf die Antwort an den Überbringer der Nachricht lautet „du aber auch"[1]. Am anderen Ende des Spektrums gibt es den Humor basierend auf kulturellen Gags. In *Asterix bei den Belgiern*, zum Beispiel, habe ich Zitate von Victor Hugo über Waterloo eingebaut, in *Das Geschenk Cäsars* gibt es in der Originalfassung seitenlange Anspielungen auf Rostands *Cyrano de Bergerac*, der ein Gedicht während eines Schwertkampfes verfasste. Im Englischen habe ich vergleichbare Passagen aus *Hamlet* zitiert, das Duell zwischen Hamlet und Laertes bietet die wohl bekannteste Passage eines Schwertkampfes in der englischen Literatur an. Kein Kind wird diese humorvollen, kulturellen Anspielungen verstehen, weder in der französischen noch der englischen Fassung. Wie auch immer, sie sind ein riesiger Spaß für eine Übersetzerin.

Ich glaube übrigens, dass Hergé *Asterix* eher ablehnend gegenüberstand. Er war wohl der Meinung, Wortspiele wären Comicbüchern unwürdig – damit nahm er das Genre wohl ein bisschen zu ernst.

BS Also könnte man dem europäischen Element von *Asterix* zusätzlich die Fülle und Tiefe des europäischen Geschichts- und Kulturbewusstseins hinzufügen?

AB Uderzo arbeitete außergewöhnlich detailliert und griff auch auf archäologische Quellen zurück, in seiner akribischen, wenn auch idealisierten Darstellung des antiken Roms. Ich liebe die kleinen Details des Tierlebens, die sich am Rande der menschlichen Gesellschaft abspielen und natürlich auch das Leben der Kinder. Übrigens, der andere großartige

Partner von Goscinny war gar nicht in der BD Szene aktiv: Jean-Jacques Sempé, der viele Cartoons für den *New Yorker* zeichnete. Kennst Du *Der Kleine Nick*? Eine gelungene Zusammenarbeit der beiden. Die Nick-Bücher sind immer noch sehr lustig, auch wenn sie eine völlig altmodische Gesellschaft darstellen, in der die Mutter zuhause bleibt und als sie ihren Führerschein macht, sie zu nervös ist, ihre neuen Fähigkeiten in die Praxis anzuwenden. Papa ist der Ernährer der Familie, immer darauf bedacht es katzbuckelig seinem Boss recht zu machen. Doch unterhalb der Gürtellinie der Erwachsenen gibt es eine Horde heiterer, kleiner Jungen, die ein Chaos in ihrer eigenen Kinderwelt veranstalten.

Kinderliteratur ist die letzte akzeptable Bastion des politisch unkorrekten Witzes.

BS Wenn wir schon von einer altmodischen Gesellschaft sprechen: Die Welt in *Asterix* wird zweifellos von Männern dominiert. Zwei Ausnahmen weiblicher Hauptcharaktere stellen Kleopatra in *Asterix und Kleopatra* und Maestria in *Asterix und Maestria*, dar. Die anderen weiblichen Figuren bei Asterix werden untergeordnet dargestellt. Die Frauen in den Geschichten sind passiv und bleiben zuhause, während die Männer abenteuerlustig in die Welt hinausziehen. Sie servieren den Helden beim Festmahl das Essen und die Getränke. Wie verstehen Sie die von Männern dominierte Welt bei *Asterix*? Beeinflusste sie ihre Übersetzung?

AB Schauen Sie sich das Romeo und Julia Paar in *Der große Graben* an, dem ersten Band, den Uderzo alleine schrieb. Auf Französisch heißen sie „Comix" und „Fanzine". Beide Namen hätten so bleiben können, aber alle weiblichen Namen der Gallier im Englischen enden mit dem Buchstaben -a, zum Beispiel „Bonnemine" wurde zur „Impedimenta". „Fanzine" wurde im Englischen zur „Melodrama" und um sie als Paar zu bewahren, nannte ich den Liebhaber „Histrionix". Ich bedaure fast die Wahl des Namens der wunderschönen, blonden Frau, die tatsächlich mehr gesunden Menschenverstand besaß, als alle anderen Personen der sich streitenden Familien zusammen. Ich führe sie häufig als Beispiel eines vernünftigen, weiblichen Charakters, und nicht eines melodramatischen, an.

Übrigens freut es mich sehr, wenn ich von jungen Mädchen kontaktiert werde, die mir erzählen, dass ihnen die Bücher sehr gefallen. Ein australisches Mädchen schrieb mir, dass Asterix ihre Neugierde auf das antike Rom weckte und bat mich um Rat, was sie als nächstes lesen sollte? (Ich empfahl ihr die Römischen Detektivromane Lindsey Davis.)

BS *Asterix* bedient aber auch noch viele andere Klischees, nicht nur die der Geschlechterrollen. Denken Sie doch nur an die Stereotypen fremder Nationen, denen ganze Bände gewidmet sind, in denen typische Eigenarten der Spanier, der Briten, der Belgier, der Deutschen oder der Amerikaner auf die Schippe genommen werden. Während sich andere Comics unsensibler Stereotypen bedienen (denken Sie zum

Beispiel an *Tim im Kongo*), würde man in Asterix niemals auf die Idee kommen, die Autoren hätten die Grenze des schlechten Geschmacks überschritten. Das macht vielleicht auch den internationalen Erfolg der Serie aus, sich über andere Nationen lustig zu machen und mit Asterix über sich selber zu lachen.

AB Die Schriftstellerin Alison Lurie behauptet, dass die Kinderliteratur die letzte akzeptable Bastion des politisch unkorrekten Witzes ist, wie zum Beispiel sich über die Eigenarten der verschiedenen Ländersitten zu amüsieren. *Asterix* ist ein gutes Beispiel dafür.

BS Wie haben Sie als Britin auf die Vorurteile in *Asterix bei den Briten* reagiert?

AB Die Klassikerin Mary Beard ist der Meinung, dass die englische Version von *Asterix bei den Briten* im Spott schärfer ist als das Original, da sie sich im Humor der typischen, britischen Selbstironie bedient. Wenn dies in der Tat so ist, kann ich nicht mehr sagen, dass es vorsätzlich war.

BS Eine letzte Frage – ich habe mich schon immer gewundert, woher der Ursprung der Namen Asterix und Obelix stammt. In allen Übersetzungen sind das die einzigen Namen, die gleich geblieben sind, während die anderen Namen spielerisch umgewandelt wurden. Es ist mir bewusst, dass ein Asterisk und ein Obeliscus zwei typografische Schriftzeichen sind, das eine repräsentiert einen Stern (*), das andere ein Kreuz (†). Wissen Sie mehr über den Hintergrund dieser Namenswahl?

AB Ich glaube es ist einfach von Asterisk und Obelisk abgeleitet. Es ist auch ein Wortspiel des Satzes „niemals in Eintracht zu sein", mit einer Anspielung auf den Platz der Eintracht in Paris, auf dem der Luxor Obelisk steht.

BS Das ist sehr interessant! Meinen Sie, dass beide Namen, Asterix und Obelix, eine Anspielung auf beide Orte in Paris, den „Arc de Triomphe" und den „Place de la Concorde" sind? Der ursprüngliche Name des „Arc de Triomphe" war „Place de l'Étoile", denn die Straßen strömen sternenförmig vom Platz weg, wie eben ein Asterisk. Am „Place de la Concorde", der mit dem „Arc de Triomphe" über die Champs-Élysées verbunden ist, steht der Luxor Obelisk. Es gibt einen direkten Hinweis auf den Luxor Obelisken in *Asterix und Kleopatra*, wo Obelix eine Idee hatte, diesen Obelisken zu Hause auf den Dorfplatz zu stellen. Das Bild im Band zeigt noch zwei Obelisken am Eingang zum Luxor-Tempel, einer der beiden ist natürlich entfernt worden, und befindet sich heute auf dem Place de la Concorde.

AB Ich glaube die Namen Asterix und Obelix wurden gewählt, weil die Wörter „Asterisk" und „Obelisk" an den Namen des historischen Fürsten Vercingetorix angepasst werden konnten. Die Namen der altertümlichen, britischen Cousins der Gallier hatten Namen, die auf -ax endeten, denn auch im Bericht *De Bello Gallico* erwähnte Julius Caesar einen britischen König namens Segovax. Leider habe ich zu Lebzeiten René Goscinny nie darüber befragt. Übrigens war sein Englisch ausgezeichnet, er prüfte die englische Übersetzung persönlich. Ich erinnere mich noch, in Paris beriet ich ihn einst zur Wahl des Sprachstils in der englischen Über-

setzung. Ich schlug einen altmodischen Jargon vor, wie man ihn in den Romanen des Humoristen P.G. Wodehouse findet, die reich an Mundarten sind wie „I say, what", „old boy", „jolly good, old fruit", usw. Die Augen von Goscinny funkelten auf bei „old fruit". „Ah", sagte er, „ich wünschte ich wäre selbst darauf gekommen ... vieux fruit".

[1] Engl. „the slaves are revolting". Der Wortwitz ergibt sich aus der Doppeldeutigkeit des Wortes „revolting" im Englischen. „Revolting" bedeutet zum einen „rebellieren", aber auch „abscheulich". Der ursprüngliche Sinn von „die Sklaven rebellieren" kann somit umgedeutet werden in „Sklaven sind abscheulich", worauf die Antwort lautet: „du aber auch".

SHAKESPEARE

36

POE

69 ½

SHAKESPEARE

36

112

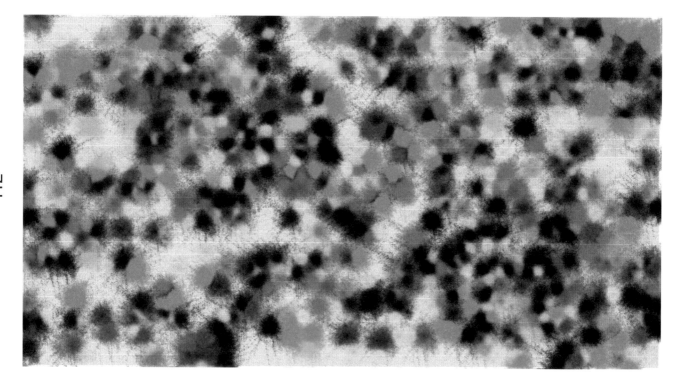

Shakespeare 36
2015, double duraclear transparencies in lightbox, 230 × 122 cm

POE
69 ½

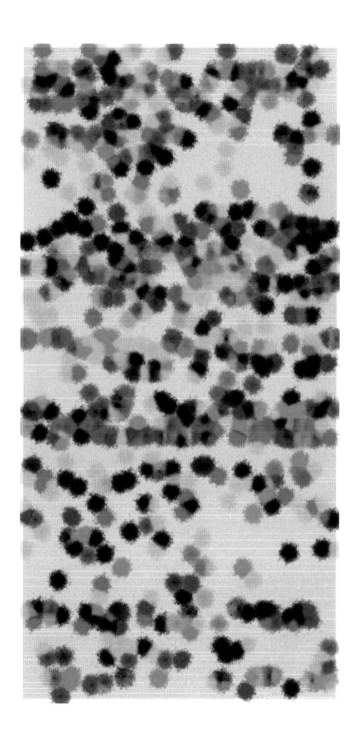

Poe 69 ½
2015, double duraclear transparencies in lightbox, 166 × 83 cm

Number of Colour Words Found
Anzahl der gefunden Farbwörter

Shakespeare 36

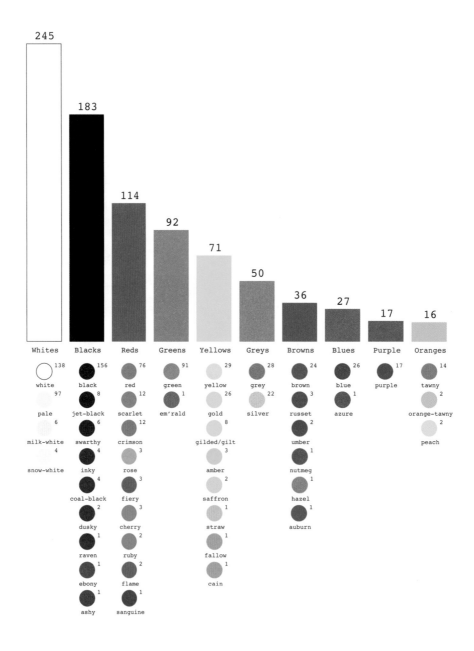

The dataset for this work is based on the 36 plays by William Shakespeare included in the first folio published in 1623. The work was created in two layers. On the back layer, the entire text of the plays, a total of 4,939,199 text characters, is represented. On the front layer, at all locations at which a specific colour term appears in the text, the corresponding colour emanates and spreads out on the layer from that spot.

Die Datengrundlage dieser Arbeit basiert auf den 36 Dramen William Shakespeares, die in der ersten Folio-Ausgabe von 1623 veröffentlicht wurden. Das Werk wurde in zwei Ebenen erstellt. In der hinteren Ebene ist der gesamte Text der Dramen, insgesamt 4.939.199 Schriftzeichen, dargestellt. In der vorderen Ebene strömt an jeder von einem Suchalgorithmus gefundenen Textstelle, an der ein bestimmtes Farbwort Verwendung findet, die korrespondiere Farbe aus.

Poe 69½

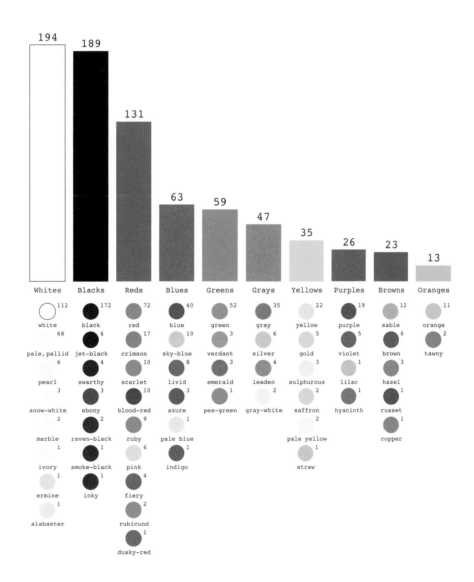

The dataset for this work is based on the 69 finished and one unfinished tale by Edgar Allan Poe. The work was created in two layers. On the back layer, the entire text of the tales, a total of 2,327,600 text characters, is represented. On the front layer, at all locations at which a specific colour term appears in the text, the corresponding colour emanates and spreads out on the layer from that spot.

Die Datengrundlage dieser Arbeit basiert auf den 69 vollendeten und einer unvollendeten Geschichte Edgar Allan Poes. Das Werk wurde in zwei Ebenen erstellt. In der vorderen Ebene ist der gesamte Text der Geschichten, insgesamt 2.327.600 Schriftzeichen, dargestellt. In der hinteren Ebene strömt von jeder von einem Suchalgorithmus gefundenen Textstelle, an der ein bestimmtes Farbwort Verwendung findet, die korrespondiere Farbe aus.

And nightly, meadow-fairies, look you sing,
Like to the Garter's compass, in a ring:
The expressure that it bears, green let it be,
More fertile-fresh than all the field to see;
And *Honi soit qui mal y pense* write
In emerald tufts, flowers purple, blue and white;
Let sapphire, pearl and rich embroidery,
Buckled below fair knighthood's bending knee:
Fairies use flowers for their charactery.

Shakespeare, *The Merry Wives of Windsor*, V.v.64–72

These windows were of stained glass whose color varied in accordance with the prevailing hue of the decorations of the chamber into which it opened. That at the eastern extremity was hung, for example, in blue --and vividly blue were its windows. The second chamber was purple in its ornaments and tapestries, and here the panes were purple. The third was green throughout, and so were the casements. The fourth was furnished and lighted with orange --the fifth with white --the sixth with violet. The seventh apartment was closely shrouded in black velvet tapestries that hung all over the ceiling and down the walls, falling in heavy folds upon a carpet of the same material and hue. But in this chamber only, the color of the windows failed to correspond with the decorations. The panes here were scarlet --a deep blood color.

Poe, *Masque of the Red Death*

Works Used
Verwendete Werke

The 36 Plays by William Shakespeare
Die 36 Dramen von William Shakespeare

COMEDIES

NO.	TITLE	YEAR
1	The Tempest	1612
2	The Two Gentlemen of Verona	1595
3	The Merry Wives of Windsor	1601
4	Measure for Measure	1605
5	The Comedy of Errors	1593
6	Much Ado About Nothing	1599
7	Love's Labour's Lost	1595
8	A Midsummer Night's Dream	1596
9	The Merchant of Venice	1597
10	As You Like It	1601
11	The Taming of the Shrew	1594
12	All's Well That Ends Well	1603
13	Twelfth Night, or what you will	1602
14	The Winter's Tale	1611

HISTORIES

NO.	TITLE	YEAR
15	The Life and Death of King John	1597
16	The Life and Death of Richard the Second	1596
17	The First Part of King Henry the Fourth	1598
18	The Second Part of King Henry the Fourth	1598
19	The Life of King Henry the Fifth	1599
20	The First Part of King Henry the Sixth	1592
21	The Second Part of King Henry the Sixth	1591
22	The Third Part of King Henry the Sixth	1591
23	The Life and Death of Richard the Third	1593
24	The Life of King Henry the Eigth	1611

TRAGEDIES

NO.	TITLE	YEAR
25	The Tragedy of Coriolanus	1608
26	Titus Andronicus	1594
27	Romeo and Juliet	1595
28	Timon of Athens	1608
29	The Life and Death of Julius Caesar	1599
30	The Tragedy of Macbeth	1606
31	The Tragedy of Hamlet, Prince of Denmark	1604
32	King Lear	1606
33	Othello, the Moor of Venice	1605
34	Antony and Cleopatra	1607
35	Cymbeline King of Britain	1609
36	Troilus and Cressida	1602

The 69 ½ Tales by Edgar Allan Poe
Die 69 ½ Geschichten von Edgar Allan Poe

NO.	TITLE	PUBLICATION DATE
1	Metzengerstein	JAN. 1832
2	The Duc de L'Omelette	MAR. 1832
3	A Tale of Jerusalem	JUN. 1832
4	Loss of Breath	NOV. 1832
5	Bon-Bon	DEC. 1832
6	Ms. Found in a Bottle	OCT. 1833
7	The Assignation	JAN. 1834
8	Berenice	MAR. 1835
9	Morella	APR. 1835
10	Lionizing	MAY 1835
11	The Unparalleled Adventure of One Hans Pfaall	JUN. 1835
12	King Pest	SEP. 1835
13	Shadow — A Parable	SEP. 1835
14	Four Beasts in One; The Homo-Camelopard	MAR. 1836
15	The Narrative of Arthur Gordon Pym of Nantucket	JUL. 1838
16	Silence — A Fable	1839
17	Mystification	JUN. 1837
18	Ligeia	SEP. 1838
19	How to Write a Blackwood Article	NOV. 1838
20	A Predicament	NOV. 1838
21	The Devil in the Belfry	MAY 1839
22	The Man That Was Used Up	AUG. 1839
23	The Fall of the House of Usher	SEP. 1839
24	William Wilson	1840
25	The Conversation of Eiros and Charmion	DEC. 1839
26	Why the Little Frenchman Wears His Hand in a Sling	1840
27	Journal of Julius Rodman	JAN. 1840
28	The Business Man	FEB. 1840
29	The Man of the Crowd	DEC. 1840
30	The Murders In The Rue Morgue	APR. 1841
31	A Descent into the Maelström	MAY 1841
32	The Island of the Fay	JUN 1841
33	The Colloquy of Monos and Una	AUG. 1841
34	Never Bet the Devil Your Head	SEP. 1841
35	Eleonora	1842
36	Three Sundays in a Week	NOV. 1841
37	The Oval Portrait	APR. 1842
38	The Masque of the Red Death	MAY 1842
39	The Mystery of Marie Roget	DEC. 1842
40	The Pit and the Pendulum	1843
41	The Tell-Tale Heart	JAN. 1843
42	The Gold-Bug	JUN. 1843
43	The Black Cat	AUG. 1843
44	Diddling Considered as One of the Exact Sciences	OCT. 1843
45	Morning of the Wissahiccon	1844
46	The Spectacles	MAR. 1844
47	A Tale of the Ragged Mountains	APR. 1844
48	The Balloon-Hoax	APR. 1844
49	The Premature Burial	JUL. 1844
50	Mesmeric Revelation	AUG. 1844
51	The Oblong Box	SEP. 1844
52	The Angel of the Odd: An Extravaganza	OCT. 1844
53	Thou Art the Man	NOV. 1844
54	The Literary Life of Thingum Bob, Esq	DEC. 1844
55	The Purloined Letter	1845
56	The Thousand-And-Second Tale of Scheherazade	FEB. 1845
57	Some Words with a Mummy	APR. 1845
58	The Power of Words	JUN. 1845
59	The Imp of the Perverse	JUL. 1845
60	The System of Doctor Tarr and Professor Fether	NOV. 1845
61	The Facts in the Case of M. Valdemar	DEC. 1845
62	The Sphinx	JAN. 1846
63	The Cask of Amontillado	NOV. 1846
64	The Domain of Arnheim, or The Landscape Garden	MAR. 1847
65	Mellonta Tauta	FEB. 1849
66	Hop-Frog	MAR. 1849
67	Von Kempelen and His Discovery	APR. 1849
68	X-Ing a Paragrab	MAY 1849
69	Landor's Cottage	JUN. 1849
69½	The Light-House	1849

Typography
Typografie

Custom 9×15 Monospace Bitmap Font
Maßgeschneiderte 9×15 Monospace Bitmap-Schrift

0,57 mm

0,95 mm

Latin Letters
Lateinische Schriftzeichen

ABCDEFGHIJKLMNOPQRSTUVWXYZ

abcdefghijklmnopqrstuvwxyz

Numerals and Punctuation
Zahlen und Satzzeichen

0123456789<=>!"´()*+,-.:;/

?[\]^_.{|}$%&

Special Characters and Ligatures used in Shakespeare 36
Sonderzeichen und Ligaturen in Shakespeare 36

Special Characters used in Poe 69½
Sonderzeichen in Poe 69½

119

#1	brown	(4035-4039)	"… sea for \| an acre of barren ground-long heath, BROWN furze, any \| thing.
#2	blue	(17370-17373)	"… this true? \| ARIEL. Ay, sir. \| PROSPERO. This BLUE-ey'd hag was hither bro
#3	red	(22129-22131)	"… on't \| Is, I know how to curse. The RED plague rid you \| For learning me
#4	yellow	(22787-22792)	"… FERDINAND following \| ARIEL'S SONG. \| Come unto these YELLOW sands, \| And
#5	green	(31191-31195)	"… GONZALO. How lush and lusty the grass looks! how GREEN! \| ANTONIO. The gr
#6	tawny	(31230-31234)	"… looks! how green! \| ANTONIO. The ground indeed is TAWNY. \| SEBASTIAN. Wit
#7	green	(31265-31269)	"… indeed is tawny. \| SEBASTIAN. With an eye of GREEN in't. \| ANTONIO. He mis
#8	black	(45489-45493)	"… hear it \| sing i' th' wind. Yond same BLACK cloud, yond huge one, \| looks
#9	white	(74186-74190)	"… vow! \| FERDINAND. I warrant you, sir, \| The WHITE cold virgin snow upon my
#10	saffron	(75335-75341)	"… disobey the wife of Jupiter; \| Who, with thy SAFFRON wings, upon my flow'r
#11	blue	(75438-75441)	"… refreshing show'rs; \| And with each end of thy BLUE bow dost crown \| My b
#12	green	(75592-75596)	"… thy Queen \| Summon'd me hither to this short-grass'd GREEN? \| IRIS. A cont
#13	green	(77755-77759)	"… looks, \| Leave your crisp channels, and on this GREEN land \| Answer your
#14	red	(79996-79998)	"… varlets? \| ARIEL. I told you, sir, they were RED-hot with drinking; \| So f
#15	green	(86709-86713)	"… back; you demi-puppets that \| By moonshine do the GREEN sour ringlets mak
#16	green	(86990-86994)	"… call'd forth the mutinous winds, \| And ,twixt the GREEN sea and the azur'd
#17	white	(130284-130288)	"… my sister, \| for, look you, she is as WHITE as a lily and as small as a wa
#18	swart	(145346-145350)	"… that made her fair!- \| Shows Julia but a SWARThy Ethiope. \| I will forget
#19	black	(155093-155097)	"… praise, commend, extol their graces; \| Though ne'er so BLACK, say they hav
#20	white	(160650-160654)	"… knees, her humble self, \| Wringing her hands, whose WHITEness so became t
#21	pale	(160702-160705)	"… became them \| As if but now they waxed PALE for woe. \| But neither bended
#22	milkwhite	(161717-161721)	"… to me, shall be deliver'd \| Even in the milk-WHITE bosom of thy love. \| Th
#23	black	(163361-163365)	"… news, \| then, in your paper? \| LAUNCE. The BLACK'st news that ever thou he
#24	black	(163423-163427)	"… that ever thou heard'st. \| SPEED. Why, man? how BLACK? \| LAUNCE. Why, as b
#25	black	(163448-163452)	"… SPEED. Why, man? how black? \| LAUNCE. Why, as BLACK as ink. \| SPEED. Let m
#26	black	(191238-191242)	"… her face, \| That now she is become as BLACK as I. \| SILVIA. How tall was
#27	auburn	(192670-192675)	"… flatter with myself too much. \| Her hair is AUBURN, mine is perfect yellow
#28	yellow	(192694-192699)	"… much. \| Her hair is auburn, mine is perfect YELLOW; \| If that be all the
#29	grey	(192801-192804)	"… me such a colour'd periwig. \| Her eyes are GREY as glass, and so are mine;
#30	black	(194612-194616)	"… THURIO. Nay, then, the wanton lies; my face is BLACK. \| PROTEUS. But pearl
#31	black	(194676-194680)	"… pearls are fair; and the old saying is: \| BLACK men are pearls in beauteo
#32	white	(207163-207167)	"… after him, may: they may \| give the dozen WHITE luces in their coat. \| SH
#33	white	(207239-207243)	"… It is an old coat. \| EVANS. The dozen WHITE louses do become an old coat
#34	brown	(208517-208521)	"… pretty virginity. \| SLENDER. Mistress Anne Page? She has BROWN hair, and \|
#35	fallow	(210288-210293)	"… you, good Master Slender. \| SLENDER. How does your FALLOW greyhound, sir?
#36	red	(213691-213693)	"… \| SLENDER. By this hat, then, he in the RED face had it; for \| though I ca
#37	scarlet	(213834-213840)	"… not altogether an ass. \| FALSTAFF. What say you, SCARLET and John? \| BARD
#38	gold	(224418-224421)	"… \| tightly; \| Sail like my pinnace to these GOLDen shores. \| Rogues, hence,
#39	yellow	(225336-225341)	"… deal \| with poison; I will possess him with YELLOWness; for the \| revolt o
#40	yellow	(226534-226539)	"… but a little whey face, with a \| little YELLOW beard, a Cain-colour'd bear
#41	cain	(226555-226560)	"… whey face, with a \| little yellow beard, a Cain-COLOUR'd beard. \| QUICKLY.
#42	green	(227570-227574)	"… me in my closet un boitier vert-a box, a GREEN-a \| box. Do intend vat I s
#43	green	(227610-227614)	"… green-a \| box. Do intend vat I speak? A GREEN-a box. \| QUICKLY. Ay, forsoo
#44	green	(235728-235732)	"… than the Hundredth \| Psalm to the tune of ,GREENsleeves.' What tempest, I
#45	green	(310944-310948)	"… growth, we'll dress \| Like urchins, ouphes, and fairies, GREEN and white,
#46	white	(310954-310958)	"… dress \| Like urchins, ouphes, and fairies, green and WHITE, \| With rounds
#47	white	(312013-312017)	"… the Fairies, \| Finely attired in a robe of WHITE. \| PAGE. That silk will I
#48	black	(317923-317927)	"… of them; Mistress Ford, good heart, is beaten \| BLACK and blue, that you c
#49	blue	(317933-317936)	"… Mistress Ford, good heart, is beaten \| black and BLUE, that you cannot see
#50	white	(317961-317965)	"… \| black and blue, that you cannot see a WHITE spot about her. \| FALSTAFF.
#51	black	(318019-318023)	"… about her. \| FALSTAFF. What tell'st thou me of BLACK and blue? I was \| bea
#52	blue	(318029-318032)	"… \| FALSTAFF. What tell'st thou me of black and BLUE? I was \| beaten myself
#53	white	(320268-320272)	"… \| Her father means she shall be all in WHITE; \| And in that habit, when S
#54	green	(320518-320522)	"… all be mask'd and vizarded- \| That quaint in GREEN she shall be loose enr
#55	white	(323109-323113)	"… know one another. I come to her in \| WHITE and cry ,mum'; she cries ,budge
#56	white	(323265-323269)	"… needs either your mum \| or her budget? The WHITE will decipher her well e
#57	green	(323674-323678)	"… \| MRS. PAGE. Master Doctor, my daughter is in GREEN; when \| you see your t
#58	black	(326022-326026)	"… my male deer. \| FALSTAFF. My doe with the BLACK scut! Let the sky rain \| p
#59	green	(326093-326097)	"… \| potatoes; let it thunder to the tune of GREENsleeves, hail \| kissing-con
#60	black	(327113-327117)	"… Hobgoblin; all with tapers \| FAIRY QUEEN. Fairies, BLACK, grey, green, a
#61	grey	(327120-327123)	"… Hobgoblin; all with tapers \| FAIRY QUEEN. Fairies, black, GREY, green, and
#62	green	(327126-327130)	"… all with tapers \| FAIRY QUEEN. Fairies, black, grey, GREEN, and white, \| Y
#63	white	(327137-327141)	"… tapers \| FAIRY QUEEN. Fairies, black, grey, green, and WHITE, \| You moonsh
#64	blue	(327496-327499)	"… and hearths unswept, \| There pinch the maids as BLUE as bilberry; \| Our r
#65	green	(328560-328564)	"… in a ring; \| Th' expressure that it bears, GREEN let it be, \| More fertile
#66	emerald	(328670-328676)	"… ,Honi soit qui mal y pense' write \| In EM'RALD tufts, flow'rs purple, blue
#67	purple	(328693-328698)	"… mal y pense' write \| In em'rald tufts, flow'rs PURPLE, blue and white; \| L
#68	blue	(328701-328704)	"… y pense' write \| In em'rald tufts, flow'rs purple, BLUE and white; \| Like
#69	white	(328710-328714)	"… write \| In em'rald tufts, flow'rs purple, blue and WHITE; \| Like sapphire,
#70	green	(330285-330289)	"… one way, and steals away a fairy in \| GREEN; SLENDER another way, and take
#71	white	(330340-330344)	"… another way, and takes off a fairy in \| WHITE; and FENTON steals away ANN
#72	white	(334914-334918)	"… her garments? \| SLENDER. I went to her in WHITE and cried ,mum' and she \|
#73	green	(335131-335135)	"… knew of your \| purpose; turn'd my daughter into GREEN; and, indeed, she \|
#74	green	(335426-335430)	"… \| MRS. PAGE. Why, did you take her in GREEN? \| CAIUS. Ay, be gar, and ,tis
#75	black	(385240-385244)	"… bright \| When it doth tax itself; as these BLACK masks \| Proclaim an ensh
#76	brown	(403444-403448)	"… beasts, we shall have all the \| world drink BROWN and white bastard. \| DUI
#77	white	(403454-403458)	"… shall have all the \| world drink brown and WHITE bastard. \| DUKE. O heave
#78	brown	(411546-411550)	"… would mouth with a beggar \| though she smelt BROWN bread and garlic. Say t
#79	white	(411702-411706)	"… mortality \| Can censure scape; back-wounding calumny \| The WHITEst virtue
#80	brown	(430109-430113)	"… \| Master Rash; he's in for a commodity of BROWN paper and old \| ginger, ni
#81	peach	(430408-430413)	"… Threepile the mercer, for some four \| suits of peach-COLOUR'd satin, which
#82	red	(436974-436976)	"… at mine heart to see thine eyes \| so RED. Thou must be patient. I am fain
#83	black	(495443-495447)	"… ensue: \| They'll suck our breath, or pinch us BLACK and blue. \| LUCIANA.
#84	blue	(495453-495456)	"… They'll suck our breath, or pinch us black and BLUE. \| LUCIANA. Why prat'st
#85	silver	(507022-507027)	"… thyself, and I will dote; \| Spread o'er the SILVER waves thy golden hairs
#86	gold	(507039-507042)	"… will dote; \| Spread o'er the silver waves thy GOLDen hairs, \| And as a bed

	ermine	(6098-6103)	"… and majestic forms of a thousand illustrious ancestors. Here, rich-ERMINED p			
	red	(8512-8514)	"… expression, while they gleamed with a fiery and unusual RED; and the distenc			
	red	(8723-8725)	"… door. As he threw it open, a flash of RED light, streaming far into the cham			
	fiery	(9335-9339)	"… were restraining the convulsive plunges of a gigantic and FIERY-colored hors			
	fiery	(13338-13342)	"… world, was utterly companionless--unless, indeed, that unnatural, impetuous,			
	pale	(17253-17256)	"… of his terrible stamp--times when the young Metzengerstein turned PALE and s			
	white	(20185-20189)	"… died away, and a dead calm sullenly succeeded. A WHITE flame still envelope			
	fiery	(23678-23682)	"… was no ceiling--certainly none--but a dense whirling mass of FIERY-colored c			
	bloodred	(23792-23794)	"… upward. From above, hung a chain of an unknown blood-RED metal--its upper e			
0	hyacinth	(25094-25101)	"… of the golden frames that besprinkled, like stars, the HYACINTH and the por			
1	pale	(25965-25968)	"… if carved in marble, et qui sourit, with his PALE countenance, si amerement?			
2	white	(30839-30843)	"… was adorned, at regular interspaces, by square towers of WHITE marble; the l			
3	fiery	(36903-36907)	"… our wedding; "thou witch!--thou hag!--thou whippersnapper--thou sink of iniq			
4	black	(41188-41192)	"… Anaxagoras, it will be remembered, maintained that snow is BLACK, and this			
5	white	(71262-71266)	"… smoothly over his forehead, and surmounted by a conical-shaped WHITE flannel			
6	peagreen	(71306-71310)	"… by a conical-shaped white flannel cap and tassels--that his pea-GREEN jerkin			
7	purple	(71722-71727)	"… velvet of Genoa--that his slippers were of a bright PURPLE, curiously filigr			
8	yellow	(71923-71928)	"… the binding and embroidery--that his breeches were of the YELLOW satin-like			
9	skyblue	(71979-71982)	"… were of the yellow satin-like material called aimable--that his sky-BLUE clo			
0	crimson	(72065-72071)	"… form a dressing-wrapper, and richly bestudded all over with CRIMSON devices,			
1	black	(75906-75910)	"… produce. Whistling to his more immediate vicinity the large BLACK water-dog			
2	red	(76126-76128)	"… of the apartment whose inexorable shadows not even the RED firelight itself			
3	black	(77830-77834)	"… minutely distinct, by means of a faded suit of BLACK cloth which fitted tigh			
4	green	(78363-78367)	"… depended a queue of considerable length. A pair of GREEN spectacles, with si			
5	white	(78616-78620)	"… there was no evidence of a shirt, but a WHITE cravat, of filthy appearance,			
6	black	(79127-79131)	"… a breast-pocket of his coat appeared conspicuously a small BLACK volume fast			
7	white	(79299-79303)	"… person as to discover the words "Rituel Catholique" in WHITE letters upon th			
8	pale	(79398-79401)	"… the back. His entire physiognomy was interestingly saturnine--even cadaverou			
9	black	(82540-82544)	"… head, laughed long, loudly, wickedly, and uproariously, while the BLACK dog,			
0	white	(82947-82951)	"… confessed, he felt a little astonishment to see the WHITE letters which form			
1	red	(83207-83209)	"… words Regitre des Condamnes blazed forth in characters of RED. This startli			
2	green	(83653-83657)	"… see how it is." And hereupon, taking off his GREEN spectacles, he wiped the			
3	black	(84039-84043)	"… of his guest's, he found them by no means BLACK, as he had anticipated--nor			
4	gray	(84073-84076)	"… them by no means black, as he had anticipated--nor GRAY, as might have been			
5	hazel	(84116-84120)	"… had anticipated--nor gray, as might have been imagined--nor yet HAZEL nor bl			
6	blue	(84126-84129)	"… gray, as might have been imagined--nor yet hazel nor BLUE--nor indeed yellow			
7	yellow	(84143-84148)	"… might have been imagined--nor yet hazel nor blue--nor indeed YELLOW nor red-			
8	red	(84154-84156)	"… been imagined--nor yet hazel nor blue--nor indeed yellow nor RED--nor purple			
9	purple	(84163-84168)	"… imagined--nor yet hazel nor blue--nor indeed yellow nor red--nor PURPLE--no			
0	white	(84175-84179)	"… yet hazel nor blue--nor indeed yellow nor red--nor purple--nor WHITE--nor gr			
1	green	(84186-84190)	"… hazel nor blue--nor indeed yellow nor red--nor purple--nor white--nor GREEN-			
2	red	(94953-94955)	"… in my pocket-book."	Thus saying, he produced a RED leather wallet, and to		
3	duskyred	(100273-100275)	"… beach. My notice was soon afterwards attracted by the dusky-RED appearance			
4	yellow	(104752-104757)	"… more to the northward.--The sun arose with a sickly YELLOW lustre, and clamb			
5	black	(106022-106026)	"… All around were horror, and thick gloom, and a BLACK sweltering desert of eb			
6	black	(107159-107163)	"… of way the ship made, the swelling of the BLACK stupendous seas became more			
7	red	(107683-107685)	"… I became aware of a dull, sullen glare of RED light which streamed down the			
8	black	(108241-108245)	"… existence. Her huge hull was of a deep dingy BLACK, unrelieved by any of the			
9	gray	(115109-115112)	"… eyes glistened with the rheum of years; and their GRAY hairs streamed terri			
0	gray	(117339-117342)	"… upon it the stamp of a myriad of years.--His GRAY hairs are records of the p			
1	gray	(117383-117386)	"… gray hairs are records of the past, and his GRAYer eyes are Sybils of the f			
2	black	(118772-118776)	"… in the immediate vicinity of the ship is the BLACKness of eternal night, an			
3	white	(119167-119171)	"… to a tide which, howling and shrieking by the WHITE ice, thunders on to the			
4	black	(120987-120991)	"… the earth; the Pole itself being represented by a BLACK rock, towering to a			
5	sable	(123352-123356)	"… greater into the smaller channel. Like some huge and SABLE-feathered condor,			
6	livid	(123574-123578)	"… turned all at once that deep gloom into a LIVID and preternatural day.	A		
7	black	(124013-124017)	"… found, alas! only within the abyss. Upon the broad BLACK marble flagstones a			
8	silver	(124622-124627)	"… name.	She stood alone. Her small, bare, and SILVERy feet gleamed in the bl		
9	black	(124650-124654)	"… Her small, bare, and silvery feet gleamed in the BLACK marble beneath her. l			
0	snowwhite	(124883-124887)	"… in curls like those of the young hyacinth. A snowy-WHITE and gauze-like drap			
1	pale	(126512-126515)	"… agitated group a spectral and ominous appearance, as with PALE countenance			
2	pallor	(128170-128175)	"… soul, and the statue has started into life! The PALLOR of the marble counte			
3	crimson	(128334-128340)	"… behold suddenly flushed over with a tide of ungovernable CRIMSON; and a sli			
4	silver	(128439-128444)	"… as a gentle air at Napoli about the rich SILVER lilies in the grass.	Why s		
5	hazel	(130717-130721)	"… wild, full, liquid eyes, whose shadows varied from pure HAZEL to intense and			
6	black	(130780-130784)	"… to intense and brilliant jet--and a profusion of curling BLACK hair, from wh			
7	ivory	(130874-130878)	"… unusual breadth gleamed forth at intervals all light and IVORY--his were fea			
8	emerald	(133463-133469)	"… censers, together with multitudinous flaring and flickering tongues of EMERA			
9	violet	(133475-133480)	"… with multitudinous flaring and flickering tongues of emerald and VIOLET fire			
0	crimson	(133595-133601)	"… through windows, formed each of a single pane of CRIMSON-tinted glass. Gland			
1	green	(140417-140421)	"…	For which my soul did pine--	A GREEN isle in the sea, love,	A fountai
2	silver	(141367-141372)	"… and from our misty clime,	Where weeps the SILVER willow!	That these lin	
3	livid	(146566-146570)	"… intelligence. But his limbs were rigid, his lips were LIVID, his lately beam			
4	black	(146687-146691)	"… the table, my hand fell upon a cracked and BLACKened goblet, and a consciou			
5	gray	(147654-147657)	"… towers in the land more time-honored than my gloomy, GRAY, hereditary halls			
6	gray	(150309-150312)	"… raven-winged hours. Berenice!--I call upon her name--Berenice!--and from the			
7	gray	(157019-157022)	"… my passions always were of the mind. Through the GRAY of the early morning--			
8	pale	(157531-157534)	"… And now--now I shuddered in her presence, and grew PALE at her approach; ye			
9	gray	(158186-158189)	"… the atmosphere--or the uncertain twilight of the chamber--or the GRAY drape			
0	pale	(158829-158832)	"… the face.	The forehead was high, and very PALE, and singularly placid; and		
1	yellow	(158984-158989)	"… hollow temples with innumerable ringlets, now of a vivid YELLOW, and jarring			
2	white	(159698-159702)	"… alas! departed, and would not be driven away, the WHITE and ghastly spectru			
3	white	(160109-160113)	"… visibly and palpably before me; long, narrow, and excessively WHITE, with th			
4	pale	(160125-160128)	"… before me; long, narrow, and excessively white, with the PALE lips writhing			
5	pale	(164170-164173)	"… There came a light tap at the library door--and, PALE as the tenant of a to			
6	white	(165278-165282)	"… some instruments of dental surgery, intermingled with thirty-two small, WHI			

Numbers
Zahlen

75,730

Lines of MIDI code / Zeilen MIDI-Code
Goldberg Variationen 30 + 2

67,770

Lines of MIDI code / Zeilen MIDI-Code
Diabelli Variationen 33

7,905

Stock quotes / Aktienkurse
Deutscher Aktienindex 30 + 1

7,874

Stock quotes / Aktienkurse
Dow Jones Industrial 30 + 1

283,500

Still frames / Standbilder
Hitchcock 30

107,445

Still frames / Standbilder
Kubrick 13 + 9 + 10

1,474

Comic book pages / Comicbuchseiten
Asterix 34

1,422

Comic book pages / Comicbuchseiten
Tintin 23

4,939,199

Text characters / Textzeichen
Shakespeare 36

2,327,600

Text characters / Textzeichen
Poe 69½

Biography / Statement
Biografie / Statement

About Benjamin Samuel

Benjamin Samuel was born in 1981 in Frankfurt am Main.
He studied architecture, film studies and music at New
York University, the University of Miami, the Architectural
Association in London and the University of Applied Arts
in Vienna. He lives and works in Frankfurt am Main.

About Arrays of Light

Arrays of Light is a series of light installations. My primary
artistic impetus is my appreciation for our humanistic,
cultural and artistic heritage. I attempt to unravel the hidden
rules that govern these phenomena. I draw inspiration
from diverse subject areas that interest me, such as music,
literature, film, comics and stock markets, which I see as
a reflection of our society. I write the programming that
decrypts the data flows into rows. The art of programming
lies in designing the algorithm; once this process is com-
plete, the programme runs automatically, creating the
results without any further intervention. The final pieces
are exposed on photographic film, lit from behind, and
presented in metal frames.

Über Benjamin Samuel

Benjamin Samuel wurde 1981 in Frankfurt am Main geboren.
Er studierte Architektur, Film und Musik an der New York
Universtiy, der University of Miami, der Architectural
Association in London und der Universität für angewandte
Kunst in Wien. Er lebt und arbeitet in Frankfurt am Main.

Über Arrays of Light

Arrays of Light ist eine Reihe von Lichtinstallationen. Mein
vorrangiger, künstlerischer Impetus basiert auf der Wert-
schätzung unseres humanistischen, kulturellen und künst-
lerischen Erbes, sowie dem Verlangen, die unsichtbaren
Regeln und Gesetzmäßigkeiten dieser Phänomene sichtbar
zu machen. Mich faszinieren die verschiedensten Themen-
bereiche: Musik und Literatur, Filme und Comics sowie die
Aktienmärkte als Abbild unserer Gesellschaft. Mit dieser
Vision vor Augen, schreibe ich den Programmiercode, der
den Datenfluss entschlüsselt und in eine Reihe lenkt. Die
Kunst des Programmiercodes liegt in der Gestaltung des
Algorithmus: Ist der Vorgang abgeschlossen, läuft das
Programm selbstständig und erschafft ein neuartiges Resul-
tat ohne weiteren Eingriff. Die finalen Reihen werden auf
fotografischem Film belichtet und in leuchtenden Metall-
rahmen präsentiert.

Note of Thanks
Danksagung

I would like to warmly thank: Chaja, for her tireless and continuous support; Shira for her inspiring ideas, uplifting conversations and affectionate assistance; Prof. Dr. Henry Keazor for an inspiring foreword; Anthea Bell for her wonderful, British humour; Uri Caine for a lesson in relaxed humility; Dan Auiler for explaining how to gain strength from art; David and Hwan for their precise, aesthetic and excellent work; Koch & Konsorten; Sonja Bahr from DISTANZ for a professional and uncomplicated undertaking; the Office of Cultural Affairs of the City of Frankfurt; the Hessian Ministry for Science and the Arts; the Heussenstamm Foundation; Brieke, Frankfurt; Arnold / Nordlicht, Friedrichsdorf.

Bedanken möchte ich mich herzlichst bei: Chaja, für die unermüdliche und beständige Unterstützung; Shira für die inspirierenden Ideen, beflügelnden Gespräche und die herzliche Mithilfe; Prof. Dr. Henry Keazor für ein anregendes Geleitwort; Anthea Bell für ihren wunderbaren, britischen Humor; Uri Caine für eine Lektion in gelassener Demut; Dan Auiler für die Erkenntnis aus der Kunst Kraft zu schöpfen; David and Hwan für ihre präzise, ästhetische und hervorragende Arbeit; Koch & Konsorten; Sonja Bahr vom DISTANZ Verlag für ein professionelles und unkompliziertes Unterfangen; dem Kulturamt Frankfurt; dem Hessischen Ministerium für Wissenschaft und Kunst; der Heussenstamm Stiftung; Brieke, Frankfurt; Arnold / Nordlicht, Friedrichsdorf.

Colophon
Impressum

Editor – Herausgeber
One to One

Design – Gestaltung
Hwan Lee & David Welbergen

Texts – Texte
Dan Auiler
Anthea Bell OBE
Uri Caine
Prof. Dr. Henry Keazor
Benjamin Samuel

Translations – Übersetzungen
Shira Stanton (19–23);
Chaja Sternberg (52–55, 86–90, 105–107)

Copy Editing – Lektorat
English: Shira Stanton
Deutsch: Koch & Konsorten

Lithography – Lithografie
Frankfurter Freiheit, Systemische und
kreative Medienproduktion GmbH

Production Management – Produktion
Sonja Bahr, DISTANZ

Production – Gesamtherstellung
DZA Druckerei zu Altenburg GmbH

© 2015 Benjamin Samuel,
and / und the authors / die Autoren,
DISTANZ Verlag GmbH, Berlin

Distribution – Vertrieb
Gestalten, Berlin
www.gestalten.com
sales@gestalten.com

ISBN 978-3-95476-126-5
Printed in Germany

Published by – Erschienen im
DISTANZ Verlag
www.distanz.de

This catalogue of works was sponsored by the
Office of Cultural Affairs of the City of Frankfurt and
the Hessian Ministry for Science and the Arts and
supported by the Heussenstamm Foundation.
Dieser Werkkatalog wurde vom Kulturamt der Stadt
Frankfurt am Main und vom Hessischen Ministerium
für Wissenschaft und Kunst gefördert und von der
Heussenstamm Stiftung unterstützt.

Photo Credits – Bildnachweise
Matteo Civaschi and Gianmarco Milesi (20, 25)
Laurie Frick (21, 27)
Roxy Radulescu (21, 27)
Oscar Santillan (22, 27)
Bibliothèque nationale de France, Paris (44)
Ulrich Kneise, Bachhaus Eisenach (44)
Beethoven-Haus Bonn (45)
Jack Mitchell (72)
LOOK Magazine Collection, Library of Congress, Prints
& Photographs Division [Reproduction number e. g.,
LC-L9-60-8812, frame 8] (73)
Quote: Auiler, Dan. Vertigo: The Making of a Hitchcock
Classic. St. Martin's Press, 2001, page 67. (73)
cineclassico / Alamy, VERTIGO – Kim Novak,
Directed by Alfred Hitchcock – Paramount 1958 (76)
Photos 12 / Alamy, 2001– l'Odyssée de l'espace,
2001–A Space Odyssey, Année 1968, UK / USA, Gary
Lockwood, Keir Dullea / Réalisateur: Stanley Kubrick (77)
DEF, Uwe Dettmar (78, 79)